The Eight

Davies Glackens Henri Lawson

Luks Prendergast Shinn Sloan

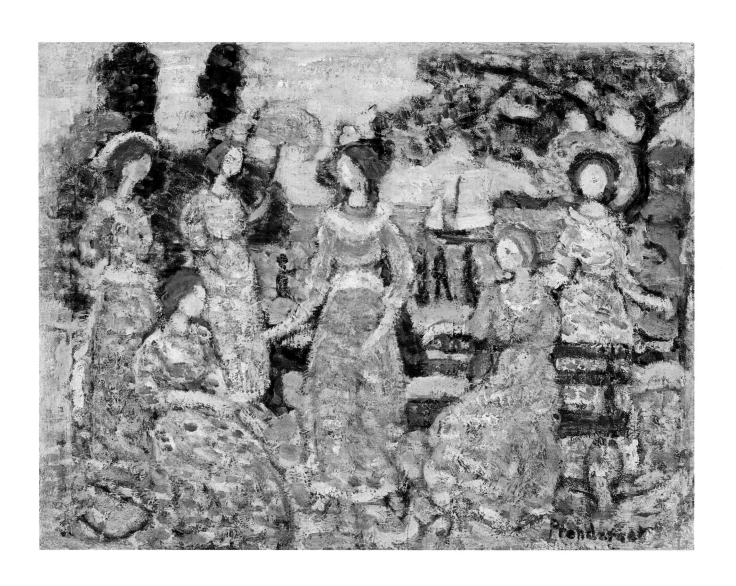

The Eight

and American Modernisms

Edited by
Elizabeth Kennedy

With contributions by
Peter John Brownlee
Elizabeth Kennedy
Leo G. Mazow
Kimberly Orcutt
Judith Hansen O'Toole
Sarah Vure
Jochen Wierich

New Britain Museum of American Art
Milwaukee Art Museum
Terra Foundation for American Art

Distributed by
The University of Chicago Press, Chicago

This book was published in conjunction with the exhibition **The Eight and American Modernisms** which was co-organized by the Terra Foundation for American Art, the New Britain Museum of American Art, Connecticut (March 6 – May 24, 2009), and the Milwaukee Art Museum (June 6 – August 23, 2009). This publication was made possible through the generous support of the Terra Foundation for American Art.

Project coordinated by Elizabeth Kennedy
Photography coordinated by Ariane Westin-McCaw
Designed and typeset by Hal Kugeler, Ltd.
Color separations by Prographics, Rockford, IL

Published by the Terra Foundation for American Art
Distributed by The University of Chicago Press, Chicago

ISBN: 978-0-932171-56-6

A catalogue record for this book is available from the Library of Congress.

The body text in this book is set in New Caledonia, a 1982 digital reworking of Caledonia, designed by William Addison Dwiggins in 1938. The bold text is set in Franklin Gothic, designed by Morris Fuller Benton in 1912 and named for Benjamin Franklin.

Printed and bound in Altona, Manitoba, Canada by Friesens

TERRA
FOUNDATION FOR AMERICAN ART

NBMAA
New Britain Museum
of American Art

MILWAUKEE ART MUSEUM

Contents

Acknowledgements

The centennial anniversary of The Eight's national tour, a single exhibition that lasted just over a year and was seen in nine states by thousands of visitors, was the impetus to organize **The Eight and American Modernisms,** an exhibition partnership among the New Britain Museum of American Art, the Milwaukee Art Museum, and the Terra Foundation for American Art. The lively ideas and enthusiasm of Douglas Hyland, director of NBMAA, and Joseph D. Ketner II, former MAM chief curator, helped to launch this revisionist project examining the relevance of The Eight's late careers. In addition, the exhibition showcases our three outstanding collections of works by these artists. The curatorial team is appreciative of the encouragement of our directors and board trustees: Elizabeth Glassman from the TFAA and David Gordon and Daniel T. Keegan, former and current directors of MAM, and Douglas Hyland.

In particular, I would like to express my gratitude to Ariane Westin-McCaw, Wendy Greenhouse, James Glission, Francesca Rose, and Bonnie Rimmer. At MAM, Liz Flaig deserves kudos for her expertise in coordinating the curatorial and registrarial staffs. Without Abigail Runyan at NBMAA, the project would have lacked a gifted manager of a myriad of details. A Zen-like demeanor overlaid with a creative mind and a sense of humor made Hal Kugeler the most inspiring of designers. Finally, my fellow authors (Peter John Brownlee, Leo G. Mazow, Kimberly Orcutt, Judith Hansen O'Toole, Sarah Vure, and Jochen Wierich) were a perfect team of colleagues, providing knowledge and timely collaboration.

Following The Eight's affable affiliation, the staffs of the three partner institutions are an able and cooperative group of museum professionals—my thanks to each one in New Britain, Connecticut, Milwaukee, and Chicago.

NEW BRITAIN MUSEUM OF AMERICAN ART STAFF
Lisa Baker, Paula Bender, Emily Blogoslawski, Shakeea Brister, Melanie Carr-Eveleth, David D'Agostino, John DeFeo, Jenna DeNovellis, Donna Downes, Morgan Fippinger, Judy Gaffney, Zbigniew Grzyb, Douglas K. S. Hyland, Adrian Lavoie, Patricia Levandoski, Linda Mare, Jonathan Morales, Melissa Nardiello, Maura O'Shea, Georgia Porteous, Andriy Shuter, Dina Silva, Joe Stanton, Susan Sterniak, Sue Sullivan, Michael Sundra, Claudia Thesing, Jennifer Walker, Heather Whitehouse, Susan Williams, and John Urgo

MILWAUKEE ART MUSEUM STAFF
Gwen Benner, Elysia Borowy-Reeder, Kelli Busch, Mary Weaver Chapin, Marilyn Charles, Jim deYoung, Christina Dittrich, Mark Dombek, John Dreckmann, John Eding, Dawn Frank, Brigid Globensky, Bambi Grajek-Specter, Stephanie Hansen, Lisa Hostetler, John Irion, Daniel T. Keegan, Beret Balestrieri Kohn, Barbara Brown Lee, Dave Moynihan, Brooke Mulvaney, Mary Louise Mussoline, Brenda Neigbauer, Keith Nelson, John Nicholson, Melissa Hartley Omholt, Therese Palazzari, Brian Pelsoh, Fran Serlin, Larry Stadler, Paul Stoelting, Sara Stum, Heather Winter, and Jane Wochos

TERRA FOUNDATION FOR AMERICAN ART STAFF
CHICAGO HEADQUARTERS
Leslie Buse, Elizabeth Glassman, Carrie Haslett, Elaine Holzman, Dennis Murphy, Eleanore Neumann, Donald H. Ratner, Cathy Ricciardelli, Jennifer Siegenthaler, Elisabeth Smith, Lynne Summers, Ariane Westin-McCaw, and Amy Zinck

Elizabeth Kennedy
Curator of Collection
Terra Foundation for American Art

Directors' Prefaces

In 1901 the New Britain Institute, established fifty years earlier as a place of learning for the working class of this industrial Connecticut town, erected a new building that included an "art room." After industrialist John Butler Talcott endowed a fund in 1903 to purchase art, the committee visited Macbeth Galleries in 1908, the same year of The Eight's notorious exhibition at this influential gallery of contemporary American art. However, the New Britain committee's choices were conservative, and it took them sixteen years to acquire twenty pictures. Only one work by The Eight, *Remembrance* by Arthur B. Davies, bought in 1909, was purchased until the late 1940s. From 1942 to 1953, the Harriet Russell Stanley Fund, created by Alix Welch Stanley, retired director of The Stanley Works, in memory of his wife, acquired 284 works of art, including sixteen works by The Eight.

By 1957, the now New Britain Museum of American Art, housed in the mansion bequeathed by philanthropist Grace Judd Landers in 1934, boasted over 600 acquisitions. Today, our new award-winning Chase Family Building allows the Museum to display more paintings than even before in its history. Visiting our galleries reveals a museum dedicated to American art that was formed by acquiring contemporary art and allows visitors the rare opportunity to appreciate the history and evolution of this field and, in particular, our numerous works by The Eight. The original mission of the Institute's art committee was to "enculturate" the laboring citizens of New Britain with American values through viewing works of art. It took almost fifty years before a significant number of works of art created by The Eight found their way into the collection. Critically, these pictures were acquired as aesthetic objects for enjoyment and not for their potential in teaching "American" lessons to a working class audience.

The outstanding collection of artworks by The Eight at the New Britain Museum of American Art was the impetus to participate with our partners in realizing **The Eight and American Modernisms.** We are most grateful to the Terra Foundation for American Art as the lead sponsor as well as The Edward C. and Ann T. Roberts Foundation for its contribution towards this important exhibition.

Douglas K. S. Hyland
Director
New Britain Museum of American Art

Kathryn Cox
Chairman of the Board of Trustees
New Britain Museum of American Art

Founded in 1888, the Milwaukee Art Museum began acquiring works by The Eight as early as 1919, when the Samuel O. Buckner Collection generously donated Robert Henri's iconic *Dutch Joe (Jopie Van Slouten)*. The Museum's unique holdings in this area have continued to grow into this century, most recently with the acquisition of an Arthur Davies print donated by the Maurice and Esther Leah Ritz Collection in 2004.

However, the Milwaukee Art Museum's superb collection of The Eight was mostly acquired between 1965 and 1981 through the generosity of Donald and Barbara Abert, who donated twenty-eight works of art by these artists. Associated with the *Milwaukee Journal* from the late 1930s, the Aberts were attracted to the newspaper background of four of The Eight (Glackens, Luks, Shinn, and Sloan). The Milwaukee natives were motivated to obtain works of art as well by other members of The Eight, who were exemplars of recording modern life. The 1991 Milwaukee Art Museum exhibition *Painters of a New Century: The Eight and American Art*, which paid homage to the 1908 Macbeth Gallery show, was fittingly dedicated to the Aberts. MAM's core collection of The Eight is more than the vision of a single collector; it demonstrated the affirmative relationship of the Abert family, who—as a token of appreciation for the citizens of their hometown—joined with the local art museum to bequeath a lasting benefit to the local community.

The works of art by The Eight represent an extraordinary core collection within the Museum's exceptional holdings of American art. We welcomed the opportunity to showcase them in **The Eight and American Modernisms** alongside other distinguished works by these artists from the collections of the New Britain Museum of American Art and the Terra Foundation for American Art. The exhibition will enjoy an interesting context in Milwaukee, presented alongside a landmark monograph of the iconic proto-modernist furniture-maker Charles Rohlfs (1853-1936).

We would like to express our appreciation to the Terra Foundation for American Art as the lead sponsor. In addition, the Milwaukee Art Museum is grateful to our presenting lead sponsor, the Caxambas Foundation and for the additional support from The Greater Milwaukee Foundation's Donald and Barbara Abert Fund, as advised by Barbara Abert Tooman.

Daniel T. Keegan
Director
Milwaukee Art Museum

W. Kent Velde
President of the Board of Trustees
Milwaukee Art Museum

Daniel J. Terra began collecting historic American art in the early 1970s. His idiosyncratic acquisition of artworks by The Eight reflects an unconventional point of view in which vibrant color was a primary allure for their selection. Ambassador Terra's choice of works was also eclectic in that there are no Arcadian pastorals by Arthur B. Davies, but 83 festive post-impressionist works of art by Maurice B. Prendergast (including 61 monotypes, the largest number in a public collection). The significant presence of The Eight in the Terra Foundation collection is signaled not only by Prendergast's numerous pictures but also its capstone painting, *Figure in Motion*, Robert Henri's magnificent nude shown at the 1913 Armory Show. Representing a later generation of collectors of The Eight, Ambassador Terra's vision was discerning in his appreciation of their art's modernist qualities. It was his admiration of the colorful aspects of The Eight's individualistic styles, noticeable when these pictures are viewed together, that suggested these artists' ambitions exceeded the usual, but inadequate, label of urban realism. On the 100th anniversary of The Eight's national tour, it seems appropriate to reassess their stylistic variations and reconsider their underappreciated late careers in **The Eight and American Modernisms.**

The works of art by The Eight are a significant bridge between nineteenth and twentieth-century American art within the Terra Foundation for American Art's collection of historic American art. Currently, the Terra Foundation initiates and grants to exhibitions and projects worldwide in the field of historical American art, dating from the colonial era to the 1940s, and actively acquires works of art to continually enhance its collection. Throughout its 30-year history, the Terra Foundation, from our headquarters in Chicago and European office in Paris, has created and supported programs designed to engage individuals in an enriching discussion of American art.

Our rewarding partnership with the New Britain Museum of American Art and the Milwaukee Art Museum has created an outstanding exhibition solely from exceptional works of art by The Eight found in our three collections. On behalf of the Terra Foundation, we would like to thank our partners in sharing this opportunity to bring attention to our collections and to advancing scholarship on the nuances of early modernism in the publication and exhibition, *The Eight and American Modernisms.*

Elizabeth Glassman
President and Chief Executive Officer
Terra Foundation for American Art

Marshall Field V
Chairman, Board of Directors
Terra Foundation for American Art

Robert Henri
Figure in Motion, 1913
Oil on canvas
77¼ × 37¼ in.
(196.2 × 94.6 cm)
Terra Foundation for
American Art, Daniel J.
Terra Collection, 1999.69

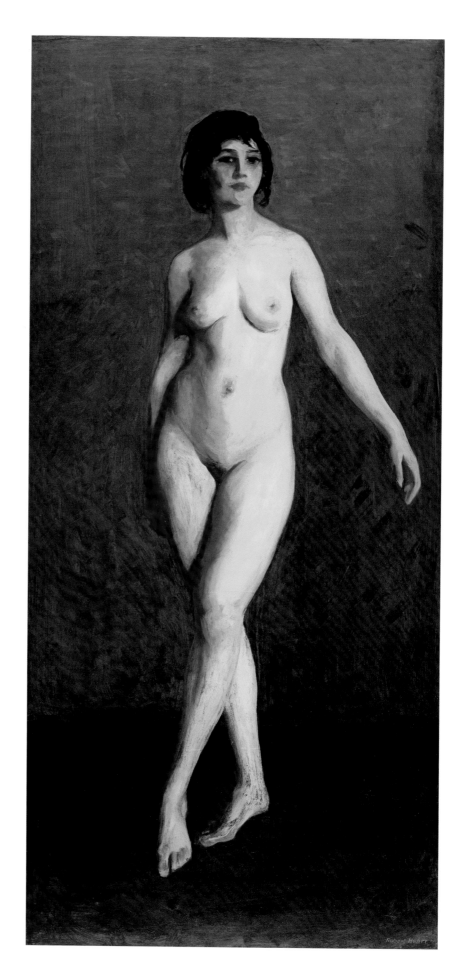

The Eight

"Modern Art of One Kind and Another"

Elizabeth Kennedy

What is pure art according to the modern idea? It is to create a suggestive magic, containing at the same time the object and the subject, the world external to the artist and the artist himself.
—Charles Baudelaire[1]

To a man, the artists who comprised The Eight embraced the romantic notion of pure art as expressed by the French critic Baudelaire: making art was their life, not merely the practice of their profession. Arthur B. Davies, William Glackens, Robert Henri, Ernest Lawson, George Luks, Maurice B. Prendergast, Everett Shinn, and John Sloan—each dedicated himself to continuous creative experimentation as a necessity of his artistic philosophy. Their commitment was exemplified by Prendergast, the oldest of the group and the last to become an artist, who was admiringly described by fellow painter Marsden Hartley as "a person of fiery enthusiasm as regards painting. It was the one thing worth doing in life—it was the means of life to him."[2] Strangely enough these individualists are forever linked by their one and only collective enterprise, their February 1908 New York exhibition at Macbeth Galleries; a century later, their artworks are still hung together in American art collections. Notably, all installations of pictures by The Eight mimic that earlier historical moment, recreating a contextual display that is a tribute to The Eight's embodiment of artistic individuality as a collective experience.

The artists of The Eight were a curious mixture of Greenwich Village bohemians and bourgeois professionals who entered their studios daily to work, went home to their wives, and enjoyed the urbane pleasures of city life. Notwithstanding the lionization of Henri as the natural leader of the group, the members were in truth more friends than followers; their collegial association is memorialized in Sloan's etching entitled *Memory* (page 14), in his affectionate drawing *George Luks in his Studio* (page 15), and in the sensitive portrait of *Dolly* (page 16), Sloan's first wife. It is significant that The Eight adopted Henri's foundational philosophy, which departed from conventional rhetoric by touting artists as exemplars of virile American manhood as well as creative, but not elitist, beings. Not surprisingly, their art reflected aspects of their personal lives as well as the visualization of abstract concepts.

The Eight's contemporaries viewed their art as uncommon and praised them for creating "modern art of one kind and another."[3] Yet, in Milton Brown's account, to use just one example, The Eight's tenure as progressive

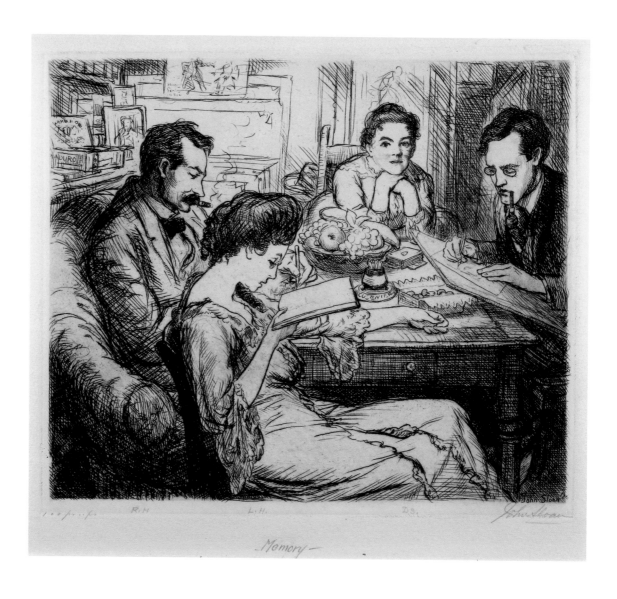

Memory —

John Sloan
Memory, 1906
Etching
7¹⁵⁄₁₆ × 8¹³⁄₁₆ in.
(20.16 × 22.4 cm)
New Britain Museum of
American Art, gift of the
Alix W. Stanley Estate
1954.15

artists ended in 1913, when the increasingly formalist-driven art of European modernism on display at the International Exhibition of Art, more popularly known as the Armory Show, rendered their purportedly realistic art and their careers irrelevant.[4] This exaggeration of the rapid ascendancy and demise of The Eight's contribution to a nascent American avant-garde obscures a far more complex tale, for each artist experienced a successful professional journey that defies group labeling, with its implication of a single unifying ideology or a static artistic outlook. In fact, the legendary aura of the men of The Eight influenced artists all across the country throughout the 1930s. The aim of *The*

Eight and American Modernisms is to reclaim these individual artists' contributions to this tumultuous era when progressive art of all tendencies was vying for attention.

By 1907, The Eight were established mid-career, critically acclaimed, New York-based artists.[5] If success can be measured by sales, Davies was flourishing, with several devoted patrons, for whom he served also as an art advisor. Henri could boast of a prestigious professional tribute: the purchase of *La Neige* (1899; Muse d'Orsay) by the French government for its contemporary art museum, in 1899. Four years later portraiture, commissions as well as figure studies, dominated Henri's artistic energies varied with only plein-

air landscape subjects made during summer respites from his teaching duties. Key sources of income for Lawson and Luks were acquisitions by collectors and monetary prizes awarded at exhibitions. Family assistance supplemented the sporadic sales of their works for Glackens and Prendergast, who devoted their energies exclusively to generating their art. The talented Shinn creatively fulfilled multiple artistic commissions but lacked the dedication to painting to become a distinguished artist. Sloan, the last of the group to relocate to New York (apart from Prendergast), relied on teaching and illustration assignments while he struggled to establish himself as a respected artist.[6]

The Eight's notorious exhibition at Macbeth Galleries—the participants, the events, and the reaction of the New York art world—has been thoroughly documented.[7] Frustrated with the jury process for National Academy of Design's 1907 spring exhibition, Henri joined with like-minded colleagues to stage an alternative show. A man of action and an experienced exhibition organizer, Henri's fluent discourse on contemporary American art provided excellent copy for newspaper and magazine journalists.[8] What is remarkable but seldom accentuated is The Eight's desire—emphasized in the publicity—to have their independent show serve as something more than a sales opportunity: the fulfillment of their mission to recognize various modes of progressive art. As art historian Bruce Altshuler has astutely recognized, the modernity of The Eight came in breaking with the sentimentality of the nineteenth century without emulating the formal experiments of European moderns and in "their focus on individual expression."[9] Thus, the prospect of critical notice not only for these artists but also for other independents was worth the cost of a self-organized show at William Macbeth's gallery.

The most relevant document that insightfully demonstrates the varied styles of The Eight is the pamphlet published for the event,

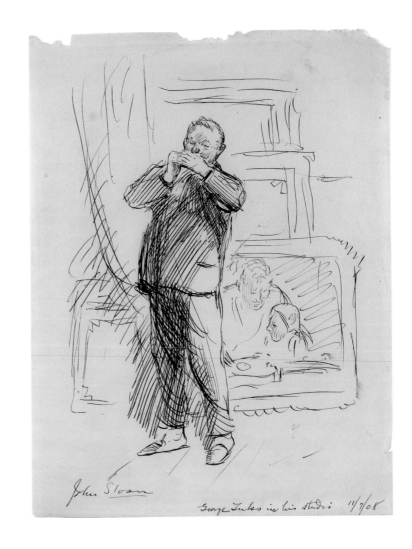

John Sloan
George Luks in His Studio, 1908
Ink on paper
10½ × 8⅛ in.
(26.7 × 21.6 cm)
New Britain Museum of American Art, A. W. Stanley Fund, 1954.14

titled simply "Exhibition of Paintings," listing the eight artists' names alphabetically on the title page.[10] Inside, on the other hand, their works were listed according to their arrangement in the two octagonal galleries, with two pages—one listing the artworks and the other reproducing a photograph of a representative work—dedicated to each artist. By organizing the pamphlet as the artworks were arranged in the galleries, the artists encouraged visitors to view the paintings in a particular order, one that emphasized the diversity of the group's members. In the first room, for example, Shinn's paintings of cosmopolitan vaudeville entertainments in such international locales as Paris and London were paired with Lawson's rural New York landscape scenes. The thematic

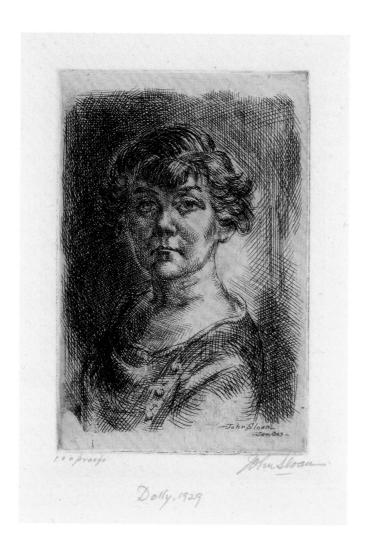

disjuncture between them is analogous to the visual contrast of dark theater interiors, in which performers are bathed in bright artificial light, and country vistas awash in post-impressionist color and pattern. Sloan's art presented a third topic: bustling New York street life, in views that affectionately evoke the lived experiences of the working class.[11] Immediately following them was the transatlantic jolt of Prendergast's eight small oil studies recalling the gaiety of the French beach resort at St. Malo; the Boston artist added even more chromatic plentitude with

the "spotty" colors of additional park and beach scenes.[12] This gallery's viewing ended with the audacious juxtaposition of Sloan's somber palette next to Prendergast's riot of color before the visitor doubled back to enter the next room.

In the second gallery, according to the printed guide, works by Luks, Henri, Glackens, and Davies were hung successively. Luks's art was undeniably vulgar, and he set out deliberately to shock the refined art lover with his portrayals of barnyard animals and the humblest of people. It must have been startling to turn next to Henri's adjacent portraits, mostly of children. Henri's performance of painting is evident in the gestural freedom used to apply buttery pigments in deeply saturated colors, set off by black. Next to Henri's portraits and landscapes, Glackens's art was optimistically anecdotal. His views of New Yorkers' recreational activity in his four brightly colored park scenes and the sophisticated shoppers and diners in his two large paintings are a far cry from the somber, impoverished figures portrayed by Luks and the working-class citizens depicted by Sloan. Works by Davies enjoyed the final word in the second gallery, although his ambiguous titles and enigmatic imagery required much from the visitor interested in interpreting their meanings. Imagine pondering Davies's dreamy symbolist painting of two nude women in a lush landscape and then turning to encounter Luks's *Pigs* just across the gallery! This modest exhibition guide demonstrates that as early as 1908 the artists of The Eight were dedicated to developing their own expressive styles with a variety of subjects based on modern life that reflected their identities as painters, not illustrators or journalists. There is no doubt that many of the themes were vulgar, but few, if any, of these exhibited works could be characterized as stark realism.

This landmark event, a showcase for eight independent artists, had a remarkable afterlife. The overwhelming numbers of visitors to

the Macbeth exhibition ensured its legendary status, while Gertrude Vanderbilt Whitney's purchase of works by Davies, Henri, Lawson, and Luks established a pattern for The Eight's continued alliance in future American art collections. Whitney Museum of American Art historian Avis Berman has proposed that The Eight's Macbeth show was an incubator for the museum, founded just twenty years later: Mrs. Whitney's purchases "became anchors and reference points for much of the art Gertrude and Juliana Force, the museum's first director, later chose to sponsor."[13] Henri's sensual portrait of Whitney in her most bohemian mode of dress (fig. 1) pays homage to her patronage of The Eight while expressing the synergy between these progressive American artists and their advocate, the founder of an art museum dedicated exclusively to American art.

The exhibition of The Eight also had an impact nationally. Following the New York showing, it traveled to the Pennsylvania Academy of the Fine Arts in Philadelphia and then on to six museums in the Midwest (the Art Institute of Chicago, the Toledo Museum of Art, the Detroit Museum of Art, the John Herron Art Institute, the Art Association of Indianapolis, the Cincinnati Art Museum, and the Carnegie Institute, Pittsburgh), ending the tour in the spring of 1909 with two venues on the east coast, the Bridgeport Art Association in Connecticut, and the Newark Museum Association in New Jersey (both institutions associated with local libraries).[14] At these art organizations and their affiliated schools, artists and art students became aware of the eight artists' independent styles and their reputations continued to rise.

The traditional narrative of American art history grants The Eight less than a decade of leadership in the development of early modernism in the United States. The achievements of The Eight as individualist artistic exemplars are especially undermined by the careless application of the "Ashcan school" label as an equivalent identity to the group and, even more egregiously, to individual members.[15] This perpetual practice of associating The Eight with urban realism fails to acknowledge their ceaseless, if at times unsuccessful, formalist experiments.[16] By focusing insistently on "urban realism," just one dimension of the art practiced by four of the artists, is to lose sight of their richly complex personas and the full development of their mature styles. The Eight's simultaneous recognition of non-representational art as a valid expression of contemporary art styles while refusing to embrace the authority of abstract art as the only "true" vehicle for modernity encouraged other American artists to insist on the integrity of their own creative visions. In the last decades of their careers (only Shinn and Sloan lived past the 1930s), The Eight's success in the art world and their autonomous stance made them profoundly relevant to their contemporaries, as the essays and the timeline in this catalogue demonstrate.

While their early experiences as newspaper illustrators may have informed a reportorial impulse among the so-called Philadelphia Four (Glackens, Luks, Shinn and Sloan), by 1905 these artists had relinquished such work to concentrate on fine art, with only occasional commercial illustrating assignments. The artists' regarded their art as the acme of modern painting, based on memory and imagination, gained from their prowling the streets and by-ways of New York in search of scenes for "pictures." A 1908 review celebrated the artists' distinctiveness: "These eccentric 'Eight' are by no means

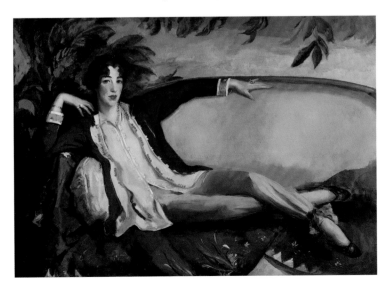

rebels against the academy or its tradition, they are merely individualists, bound together in a league of originality and unconventionality."[17] Other accounts politicized their art as carrying a message in a manner that was hotly denied by the artists themselves. The Eight never aspired to elevate "urban realism" to a philosophy of social concern or a celebration of American life. Nevertheless, within a year New York art critic Sadakichi Hartman categorized Glackens, Henri, Luks, and Sloan as proponents of "vigorous realism."[18] Hartman linked these artists to such revered figures of the American school as Thomas Eakins and Winslow Homer, famous for their approach to American subjects, whose works were considered to be encrypted with a

national style, valorizing the "unvarnished truth" of a democratic society.

A generation later in the 1930s during the nation's economic instability, the picturesque phrase "Ashcan school" was attributed to many artists of the 1910s who explored urban themes, thereby offering them as exemplars of an ideology of social concern in picturing city life.[19] For the artists of The Eight interested in the quotidian experiences of their neighbors, however, the motivation was strictly artistic. In replacing the rural European peasants of academic painting with the colorful polyglot citizenry of contemporary New York, they were motivated by a fundamental humanism but not by a particular political agenda; their

John Sloan
Anshutz on Anatomy
1912
Etching
7¼ × 8⅞ in.
(180.4 × 22.54 cm)
Milwaukee Art Museum, gift of Juel Stryker in honor of her parents, Clinton E. and Sarah H. Stryker
M1989.36

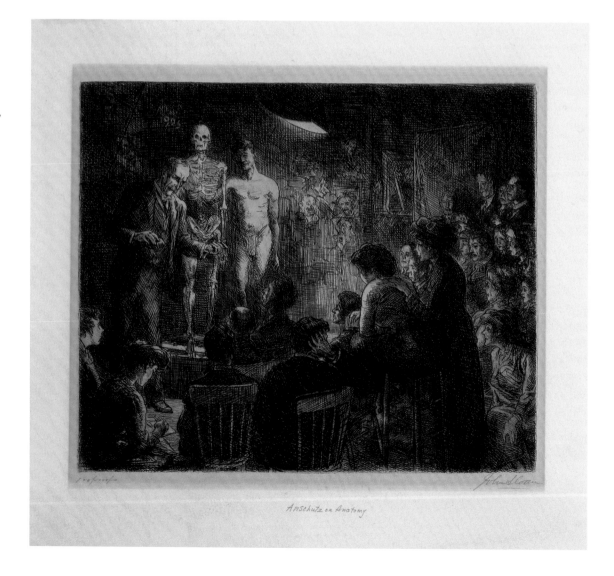

often overtly imaginative compositions reveal little of a documentary impulse.

The notion of realism as the defining characteristic of The Eight was debunked in 1979 by art historian Judith Zilczer, citing Henri's *The Art Spirit*, his 1923 treatise of his beliefs:

> Low art is just telling things, as, there is the night. High art gives the feel of night. The latter is near reality although the former is a copy …. Reality does not exist in material things. Rather paint the flying spirit of the bird than its feathers.[20]

Articulating further that "The brush stroke at the moment of contact carries inevitably the exact state of being of the … artist at that moment into the work," Henri declared his preference for emotion over beauty and his conviction that a painting's formal aspects reveal the artist's inner emotional state, a more important purpose than an overt "message" deliberately conveyed through subject matter. The philosophical underpinnings of Henri's ideas were adopted by his friend Sloan, who continued to teach that self-expression is the foundation of modern art. The series of exhibitions that culminated in the founding of the Society of Independent Artists, presided over by Sloan from 1918 to 1944, was one of the greatest legacies of The Eight's progressive attitude toward art of diverse expressions.

The Eight's experimentation with theory—in both color and composition strategies—is often overlooked, but its impact on the artists' compositions was commented upon by critics and by other artists.[21] It is perhaps most evident in these artists' treatment of the universal theme of the human body, especially the female nude. The study and portrayal of the figure is fundamental to western art and is the heart and soul of academic training.[22] Until total abstraction predominated in modern art at mid-century, the study of the nude was a constant that linked generations of American artists' varied stylistic manifestations. Surprisingly, nudes are rarely displayed in galleries of historic American art although post-1945 paintings of nudes are regularly integrated into museum installations. This conundrum must, in part, arise from the perception that nudes painted by the progressive artists of the 1920s and 1930s were interpreted as "realistic" and, thus, portray "naked" women. Understood as neither the "ideal" nude, as a statement of beauty, nor an exercise in formalism, these expressive paintings were unappreciated as theoretical essays.

As art instructors, Henri and Sloan taught life study classes for advanced students, and they were dedicated to the representation of the human figure as the vehicle for portraying their expressive ideas. *Anshutz on Anatomy* (page 18), Sloan's etching of their teacher instructing a mixed class of men and women students at the Pennsylvania Academy of the Fine Art, is a rumination on the rigors of artistic training. Critically, Sloan chose not to depict a sketching class but a technical lesson in anatomy in which a human skeleton is compared with the muscular figure of the male model, covered only by a loin cloth. While the image acknowledges the scientific underpinnings of art in its straightforward depiction of a fully modeled body spotlighted on a platform, its real subject is the implied intimacy among the students, both men and women, as they gather in the darkened classroom in training for their life's work. In this portrayal of the nude model as muse, Sloan emphasized the camaraderie of the life study classes as illustrative of a cherished endeavor unique to the artist's profession.

Among the members of The Eight, Lawson is notable as the only artist to neglect the nude in his painting; the rest approached the subject with considerable individual variation. The symbolist Davies exploited a vast repertoire of female nudes frolicking in idyllic landscapes, as in *Rhythms* (page 35), and in his works on paper

he drew women in blatantly erotic poses (page 37). After 1910, Prendergast developed his own version of generic nude female forms to infuse his pastoral landscapes with suitable lyricism (page 127). Shinn, when needed, adapted the naked bodies of women as decorative elements in his rococo house designs (fig. 33). As easel painters, Glackens and Luks (fig. 20) on occasion rendered sensitive studio nudes — using the human figure as a vehicle for exercises in shape and color.

Studio models painted by Henri and Sloan were realized as tangible women who evoked formal artistic statements. *Figure in Motion* (page 12), submitted by Henri to the Armory Show as his magnus opus, exemplifies his perception of himself as a painter. An artfully arranged dancer, the life-sized nude woman embodies the intellectual notion of *élan vital* and the conceptual spatial fulfillment of the fourth dimension as conceived by the artist.[23] Furthermore, every inch of the canvas is activated by the arousing touch of the artist's brush as it transferred his life force onto the surface. Perceptually, no distinction exists between the artist and the painting, or the man and his muse. By comparison, Picasso wrapped himself in a minotaur's guise to express his sexual dominance of his model; Henri clothed his nude model in lush colors applied with caressing brushstrokes that emphasize the act of painting to chastely portray the human figure as the ideal of art,

never more convincingly than in *Betalo Nude* (page 72). Sloan's more analytical approach was intended to eliminate the sensual in depicting the female nude. Deliberately choosing less attractive models, he intellectualized the modeling of form to achieve a volumetric expression of the figure, entangling the model in a geometric scheme of red cross-hatching. Sloan was more successful in using his cross-hatching technique in his etchings of nudes, as in the elegant *Long Prone Nude* (pages 160–161), which conveys both the vitality of life and the artifice of art. Experimental painting of the nude model in the studio was one of the theoretical strategies that some of The Eight continued late into their careers.

The recovered agency of The Eight in their post-Armory decades until the 1930s, when the Great Depression transformed the American art world, disputes the conventional wisdom that these artists were irrelevant. Yet, it is undeniable that as older artists they began to savor their successful careers and to take pleasure in the respect of their peers and patrons based on their award-winning pictures before and after 1913. Championed as modern men who succeeded in disassociating themselves from dated sentimentality while resisting uninspired efforts to "Americanize" avant-garde European styles, The Eight found "suggestive magic" in their art and encouraged countless American artists also to value their independence.

1 Charles Baudelaire quoted in Peter Gay, *Modernism: The Lure of Heresy, from Baudelaire to Beckett and Beyond* (New York: W. W. Norton, 2008), 33–4.

2 Marsden Hartley, "Somehow a Past," unpublished autobiography, 1933–1942, Yale Collection of American Literature, Beinecke Rare Book and Manuscript Library, Yale University, quoted in Richard J. Wattenmaker, *Maurice Prendergast* (New York: Harry N. Abrams, 1994), 12.

3 "The World of Art: Modern Art of One Kind and Another," *New York Times*, January 27, 1924, quoted in Nancy Mowll Mathews, "Thoroughly Modern Maurice," *Maurice Prendergast: Paintings of America* (New York: Adelson Galleries, 2003), 173, note 1.

4 Milton W. Brown, *The Story of the Armory Show* (New York: Abbeville Press, 1988), 234–43.

5 Until 1914, when he moved to New York, Prendergast divided his time between that city and Boston.

6 For biographical information on the individual artists, see the essays in this publication.

7 Important works based on exhaustive research into The Eight are Bennard B. Perlman, *Painters of the Ashcan School: The Immortal Eight* (New York: Dover Publications, 1979); William Inness Homer, "The

Exhibition of 'The Eight': Its History and Significance," *American Art Journal* 1, no. 1 (Spring 1969): 53–64; and Elizabeth Milroy, *Painters of a New Century: The Eight and American Art* (Milwaukee: University of Wisconsin Press, 1991).

8 Henri organized his first independent exhibition in 1901 at the Allan Gallery, including himself, Glackens, Alfred Maurer, and Sloan. Three years later he arranged a show at the National Arts Club in New York with the artists affiliated with The Eight except for Shinn; it was the first time art by Prendergast was included.

9 Bruce Altshuler, *The Avant-Garde in Exhibitions: New Art in the 20th Century* (New York: Harry N. Abrams, 1994), 62.

10 The pamphlet is reproduced in Perlman, *Painters of the Ashcan School*, 157–73.

11 An exception among Sloan's works was one interior subject, *The Cot*, 1907, Bowdoin College Museum of Art.

12 Charles de Kay, "Six Impressionists. Startling Works by Red-Hot American Painters," *New York Times*, January 20, 1904.

13 Avis Berman, *Rebels on Eighth Street: Juliana Force and The Whitney Museum of American Art* (New York: Atheneum, 1990), 93.

14 Judith Zilczer, "The Eight on Tour," *American Art Journal* 16, no. 3 (Summer 1984): 20–48.

15 Glackens's son describes his father as an "un-ashcanny" artist, but he still chose the catchy phrase in Ira Glackens, *William Glackens and the Ashcan Group* (New York: Crown Publishers, 1957). Major scholarly studies of the artists of The Eight that present them as urban realists or focus on subject matter rather than artistic practice include H. Barbara Weinberg, Doreen

Bolger, and David Park Curry, *American Impressionism and Realism: The Painting of Modern Life, 1885–1915* (New York: Harry N. Abrams 1994); Rebecca Zurier, Robert Snyder and Virginia Mecklenburg, *Metropolitan Lives: The Ashcan Artists and Their New York, 1897–1913* (New York: W. W. Norton, 1995); Rebecca Zurier, *Picturing the City: Urban Vision and the Ashcan School* (Berkeley: University of California Press, 2006); and Heather Campbell Coyle and Joyce K. Schiller, *John Sloan's New York* (New Haven: Yale University Press, 2007). A recent exhibition catalogue, James W. Tottis et al., *Life's Pleasures: The Ashcan Artists' Brush with Leisure, 1895–1925* (London: Merrell, 2007), highlights The Eight's engagement with subject matter remote from the "gritty realism" with which they are typically associated.

16 See "The Science of Painting" in William Inness Homer with Violet Organ, *Henri and His Circle* (Ithaca: Cornell University Press, 1969), 184–94, and Barbara Jaffee, "The Abstraction Within: Diagrammatic Impulses in Twentieth Century American Art, Pedagogy, and Art History" (PhD diss., University of Chicago, 1999), 21–72.

17 "Striking Originality in Work of 'The Eight,'" *Toledo News-Bee*, October 15, 1908, quoted in Zilczer, "The Eight on Tour," 29.

18 *Sadakichi Hartman: Critical Modernist, Collected Art Writings*, ed. Jane Calhoun Weaver (Berkeley: University of California Press, 1991), 23.

19 Holger Cahill and Alfred H. Barr Jr., eds., *Art in America in Modern Times* (New York: Reynal and Hitchock, 1934).

20 Robert Henri, *The Art Spirit* (1923), quoted in Judith K. Zilczer, "Anti-Realism in the Ashcan School," *Artforum* 7, no. 7 (March 1979): 44–49.

21 See in this publication Sarah Vure's essay on Henri. Homer, *Robert Henri and His Circle*, for information on color theorist Hardesty Maratta, 184–9, and for Jay Hambridge's Dynamic Symmetry, 189–192. For the artists' perspective on theory see Robert Henri, *The Art Spirit* (Philadelphia: The Lippincott Company, 1923) and John Sloan, *Gist of Art: Principles and Practice Expounded in the Classroom and Studio* (New York: American Artists Group, Inc., 1939). Maratta is mentioned in the index of both artists' books (Henri: 46, 52; and Sloan: 116, 119, 122) while Hambridge is mentioned only in Henri's index, 46.

22 The classic study of the nude in art is Kenneth Clark, *The Nude: A Study in Ideal Form* (Princeton: Princeton University Press, 1956). There have been relatively few studies of the nude in American art, among them William H. Gerdts, *The Great American Nude: A History in Art* (New York: Praeger, 1974); and Rebecca Zurier, "Nudes and Other Nonpolitical Art," in *Art for The Masses: A Radical Magazine and Its Graphics, 1911–1917* (Philadelphia: Temple University Press, 1988), 154–8.

23 In Henri's art notebook, he lists the work as painted in "Jan 1913" and describes it as a "nude/of Jewish girl/ black hair./ brown skin. blue/ backgr/ floor /Purple and green [sic]" Below the words "Figure in Motion" the word "Orientale" is crossed out, suggesting that it was an alternative title. For further information see Homer, *Robert Henri and His Circle*, 257; Gerdts, *The Great American Nude*, 154; and Bennard B. Perlman, *Robert Henri: His Life and Art* (New York: Dover Publications, 1991), 107, 109.

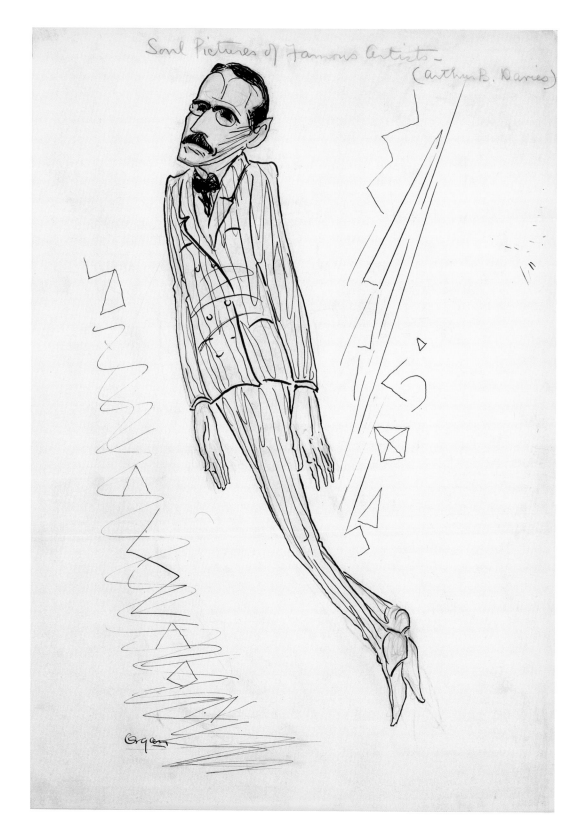

FIG. 2
Marjorie Organ
(1886–1930)
*Soul Pictures of
Famous Artists,
Arthur B. Davies*, n.d.
Ink and pencil on paper
15¼ × 10¼ in.
(38.7 × 26 cm)
Delaware Art Museum,
gift of Helen Farr
Sloan, 1978

Davies

The Problem of Arthur B. Davies

Kimberly Orcutt

In 1923, critic and Metropolitan Museum of Art curator Bryson Burroughs summed up the challenge of understanding Davies's (1862–1928) mature oeuvre by conceding, "Frankly Arthur B. Davies is a problem."[1] Burroughs's assessment rings just as true today. It is difficult to put Davies's work into chronological sequence, since he did not date most of his paintings, he often reworked them years later, and a posthumous list compiled by his wife is full of errors.[2] Burroughs's confusion would have been compounded had he known of the artist's shocking personal life. The critic was not referring to these quandaries, however, but rather to the fundamental problem of trying to make sense of an artist who, in his words, "has changed too often, crossed his own trail too many times to be easily followed." Unraveling Davies's relationship to modernism nearly a century later can be similarly confounding. Davies was a leader in bringing European avant-garde art to the United States. One might expect his own work to reflect his broad knowledge and understanding of modernism, yet after a relatively brief flirtation with abstraction, he returned to the romantic style that made his fame. Attempting to explain this contradiction sheds some light on Davies's work after the 1908 exhibition of The Eight, although it is still obscured by shadows of the artist's own making.

Davies explored a range of media, including painting, printmaking, watercolor, sculpture, and tapestry. His early works often depict children in dreamlike but recognizable landscapes, as in *Fountain Play* (page 33). After 1900 the artist began to draw upon literature and myth, leading to such themes as *Hylas and the Nymphs* (page 25). His varied work as a mature artist was united by his enduring interest in the female form, often presented in a landscape and usually given an allusive title. Whether his broad explorations of carefully circumscribed themes are a mark of genius, facility, or simply restlessness, they paralleled his quest for an ideal of love and domestic life. During his lifetime, critics revered Davies as a visionary recluse. The artist was famously diffident and retiring. He would not let himself be recognized at galleries where his work was being exhibited, except by close friends. He allowed almost no visitors to his studio (admittance was only by a special knock). He became still more secretive as the years wore on, declining to attend receptions for his own exhibitions and refusing to give interviews or serve on juries.[3] Burroughs tried to find an explanation by romanticizing the artist's behavior: "One would not say that Davies scorns praise, denies friendships; but he is fearful of interruption, ruthless in his devotion to work …. His life is dignified and royal in its powerful seclusion."[4]

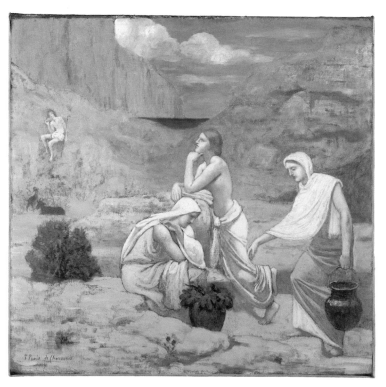

FIG. 3
Pierre Puvis de Chavannes (1824–1898)
The Shepherd's Song, 1891
Oil on canvas
41⅛ × 43¼ in.
(104.5 × 109.9 cm)
The Metropolitan Museum
of Art, Rogers Fund, 1906
(06.177)

We now know that Davies's secrecy was an effort to hide his scandalous personal life. In 1892 he married Virginia Meriweather Lewis and the following year the couple moved to a farm in Congers, New York, where Virginia would spend the rest of her life. Within a few years, conjugal bliss had faded and Davies established a routine of spending weekdays working in New York, visiting his wife and their growing family on the weekends. Virginia was trained as a doctor and developed a country practice that, along with the meager income from the farm, provided most of the family's financial support even in the artist's very prosperous later years.

In 1902 the artist engaged a young dancer named Edna Potter as a model. After an affair lasting a few years, Davies moved her into an apartment at 314 East Fifty-second Street where they lived together during the week as Mr. and Mrs. David A. Owen. In 1912 Edna gave birth to a daughter, Helen Ronven Owen. After Davies's death Edna complained bitterly about his neglect, such as the meager $10 per week allowance he gave her.[5] Only a handful of close friends knew of the arrangement: Davies's dealer

William Macbeth, the artist Walt Kuhn, and his devoted patron Lizzie Bliss. Such information makes for lively copy, and theorizing about the relationship between Davies's life and work could occupy an entire essay of its own. This aspect of his personal life must be accounted for, however, since it surely informed his art, or perhaps his art affected it. Knowing some of the practical reasons behind the artist's mysteriousness, we must see his work with different eyes from those of his contemporaries.

In May of 1907 Robert Henri explained the impetus behind the upcoming Macbeth Galleries exhibition of "Eight American Artists" by saying, "We've come together because we're so unlike."[6] He was addressing a question that would puzzle critics who saw the show. Davies's paintings seemed far removed from those of the other artists, both in their refined technique and in their dreamy, idealized subject matter. However, many of The Eight shared strong ties to earlier traditions and their heirs — for example, Henri to Velázquez and Edouard Manet; George Luks to Frans Hals; Shinn to the Rococo artists Watteau and Fragonard; and Davies to antiquity, the Renaissance, and the classical tradition of Puvis de Chavannes, whose modern vision of the age-old mural form was widely admired (fig. 3). After the success de scandale of the 1908 Macbeth Galleries exhibition, Davies's fate would continue to be intertwined with Henri's, though they would increasingly be rivals rather than the close friends they had been for well over a decade.

The Association of American Painters and Sculptors was formed in 1912 and its only exhibition, now known as the Armory Show, took place the following year. Davies was elected president after J. Alden Weir's resignation and immediately set upon his most visible and most enduring contribution to the development of modern art in the United States. Although the works of the European avant-garde were familiar to many

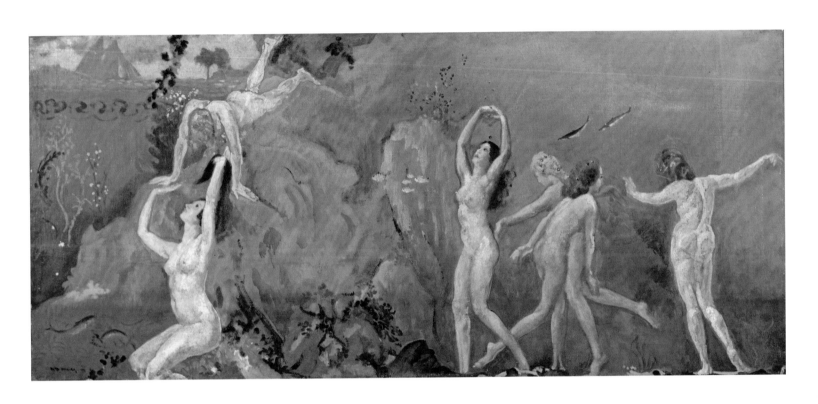

Arthur B. Davies
Hylas and the Nymphs, c. 1910
Oil on canvas
18 × 40 in.
(45.72 × 101.6 cm)
New Britain Museum
of American Art,
Harriet Russell Stanley
Fund, 1946.11

FIG. 4
Marsden Hartley
(1877–1943)
Berlin Ante War, 1914
Oil on canvas
with painted wood frame
41¾ × 34½ in.
(106 × 87.63 cm)
Columbus Museum of Art,
Ohio: gift of Ferdinand
Howald, 1931.173

artists and collectors by this time, the Armory Show brought them en masse to a national audience, forcing a consideration of how they would impact the future of American art. Davies's role in planning the exhibition cannot be overstated, and he surprised — and angered — many of his colleagues with his energy, efficiency, and autocratic style. Burroughs would later recall that "Such executive energy and efficiency were very astonishing in the solitary and the idealist, as he had hitherto been considered." Guy Pène du Bois was less generous, calling Davies "a dictator, severe, arrogant, implacable."[7]

Davies was careful to consolidate his leadership by shutting Henri out of the proceedings. He, Walt Kuhn, and Elmer MacCrae quietly made the initial arrangements for the exhibition before involving Henri and his adherents, so that, in Kuhn's words, "they can't do any monkey business."[8] Davies joined Kuhn abroad in the summer of 1912 to choose the European works. Davies had not been in Paris, the center of the new movements, in seventeen years, but his deep and almost instantaneous understanding of the "new art" was remarkable. Walter Pach marveled at the depth of Davies's intuitions, calling them "astonishing — in my experience, unique."[9] The problem of Davies's modernism is encapsulated in the juxtaposition of his mythic idylls with the works that he chose for the Armory Show, which included paintings by the likes of Marcel Duchamp, Henri Matisse, and Pablo Picasso. The 1913 exhibition illuminates a key point in understanding his career: Davies's contribution to modernism in the United States went far beyond his own works of art.

The critic Frank Jewett Mather, Jr., called Davies's role in the Armory Show his "first and only public gesture."[10] Mather's assessment reflects the widely accepted image of Davies as an aloof, otherworldly figure, but in truth he was something of an impresario, organizing numerous exhibitions of modern art. Davies was one of five artists contributing seed money to support the 1910 Exhibition of Independent Artists in New York, and after the notorious Armory Show he was called upon to organize numerous other exhibitions of avant-garde art, including displays of cubist works in 1913 at department stores in Cleveland, Pittsburgh, and Philadelphia as well as at the Carnegie Institute. That year he was asked to join the board of the Carroll Gallery, founded by the collectors John Quinn and Mrs. Charles C. Rumsey, where he developed contemporary art exhibitions.[11] In 1914 he worked with Montross Gallery in New York on exhibitions of modern art by Matisse and Paul Cézanne and group shows of such Americans as William Glackens, Kuhn, Maurice B. Prendergast, Morton Schamberg, and Charles Sheeler. In the 1920s he became involved with the Sculptors' Gallery in New York where he presented exhibitions of Quinn's acclaimed collections of

English and French modern art, as well as shows featuring American modernists.[12]

Davies's involvement with the avant-garde extended to collecting as well. As early as 1901 he purchased an Alfred Maurer sketch from Alfred Stieglitz, and by the time of his death in 1928, he owned more than five hundred objects. He cast a broad net that suggests the dizzying catholicity of his interests: a 1929 sale of his collection included Coptic textiles, Roman glass, Egyptian beads, Babylonian seals, Hellenistic bronzes, Chinese jades, Japanese scrolls, Buddhist steles, Persian tiles, French furniture, Alaskan bone carvings, Pre-Columbian pottery, and American antiques. He accumulated paintings, prints, drawings, and sculpture by seventy-five artists, among them the Europeans Constatin Brancusi, Cézanne, Giorgio de Chirico, André Derain, Paul Gauguin, Juan Gris, Fernand Leger, Matisse, Picasso, Puvis de Chavannes; and such Americans as George Bellows, Patrick Henry Bruce, Preston Dickinson, Glackens, George Luks, Schamberg, Joseph

Stella, and Max Weber. His notable acquisitions included one of Marsden Hartley's most accomplished and innovative paintings, *Berlin Ante War* (fig. 4).[13]

Davies also assisted his fellow artists in personal and practical ways, leveraging his own burgeoning success and his contacts to advance their careers. He helped finance Hartley's seminal trip to Europe in 1912. When Rockwell Kent faced financial troubles in 1911, Davies recommended him to the dealer Macbeth, who purchased a group of Kent's works. He encouraged other artists who are of greater and lesser renown today, such as Sheeler, Arthur Crisp, and Manierre Dawson.[14]

What of the impact of modernism on Davies' own work? The Armory Show marked the beginning of a brief experimental period. After the 1913 exhibition, he began to combine cubism and synchromy, abstracting his female forms into streamlined, often chromatic shapes, as is seen in *Day of Good Fortune* (fig. 5). Perhaps

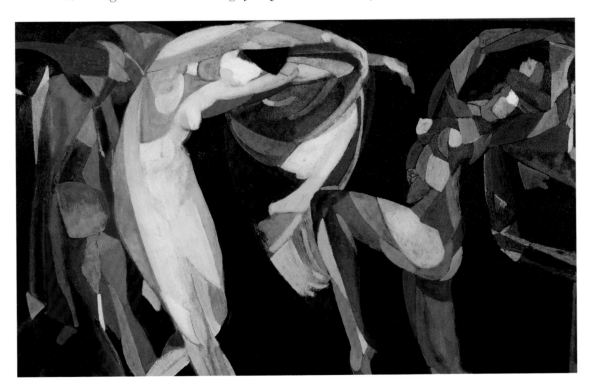

FIG. 6
Arthur B. Davies
***Lizzie Bliss Music
Room Mural,*** 1914
Oil on canvas
54¼ × 68 in.
(137.8 × 172.72 cm)
Munson-Williams-Proctor
Arts Institute, Museum
of Art, Utica, New York
59.80.1–13

his most widely publicized work during this period was a 1914 commission from his devoted patron Lizzie Bliss for murals to decorate her music room (fig. 6). Their brown and tan color scheme recalls the restrained palette of Picasso's early cubist works. By 1918 Davies seems to have all but returned to his earlier style, although his figures retained some qualities of abstraction in their planar, streamlined quality, as is evident in *Afterthoughts of Earth* (fig. 7).

In his later works Davies continued to draw from the entirety of the history of art, including his own time. This would have been difficult for his contemporaries to understand, since during its early years modernism was perceived by its most daring practitioners as an abrupt break with the past. Even in the span of his own career, Davies continually drew from and recast his own "history." He often revisited old works as a starting point for new ones or worked over old paintings, sometimes many years later. He used old figure sketches as source material for his cubist works of 1913 and 1914, and between 1914 and 1928 he painted his model Wreath McIntyre into landscape paintings dating back to 1882 that remained in his studio.[15]

Explaining the short duration of Davies's foray into avant-garde styles is the fundamental "problem" in understanding his mature career,

and his own comments and scraps of writings and commentary offer only tantalizing hints.[16] Davies occasionally made comments in print or to friends that suggest a struggle between the calls of emotion and intellect. He began his career as a romantic and that impulse continued to guide his work, but he became keenly aware of the emphasis on cool intellectual analysis that many avant-garde artists of his day employed. In explaining murals that he executed in 1924 for New York's International House, he wrote that his method of "continuous composition" was "a subjective realization by inspiration of a way used by the early Christian artist to preserve his original spontaneous subjectivity and oneness — otherwise knowledge would flow from without inward, and Reason would impair the process of Love and Beauty." In a seeming contradiction, du Bois recalled Davies telling him that emotion should enter into a painting only after the structure had been intellectually settled.[17]

The clearest statement of Davies's views can be seen in a chart (fig. 8) that he created for a pre-Armory Show article intended, according to the title, to "show the growth of modern art."[18] He divided modern art movements into three strains: classicists such as Jean-Auguste-Dominique Ingres and Puvis de Chavannes with Cézanne at an intermediate stage, leading ultimately to Picasso and the cubists; realists such as Gustave Courbet, Manet, and Claude Monet, leading again to Cézanne and then to the futurists (whom he characterized as "feeble realists"); and romanticists, such as Honoré Daumier and Odilon Redon, leading to Vincent Van Gogh and Gauguin, culminating in … nothing. That space on the chart is blank, suggesting that Davies, the most famous American romantic, felt that his current work had no place in modern art. Since he clearly did not admire the "feeble realism" of the futurists, the only path left open to him was cubism.

Critics, however, disagreed. By the time of the Armory Show, Davies was the focus of widespread attention. Critics delighted in identifying his antecedents and fixing his place in the history of art. Davies embraced a wide array of influences that began with classical antiquity and extended through the Renaissance to the present day. He was associated with a range of artists spanning hundreds of years, including Giovanni Bellini, Botticelli, Piero di Cosimo, El Greco , and Giorgione.[19] In a time of confusion and upheaval, Davies had the imprimatur of a modernist, but his work had reassuring associations with a respected past.[20]

For this reason, Davies's stylistic departure after the Armory Show must have come as a shock to the critics who knew and admired his work and considered him an influential leader in the art world. Henry McBride expressed ambivalence in 1913: "Well, well, well. It seems that Arthur B. Davies has been and gone and done it. Is everybody going to do it? We knew all along

that the Armory Show wasn't the last of it Yet the new picture ... is, as the doctors would say, a highly interesting case." Notwithstanding a few good notices, the critical tide turned against Davies's new direction, with such epithets as "extreme" and "fruitless experiments." American expatriate collector Leo Stein accused Davies of abandoning his native feeling, and critic F. Newlin Price mourned the loss of the earlier Davies: "Where today he puzzles and interests and intrigues you, [in the past] he made you love his paintings." Collector Duncan Phillips was most scathing of all, calling his cubist work "vulgar" and "sheer perversity." As Burroughs dryly recalled after Davies's death, "Some of his friends deplored his new development."[21]

Davies may have been particularly sensitive to these harsh responses. Burroughs recalled from an early visit to Davies's studio that he was "hungry for praise" and "would only hear admiring remarks." It has been suggested that his otherwise robust sales declined during this

FIG. 7
Arthur B. Davies
Afterthoughts of Earth, c. 1921
Oil on canvas
26 × 42 in.
(66 × 106.68 cm)
Collection of Jane F. Clark

FIG. 8
Arthur B. Davies
"Chronological Chart Made by Arthur B. Davies Showing the Growth of Modern Art," *Arts & Decoration* 3 (March 1913): 150

period, and Burroughs also remembered the artist saying that "a work of art has no value until it's sold."[22] It is possible that Davies could not withstand these pressures, and returned to the style that was expected of him, the one that had brought him praise and prosperity.

There was palpable relief among critics and collectors after Davies retreated from his most radical uses of abstraction and intense color. Critics were quick to excuse his brief indiscretion and tried to fit it neatly into their previous understanding of his oeuvre. Burroughs cast the change as "completing the circle back to Classicism." Henry McBride declared in the *New York Herald* that "The synthesis is complete." Royal Cortissoz called a 1926 sale of some of those works "the sloughing off of a passing misconception." And in 1922 Duncan Phillips was delighted to find Davies's recent work "normal, free from affectations and distortions and confusions of all kinds." The Metropolitan Museum of Art's 1930 memorial retrospective, curated by Burroughs, did not include any examples of Davies's abstractions, as if Burroughs was trying to will that period out of memory. In 1919 Davies's friend Frederick James Gregg summed things up when he wrote flippantly that perhaps artists should die young so that they wouldn't upset the critics' "neat system of classification" that requires artists to continue perpetually in their early successful style.[23]

Davies's impact on modernism as a leader and organizer is undeniable, but the question of how modernism bears on his artwork is more complex. He might be seen as a victim of some critics' desire to create a hero of conservatism, an artist who confronted the avant-garde and turned away, choosing the old masters and traditional orthodoxy. He may also be considered in his best-known role as a visionary, one who could see far beyond his time in a way that reunites him with Henri and his urban realist followers as practitioners who drew unapologetically from the art of the past and the present. With the advent of post-modernism and decades of hindsight, it is easier to recognize the ultimate impossibility of truly breaking with the past, and it seems that Davies understood that. The hallmark of his work is cyclical motion, rather than the teleological concept of progress that marked the beginnings of modernism. It may be that Davies's long view was the most prescient.

Kimberly Orcutt is Associate Curator of American Art at the New-York Historical Society.

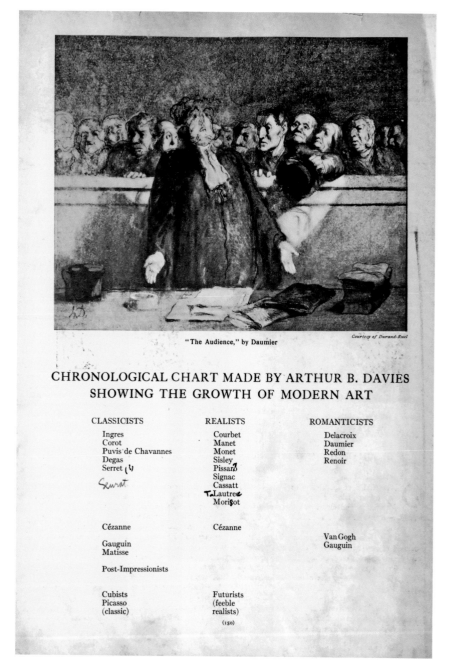

"The Audience," by Daumier

Courtesy of Durand-Ruel

CHRONOLOGICAL CHART MADE BY ARTHUR B. DAVIES
SHOWING THE GROWTH OF MODERN ART

CLASSICISTS	REALISTS	ROMANTICISTS
Ingres	Courbet	Delacroix
Corot	Manet	Daumier
Puvis de Chavannes	Monet	Redon
Degas	Sisley	Renoir
Serret	Pissaro	
	Signac	
	Cassatt	
	T. Lautrec	
	Morisot	
Cézanne	Cézanne	
		Van Gogh
Gauguin		Gauguin
Matisse		
Post-Impressionists		
Cubists	Futurists	
Picasso	(feeble	
(classic)	realists)	

(150)

I am indebted to Bennard Perlman's exhaustive monograph *The Lives, Loves, and Art of Arthur B. Davies*, which paved the way for this essay. Perlman's book draws upon some sources that are not publicly available and is therefore an invaluable basis for study of the artist. Catherine K. Mackay, Intern at the New-York Historical Society, provided much-appreciated research assistance, as did Rachael Duffin, Librarian of the Helen Farr Sloan Library at the Delaware Art Museum. I am also grateful to Linda S. Ferber, Executive Vice President and Museum Director of the New-York Historical Society, for her support of this project.

1 Bryson Burroughs quoted in Alan Burroughs, *The Art of Arthur B. Davies* (New York: E. Weyhe, 1920), 6.

2 Bennard B. Perlman, *The Lives, Loves, and Art of Arthur B. Davies* (Albany: State University of New York Press, 1998), 375.

3 Perlman, *Lives*, 130, 227, 321.

4 A. Burroughs, *Art of Arthur B. Davies*, 5.

5 Perlman, *Lives*, 129–30, 203–7.

6 Henri quoted in "Eight Independent Painters to Give an Exhibition of Their Own Next Winter," *New York Sun*, May 15, 1907.

7 Bryson Burroughs, *Catalogue of a Memorial Exhibition of the Works of Arthur B. Davies* (New York: Metropolitan Museum of Art, 1930), xv; Guy Pène du Bois, *Artists Say the Silliest Things* (New York: American Artists Group, Duell, Sloan and Pearce, 1940), 174.

8 Kuhn quoted in Perlman, *Lives*, 202, 208.

9 Pach quoted in Elizabeth Johns, "Arthur B. Davies and Albert Pinkham Ryder: The 'Fix' of the Art Historian," *Arts Magazine* 56 (January 1982): 72. Ironically, Davies's own contribution to the exhibition was minimal, since he had little time to paint in the months leading up to it. He was represented by three paintings, *Hill Wind*, *Seadrift*, and *Moral Law–Line of Mountains*, and three pastels.

10 Frank Jewett Mather, Jr., "The Art of Arthur B. Davies," in *Arthur B. Davies: Essays on the Man and His Art* (Washington, D.C.: The Phillips Publications, 1924), 50.

11 Perlman, *Lives*, 185–6, 237–8, 241.

12 Judith Zilczer, "Arthur B. Davies: The Artist as Patron," *American Art Journal* 19 (Summer 1987): 64–5, 76.

13 The contents of Davies' collection at his death are listed in the auction catalogue issued by the American Art Association, *Works by Picasso, Derain, Cézanne, Degas, Rivera, Max Weber, Matisse, "Pop" Hart, Dickinson, Laurencin* (New York: American Art Association, 1929).

14 Perlman, *Lives*, 196, 200; Zilczer, 66–7.

15 Perlman, *Lives*, 249; Bennard Perlman, "A Model's Tale," *Art and Antiques* (May 1987): 110.

16 Brooks Wright, *The Artist and the Unicorn: Lives of Arthur B. Davies* (New City, NY: Historical Society of Rockland County, 1976), 110. Some Davies letters can be found in the Archives of American Art, for example in the papers of Walt Kuhn and Macbeth Galleries. No letters were found in Davies's studio at the time of his death. The Niles M. Davies, Jr., Family Archive holds a leatherbound notebook containing various notes on his ideas, but many are more effusions of idealism and emotion than attempts at a coherent system of thought.

17 Wright, 110; du Bois, *Artists Say the Silliest Things*, 192.

18 Arthur B. Davies, "Explanatory Statement," *Arts & Decoration* 3 (March 1913): 150.

19 Duncan Phillips, "The American Painter, Arthur B. Davies." *Art and Archaeology* 4 (September 1916): 173; A. Burroughs, *Art of Arthur B. Davies*, 8; Duncan Phillips, "Arthur B. Davies: Designer of Dreams," in *Arthur B. Davies: Essays*, 7, 9, 11; *Exhibition of Paintings, Watercolors and Aquatints by Arthur B. Davies* (New York: M. de Zayas, 1920), unpaged.

20 See "Arthur B. Davies, A Modern Idealist," *Christian Science Monitor*, February 9, 1920.

21 Henry McBride, *New York Sun*, November 16, 1913; "Ever Youthful Work of Arthur B. Davies," *Vanity Fair* 9 (September 1917): 60; Frederic Fairchild Sherman, "The Early and Later Work of Arthur B. Davies," *Art in America* 6 (October 1918): 299; Leo Stein, "The Painting of Arthur B. Davies," *The New Republic* 13 (January 19, 1918): 338; F. Newlin Price, "Davies the Absolute," *International Studio* 75 (June 1922): 217; Phillips, "The American Painter, Arthur B. Davies," 175–6 (Phillips could not even bear to reproduce any such works in the article to illustrate his point); Bryson Burroughs, "Arthur B. Davies," *The Arts* 15 (February 1929): 86.

22 B. Burroughs, "Arthur B. Davies," 82, 86; Perlman, *Lives*, 274.

23 A. Burroughs, *Art of Arthur B. Davies*, 10; Henry McBride, "Arthur B. Davies Exhibition," *New York Herald*, January 1920, quoted in Perlman, *Lives*, 312; Royal Cortissoz, "The Field of Art," *Scribner's Magazine* 80 (September 1926): 350; Duncan Phillips to Frank Jewett Mather, Jr., November 29, 1922, Phillips Collection Archives, quoted in Perlman, *Lives*, 317; Frederick James Gregg, "The Earlier Work of Arthur B. Davies," *Vanity Fair* 12 (April 1919): 55.

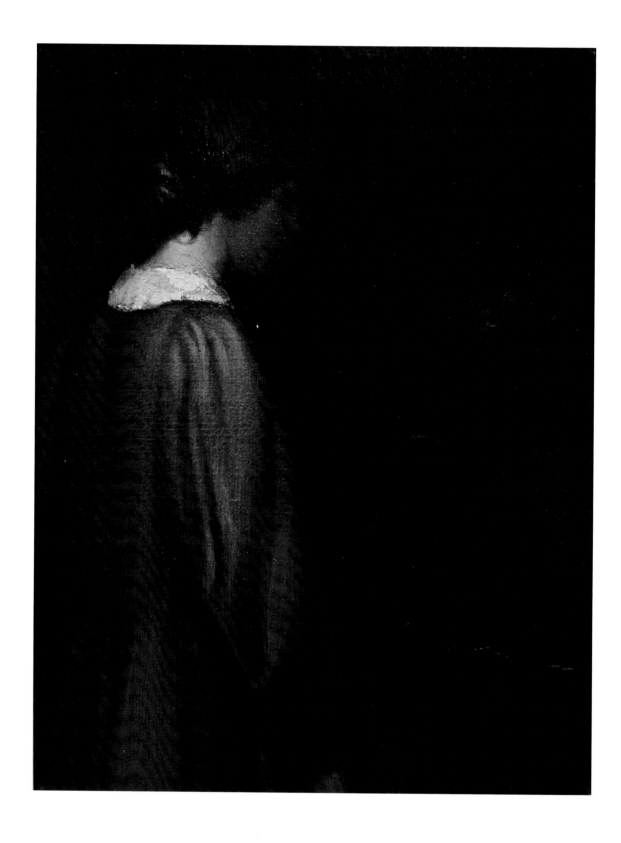

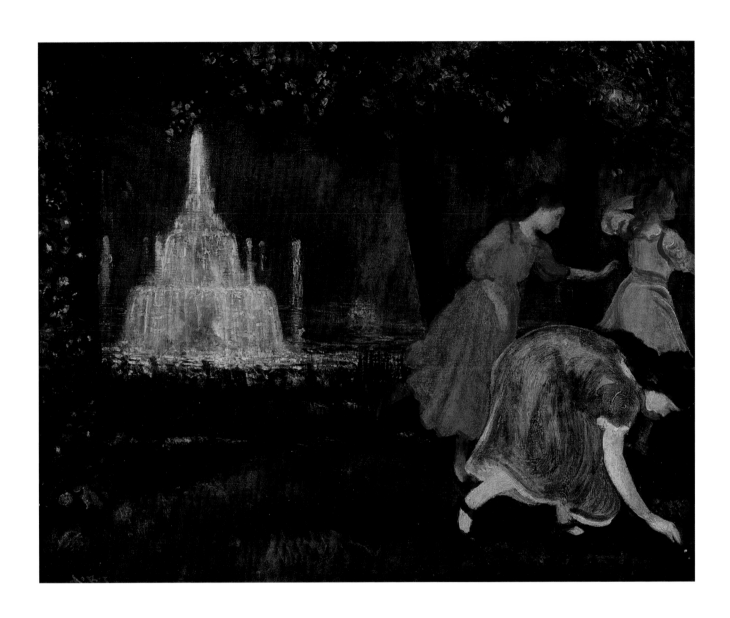

Arthur B. Davies
Remembrance, c. 1903
Oil on canvas
22 × 17 in.
(55.9 × 43.2 cm)
New Britain Museum of
American Art, John Butler
Talcott Fund, 1909.01

Arthur B. Davies
Fountain Play, c. 1900
Oil on canvas
16¹⁄₁₆ × 20⅛ in.
(25.56 × 51.1 cm)
Milwaukee Art Museum,
gift of William Macbeth
Incorporated, M1949.2

Arthur B. Davies
Struggle, 1917
Drypoint
3⅛ × 9⅛ in.
(7.9 × 23.2 cm)
New Britain Museum
of American Art,
gift of Mrs. Sanford Low
1973.54

34

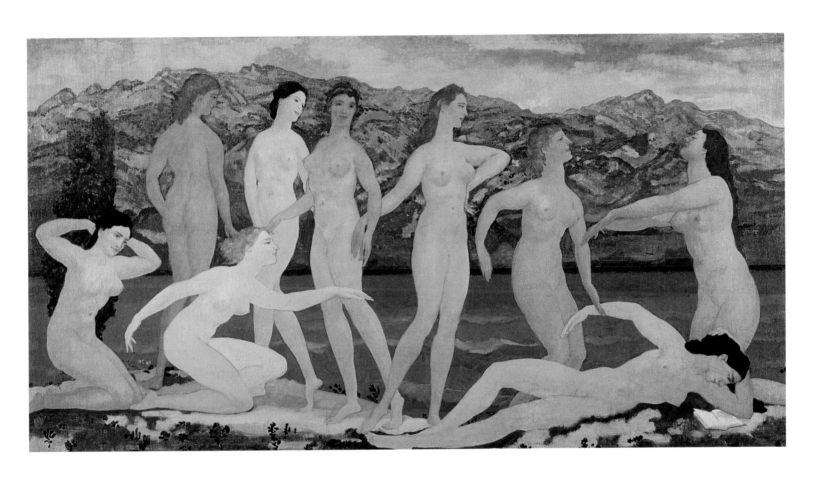

Arthur B. Davies
Rhythms, c. 1910
Oil on canvas
35 × 66 in.
(88.9 × 167.64 cm)
Milwaukee Art Museum,
gift of Mr. and Mrs.
Donald B. Abert in Memory
of Harry J. Grant
M1966.57

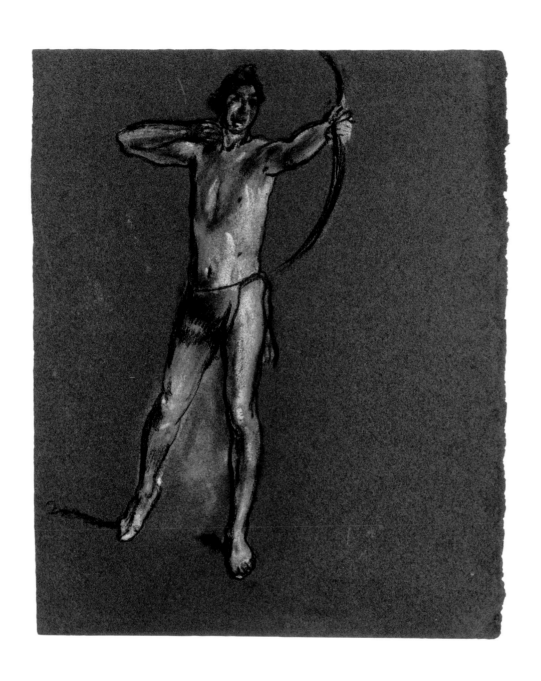

Arthur B. Davies
Male Model with Bow
Early 20th century
Charcoal and chalk
on green paper
12½ × 10¼ in.
(31.75 × 26 cm)
Milwaukee Art Museum,
gift of Mr. and Mrs.
Donald B. Abert
M1974.1

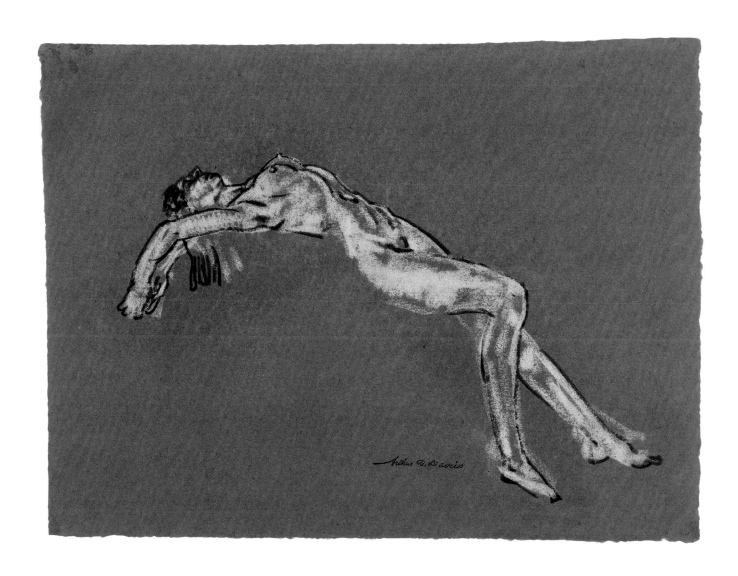

Arthur B. Davies
Reclining Female Nude, c. 1910
Charcoal and chalk on brown paper
13 × 17¾ in.
(33 × 45 cm)
Milwaukee Art Museum,
gift of Mr. and Mrs.
Donald B. Abert
M1974.2

Arthur B. Davies
Andante, 1916
Drypoint
6 × 4¾ in.
(15.24 × 12 cm)
Milwaukee Art Museum,
Maurice and Esther Leah
Ritz Collection
M2004.173

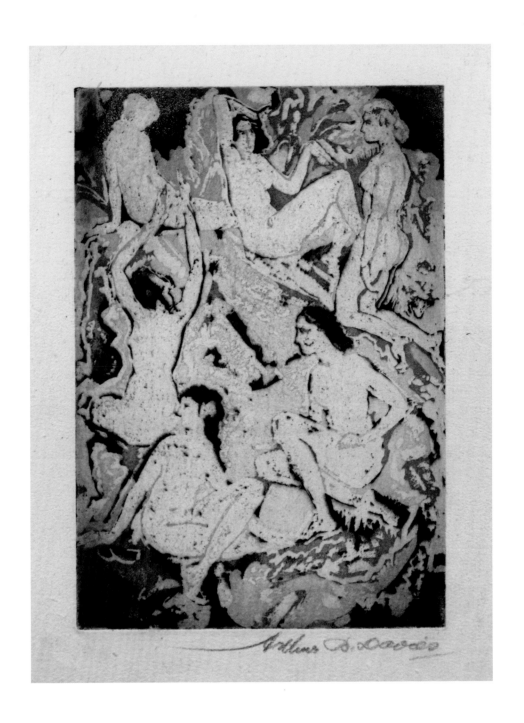

Arthur B. Davies
Snow Crystals, 1919–20
Etching
6⅜ × 4½ in.
(16.2 × 11.4 cm)
New Britain Museum
of American Art,
gift of Mrs. Sanford Low
1973.05

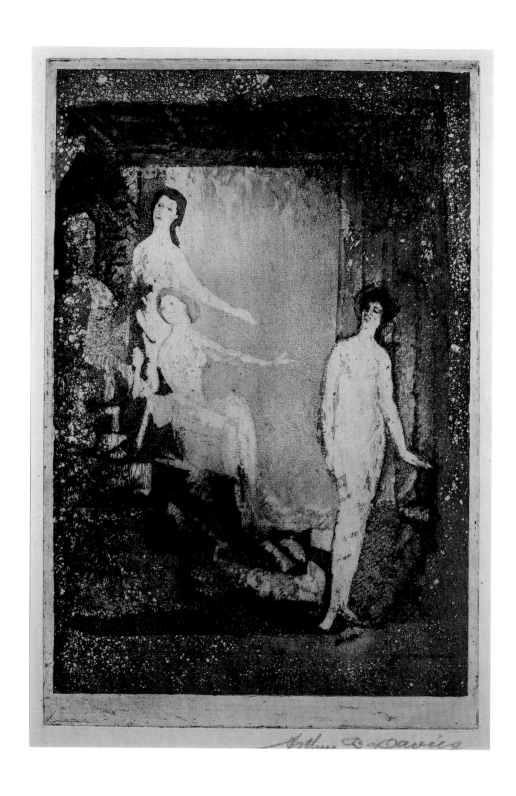

Arthur B. Davies
The Temple, 1918–19
Etching on blue paper
11⅞ × 8 in.
(30.16 × 20.32 cm)
New Britain Museum of
American Art, gift of the
Alix W. Stanley Estate
1954.57

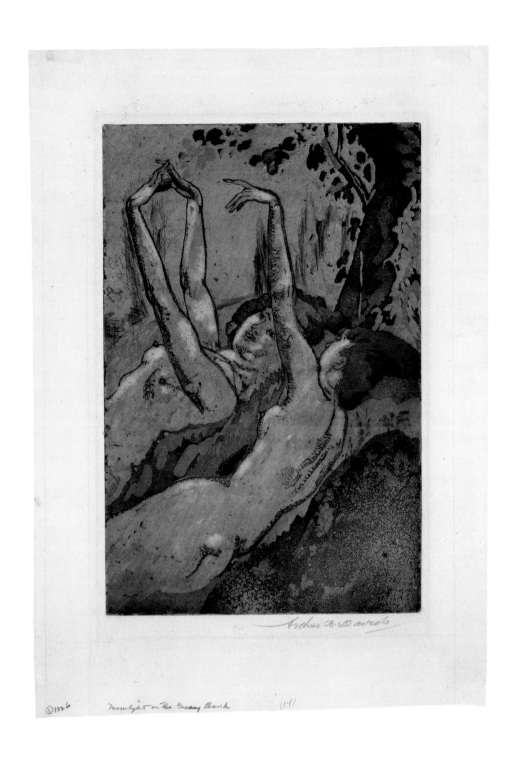

Arthur B. Davies
Moonlight on the Grassy Bank, 1920
Aquatint and drypoint, printed
in color on green paper
11⅞ × 7⅞ in. (30.16 × 20 cm)
Milwaukee Art Museum,
gift of Mr. and Mrs.
Donald B. Abert and
Mrs. Barbara Abert Tooman
M1984.12

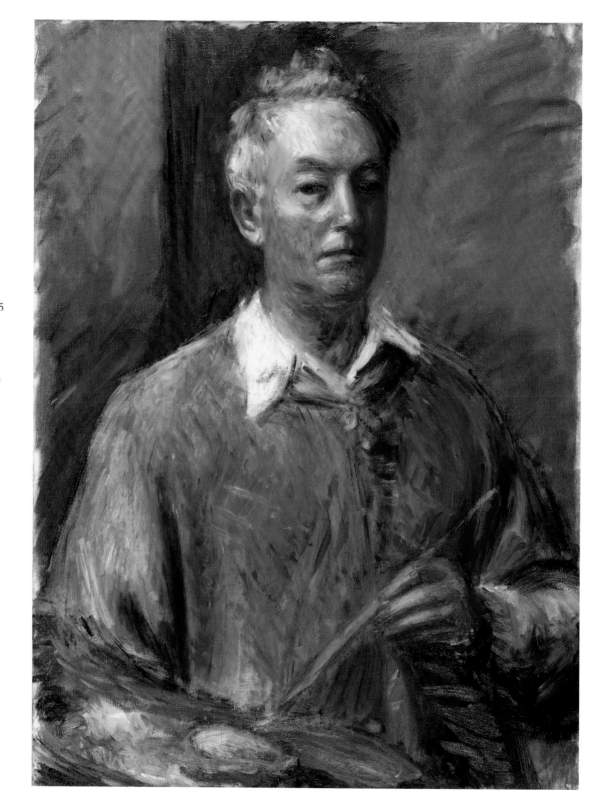

FIG. 9
William Glackens
Self-Portrait, c. 1935
Oil on canvas
28½ × 21¼ in.
(72.4 × 54 cm)
National Portrait
Gallery, Smithsonian
Institution,
gift of Ira Glackens
NPG.72.3

Glackens

On a Perpetual Holiday: The Art of William Glackens After The Eight

Peter John Brownlee

In the May 1937 issue of *Esquire* magazine, writer and critic Harry Salpeter effusively praised William Glackens (1870–1938) as a preeminent "painter of the human frame in its full freshness and innocence of color" and positioned him as a maverick artist, unbending to the dictates of curators, dealers, and critics. "He is supremely above the battle," Salpeter wrote, "partly through serenity, partly through indifference and partly through the absence of economic pressure." Freed from these constraints, Glackens was able to pursue his art in his own way. "He gives the impression of regarding his work as a private exercise," Salpeter continued, "in which it is slightly disconcerting, if not astonishing, to find even a small part of the world interested." For Salpeter, the artist's inward orientation reflects one aspect of Glackens as the modernist painter turned isolated genius, singularly focused on the investigation of his subjects and the interrogation of his medium and oblivious to the demands of the art establishment. The other, as noted by Salpeter, derived from the artist's simultaneous embrace of and engagement with a broader spectrum of color: "In his early days, influenced by Manet and Whistler, he painted on the dark side of the palette, moving over to the middle range of colors and finally singing the whole song of color, playing the entire range of the piano in

unashamed delight at the possibilities hidden in the treble."[1]

Salpeter's synaesthetic description of Glackens's painting lends outline to the modernist nature of the artist's later career. He also indirectly summarizes a dictum of Glackens's mentor Robert Henri of roughly a decade prior. In *The Art Spirit* Henri wrote, "The greatness of art depends absolutely on the greatness of the artist's individuality and on the same source depends the power to acquire a technique sufficient for expression."[2] Apparently, in Salpeter's estimation, Glackens had taken Henri's statement to heart.

The paths Glackens took to achieve the artistic individuality advocated by Henri and to obtain a technique sufficient for its expression led him through commercial illustration and painterly realism. Though he never fully gave up drawing as preparation for his painted works—with the exception of his figural works, which he painted directly onto canvas without preparatory drawings—the art he made over the course of his career traces a movement from sketchy line to wispy brushstroke, from graphic form to vibrant color, from the terse linearity of illustrational reportage to the impressionistic delineation of perceptions, and from the deadline-driven grind of professional illustration to the daily practice of painting for painting's sake.

William Glackens
A Headache in Every Glass, 1903–04
Charcoal, watercolor, and gouache on paper
13¼ × 19½ in.
(33.7 × 49.5 cm)
Terra Foundation for American Art, Daniel J. Terra Collection, 1992.170

Simultaneously illustrational and painterly, Glackens's early works on both paper and canvas stress line and rudimentary color. By the turn of the century, Glackens had established himself as an illustrator of the first rank, contributing images to magazines such as *Scribner's*, *Harper's Weekly*, and *Collier's*, among others. The sketchiness of his style animates the scene in *A Headache in Every Glass* (page 44), one of seven images Glackens made for "Our Melancholy Pastimes," a 1904 article by James L. Ford published in *Frank Leslie's Popular Monthly*. One of the artist's early forays into oil painting, *Bal Bullier* of around 1895 (page 51) bears the imprint of his technical training in graphic illustration, revealing

in particular the gestural sketchiness of his drawing. It features heavily outlined figures filled in with thick, saturated brushstrokes of pigment keyed to the heavy and darkly somber palettes of Rembrandt and Frans Hals and rendered in the loose style of Edouard Manet. Glackens's growing attention to color and color relationships is evidenced in the brightly colored pastel drawing of 1899 simply titled *Interior* (page 47). The appearance and positioning of the seated man looking on as a standing woman fastens her slip suggests a link to Glackens's most famous oil, *At Mouquin's* (fig. 10), one of the most-noticed images in The Eight's 1908 exhibition at the Macbeth Galleries in New York, a show

that would finally place his work and that of his closest colleagues on a national stage.

By the time the exhibition embarked on its famed national tour, however, Glackens had shifted away from the urban realism of George Luks, Everett Shinn, and John Sloan, and toward something more akin to the tranquil pastoralism and coloristic gentility of Arthur B. Davies, Ernest Lawson, and Maurice B. Prendergast. Glackens's affiliation with Maurice and Charles Prendergast, in particular, encouraged what became for him a lifelong devotion to the daily practice of painting and the rigorous pursuit of art for art's sake.[3] The lightening of Glackens's palette has traditionally been identified as the key element in this shift in his painting. But the artist's choice of subject matter and especially the loose handling and vigorous brushwork that increasingly animated his paintings reflect more important, if less heralded, dimensions of his artistic transformation from illustrator to fine artist.

Glackens's images of the beach and of figures posed in lush interiors reflect both the charmed life of the traveler and the rigor of an assiduous practitioner devoted to the act of painting, regardless of milieu. With the solid financial backing that came with his marriage to artist Edith Dimock in 1904, Glackens was freed from the physical confinements of the struggling artist and the fiscal constraints that tethered artistic style and painterly subjects to the dictates of a fluctuating art market. Instead, he chose to paint the world as he saw it—as if he were, to borrow Salpeter's words, "on a perpetual holiday." But Glackens's continued exploration of color relationships and the gestural, painterly techniques demonstrated in the facture of his canvases reveal the complexities of the artist's technical sophistication and lend further nuance to our understanding of his goals as an assiduously practicing, resolutely modern artist.

During the summer of 1908, Glackens's wife Edith rented a house in Dennis, Massachusetts, on Cape Cod, where the family spent their first seaside holiday. It was during this period that, perhaps inspired by the presence of and conversations with Prendergast, who visited at some point during the season, Glackens began to transform his method of painting. Apparently a deliberate reeducation had begun, likely stimulated by the bright and colorful scenery of the beaches on the Cape as well as by the example set by Lawson and especially Prendergast, whose paintings of this period, particularly the St. Malo sketches he showed at the Macbeth Galleries that February, exhibit the thickly applied paint and looser handling that soon came to characterize Glackens's canvases as well.[4]

Although he had already begun showing a few of the works that reflect the new direction his art had taken, it was at the Exhibition of Independent Artists in April 1910 that critics first identified and responded to Glackens's conversion. Critic Arthur Hoeber was struck by the painter's new colorism and concluded,

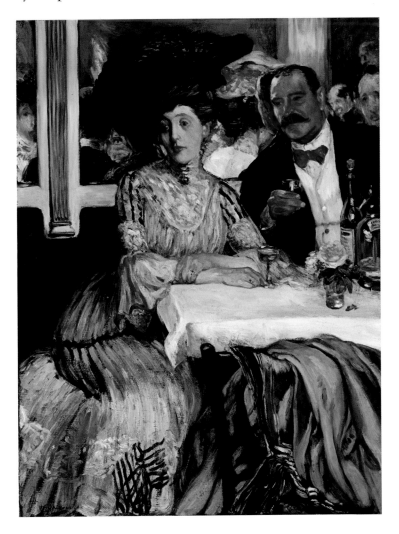

FIG. 10
William Glackens
At Mouquin's, 1905
Oil on canvas
48¼ × 36¼ in.
(122.4 × 92.1 cm)
The Art Institute of Chicago, Friends of American Art Collection
1925.295

"If Mr. Glackens thus sees his nature, he must enjoy life far more than the ordinarily equipped human, for there is a riot of tone to his vision."[5] Two scenes painted in or around 1910 reflect the shift in Glackens's palette toward the "riot of tone" identified by Hoeber and testify to the artist's new way of handling the surface of his canvases. The fluid pencil, charcoal, and pastel strokes of the illustrator give way in paintings such as *Breezy Day, Tugboats, New York Harbor* (page 52) and *Washington Square* (page 53) to shorter yet fluid staccato brushstrokes loaded with pigment. Here strokes of intense, unmodulated color are weighty, with thick impasto swirls protruding from the surface, lending a choppy texture to windblown waves and a soiled crust to piles of dirty urban snow. Together, these paintings reveal Glackens's intentional and self-critical preoccupations with the demands of his medium, highlighting in particular the "relative explicitness of the facture and the consequent stressing of the picture plane" characteristic of modernist painting.[6]

As his painting style evolved, the years 1912 and 1913 would prove pivotal for Glackens. In February 1912, he traveled to Paris to purchase examples of advanced French art—works by Paul Cézanne, Edgar Degas, Henri Matisse, Claude Monet, Pablo Picasso, and Auguste Renoir—for his former high school friend-

FIG. 11
William Glackens
Family Group, 1910/1911
Oil on canvas
71¹⁵/₁₆ × 84 in.
(182.8 × 213.3 cm)
National Gallery of Art,
gift of Mr. and Mrs. Ira
Glackens, 1971.12.1

turned-collector, Albert C. Barnes. And in the fall of that year, he helped to organize the 1913 Armory show, which enlarged considerably the revolution initiated by The Eight's exhibition held five years earlier. In addition to assuming administrative duties as chairman of the Domestic Committee in charge of selections for the American section, Glackens showed three of his oils in the exhibition. Together, they offered further evidence of the course his painting had taken and would continue to take in the decades to come.

The three works Glackens exhibited feature the key subjects that allowed him to explore a full range of color harmonies, the intricacies of flesh and fabric, and the radiance of bright light. The largest and most ambitious of the three, *Family Group* (fig. 11), indicated Glackens's turn toward the figure positioned in the intimate interior of his own home and studio. It depicts Edith, their son Ira, Edith's sister Irene, and Edith's longtime friend Grace Dwight Morgan in the Glackenses' Fifth Avenue apartment. Critic Mary Fanton Roberts, praised this rather generously scaled work as "one of the most radiant, courageous color paintings America has produced. In addition," she wrote, "it has grace, humanity and the quality that artists call painting."[7] Sloan, too, identified the change in Glackens's artistic strategy. In a comment perhaps specifically addressing *Family Group*, he noted that Glackens was "in the obviously color class just now."[8] Two pictures Glackens painted in Nova Scotia in 1910, *Seashore and Sailboats* (also known as *Sailboats and Sunlight*) (unlocated) and *The Bathing Hour* (The Barnes Foundation, Merion, Pennsylvania), offered viewers exquisite examples of Glackens's other important subject: the beach scene. All three paintings were hung next to those by Alfred Maurer in Gallery N of the Armory Show, which also featured Henri's *Figure in Motion* (page 12).

From the mid-1910s onward, Glackens increasingly focused his attention on the human figure, both clothed and nude.[9] His turn toward figure studies is part of a general shift in his orientation away from the public sphere and toward the private studio and the personal spaces of his home. Though perhaps first exercised in his brightly lit beach scenes, Glackens's continued exploration of vibrant color relationships coincided with his increased interest in more mundane and subdued subject

William Glackens
Interior, 1899
Pastel on green
wove paper
13½ × 7½ in.
(34.3 × 19 cm)
New Britain Museum
of American Art,
Harriet Russell Stanley
Fund, 1949.03

matter. As he turned from painting multifigural scenes of kinetic movement to static subjects that included portrait sitters, nude models, and still life objects, however, the sense of action and movement characteristic of his outdoor scenes migrated from animated pictorial content to his own vigorous brushwork, which emphasizes the artist's activity, not as a recorder of urban life or beach scenes, but as a painter of canvases.

Other than the likeness of painter Alice Mumford, the great majority of Glackens's many figure paintings of this later period were not of publicly recognizable figures. The models with whom the artist felt the closest kinship were undoubtedly his own family: Edith, Ira, and their daughter Lenna. Typically set in the shallow spaces of the familiar setting of his somewhat lavish studio, Glackens's figure studies display brushwork that is as animate and animated as the brilliant array of colors in his palette. Flesh tones are created through the intermixing of myriad blues, pinks, greens, and whites, while fabrics are rendered with a multitude of colors in long wispy, feathery brushstrokes. Despite the richness of the colors the pictures have a light, airy quality, but the tranquil, even melancholic gazes of Glackens's sitters subdue the cheerfulness exuded by his bright palette as they stare blankly into space. Two works painted around 1915 on same-sized canvases, *Portrait of a Young Girl* (page 54) and *Julia's Sister* (page 49), portray single female figures who share a look of emotional isolation. The aquatic greens and blazing oranges at play in *Julia's Sister*, along with the bouquet of flowers over her right shoulder, the ring of flowers around the brim of her hat, and the indistinct patterning of the wall around her, all position the sitter as the centerpiece of a complex floral arrangement. While Glackens's paint application is much thinner in these works than in his paintings of around 1910, a few swirls of pigment, particularly in the organic matter depicted, register the fluid strokes of his brush, imbuing the work with a measure of texture and tactility.

Beach scenes, the other subject that occupied the artist for the remainder of his career, formed the largest portion of Glackens's outdoor work; they were the most frequently exhibited, and the most popular, of his paintings.[10] During the Armory Show's New York run, Glackens simultaneously displayed eighteen canvases at the Folsom Gallery, of which at least six were beach scenes.[11] Critics responded favorably and reported that five of the works had sold.[12] Charles H. Caffin was struck by Glackens's "eagerly experimental" temperament and what he called the artist's "picture-seeing eye," able to capture the "suggestion of fullness of life in color and air and light of these scenes."[13] Of Glackens's beach and park scenes exhibited during 1922, artist and critic Walter Pach wrote "His world is a restless reflection of himself—a world crowded with a multitude of accidents and incidents all worth recording; all crying out to be recorded and all unseen by most of us, for most of us have grown a hard shell around our curiosity."[14] Clearly, experimentation, freedom, and curiosity were the facets of Glackens's work that critics found most engaging.

"The present position occupied by William Glackens as an artist," wrote critic Forbes Watson in the early 1920s, "may be described by the word solitary—a word by the way that describes the position of more than one artist, if not at all." Watson continued: "Glackens plays at painting. There is no tormented, morbid struggle with profound life facts disturbing him. He doesn't delve deeply into psychology. The color of the world makes him thoroughly happy, and to express that happiness in color has become his first and most natural impulse. He lives in a kind of dream of painting, absorbed, distrait, unaware of the problems that bother more unhappy natures."[15] The peripatetic years between 1925 and 1931 yielded, among numerous city scenes and landscapes, the colorful and lively *Beach, St. Jean de Luz* (page 55), a picture invigorated by and illustrative of Glackens's pursuit of his more playful impulses.

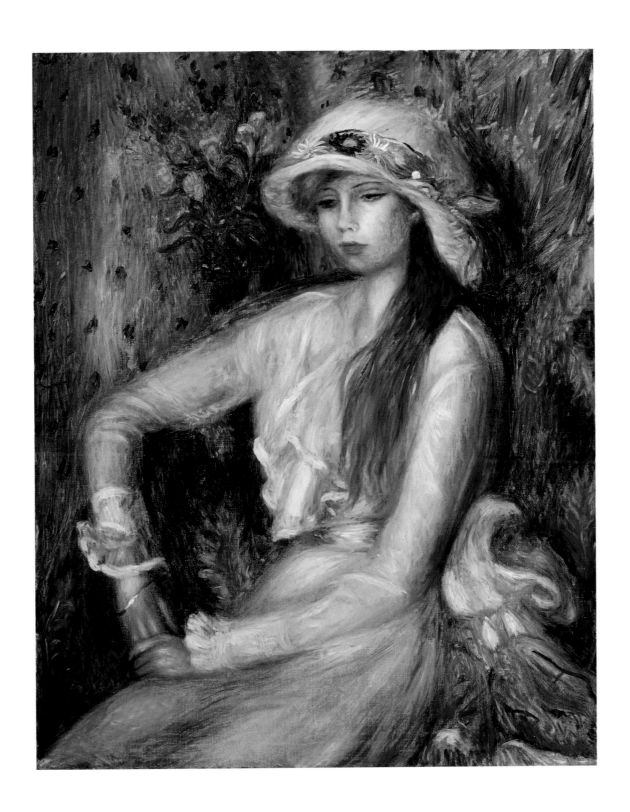

William Glackens
Julia's Sister, c. 1915
Oil on canvas
32⅛ × 26⅛ in.
(81.6 × 66.4 cm)
Terra Foundation for
American Art, Daniel J.
Terra Collection, 1999.58

The painting centers on the compressed space of a crowded beach, beyond which four sea vessels undulate among windswept waves in rather close proximity. Vigorously painted with the active and flowing brushstrokes seen in his figure studies and still lifes, the picture is about movement and energy. Exhibited at Glackens's solo show at the Kraushaar Galleries in 1931, the painting was well received: "I should unhesitatingly put down these new Glackens landscapes as the best work he has ever shown … indeed epoch-making for this artist," one critic wrote.[16] The painting eventually won the Jennie Sesnan Medal for the finest landscape in the annual exhibition held at the Pennsylvania Academy in January of 1936.[17]

In the wake of the Armory Show, Glackens appeared to follow his curiosity down a solitary path. Accepting of abstraction but unwilling to adopt its various modes for his own art-making, he continued in the trajectory he had established in the early 1910s. To his beach scenes and figure studies, he eventually added still life and floral portraits. But regardless of subject, the sheer number of his canvases attests to Glackens's playful yet persistent engagement with his medium. He practiced his art passionately on a daily basis in a variety of locales, both familiar and exotic, tranquil and exciting. Indeed, Glackens's

painterly *jouissance* and the independent nature of its pursuit underscore the modernity of his later oeuvre. Animated and vibrantly colored, *Beach, St. Jean de Luz* embodies the verve with which Glackens approached and practiced his art. As his health failed him in the later 1930s, his subjects, particularly his still life and flower arrangements, reflect his inability to venture too far from the comforts of home. But physical limitations did little to impede the lively nature of his art. Glackens the artist was a fluid figure thoroughly versed in the artistic language of his transatlantic world, a modernist by practice, technique, and peripatetic personality. As a prominent member of The Eight who had nearly that many artistic lives — as an illustrator, an Ashcan realist, and an experimental painter of landscapes, beach scenes, portraits, and still lifes — Glackens essayed a range of subjects nearly as wide as the spectrum of colors with which he painted them. Chromatically as well as technically, he pushed the limits of the figural tradition by combining steady practice, an openness to new ideas and methods of painting, and an eye kept constantly busy in the relay between his subjects and his lively canvases.

Peter John Brownlee is the Associate Curator at the Terra Foundation for American Art in Chicago.

I would like to thank Elizabeth Kennedy, Wendy Greenhouse, and the other essayists for their insightful comments and useful suggestions. Thanks also to Cathy Ricciardelli, Ariane Westin-McCaw, and Jobyl Boone for their assistance in securing related images.

1 Harry Salpeter, "America's Sun Worshiper: William Glackens Paints the World as He Sees It—On a Perpetual Holiday," *Esquire* 7 (May 1937): 87.

2 Robert Henri, *The Art Spirit* (1923; reprint ed., New York: Harper & Row, 1984), 122.

3 On the working habits of Maurice and Charles Prendergast and their influence on Glackens, see Ira Glackens, *William Glackens and the Ashcan Group: The Emergence of Realism in American Art* (New York: Crown Publishers, 1957), 116–22.

4 On the transformation of Glackens' painterly style and on his reeducation, see Richard J. Wattenmaker, *William Glackens: The Formative Years* (New York: Kraushaar Galleries, 1991). An even more comprehensive account of Glackens's career on which this essay draws is William H. Gerdts and Jorge H. Santis, *William Glackens* (New York: Abbeville Press, 1996).

5 Hoeber was reacting particularly to Glackens's earlier *Brighton Beach, Race Track*, with "its vivid reds and greens." See Arthur Hoeber, "Art and Artists," *New York Globe and Commercial Advertiser*, April 5, 1910.

6 For a summary of these and other facets of so-called "modernist" pictures, see Charles Harrison, "Modernism," in *Critical Terms for Art History*, eds. Robert S. Nelson and Richard Shiff (Chicago: University of Chicago Press, 1996): 142–55.

7 Mary Fanton Roberts,"Notes of General Interest: Art in New York This Season," *Craftsman* 24 (April 1913): 136.

8 The full quote reads: "From this exhibition [at the Union League Club] we went with him to Kuhn's show at the Madison Gallery which is very interesting. Kuhn has gone ahead splendidly in the past year. The color of the obvious sort as all the new things are—even Glackens is in the obvious color class just now." John Sloan, diary entry for April 15, 1911, in *John Sloan's New York Scene: From the Diaries, Notes and Correspondence*, ed. Bruce St. John (New York: Harper & Row, 1965), 526.

9 In focusing on the human figure, Glackens was one of several artists during this period and later who turned to figural studies made in the studio. Milton W. Brown noted this trend in a chapter titled "The Studio Picture" in his landmark study *American Painting from the Armory Show to the Depression* (Princeton: Princeton University Press, 1955): 154–9.

10 On critical attention to Glackens's beach scenes, see Gerdts and Santis, *William Glackens*, 109. For the most thorough account of Glackens's beach scenes, see Richard J. Wattenmaker, "William Glackens's Beach Scenes at Bellport," *Smithsonian Studies in American Art* 2 (Spring 1988): 75–94.

11 Wattenmaker, "William Glackens's Beach Scenes at Bellport," 80.

12 Gerdts and Santis, *William Glackens*, 111–2.

13 Charles H. Caffin, "Eighteen Canvases by Glackens on View," *New York American*, March 10, 1913, quoted in Wattenmaker, "William Glackens's Beach Scenes," 81.

14 Walter Pach, "William J. Glackens," *Shadowland* 7 (October 1922): 76.

15 Forbes Watson, *William Glackens* (New York: Duffield and Company, The Arts, 1923), 13, 21.

16 "William Glackens: Kraushaar Galleries," *Artnews* 29 (April 18, 1931): 10.

17 Owned at one time by the Milwaukee Art Museum, *Beach, St. Jean de Luz* was deaccessioned in order for the museum to buy a painting by Maurice B. Prendergast, an artist whose "modernist" status was firmly established by the early-to-mid-twentieth century. Richard J. Wattenmaker to Elizabeth Glassman, December 20, 2004, in curatorial files, Terra Foundation for American Art.

William Glackens
Bal Bullier, c. 1895
Oil on canvas
23¹³⁄₁₆ × 32 in.
(60.5 × 81.3 cm)
Terra Foundation for American Art, Daniel J. Terra Collection, 1999.59

William Glackens
Breezy Day, Tugboats,
New York Harbor, c. 1910
Oil on canvas
26 × 31¾ in.
(66 × 80.65 cm)
Milwaukee Art Museum,
gift of Mr. and Mrs.
Donald B. Abert and
Mrs. Barbara Abert Tooman
M1974.230

William Glackens
Washington Square, 1910
Oil on canvas
25 × 30 in.
(63.5 × 76.2 cm)
New Britain Museum
of American Art,
Charles F. Smith Fund
1944.03

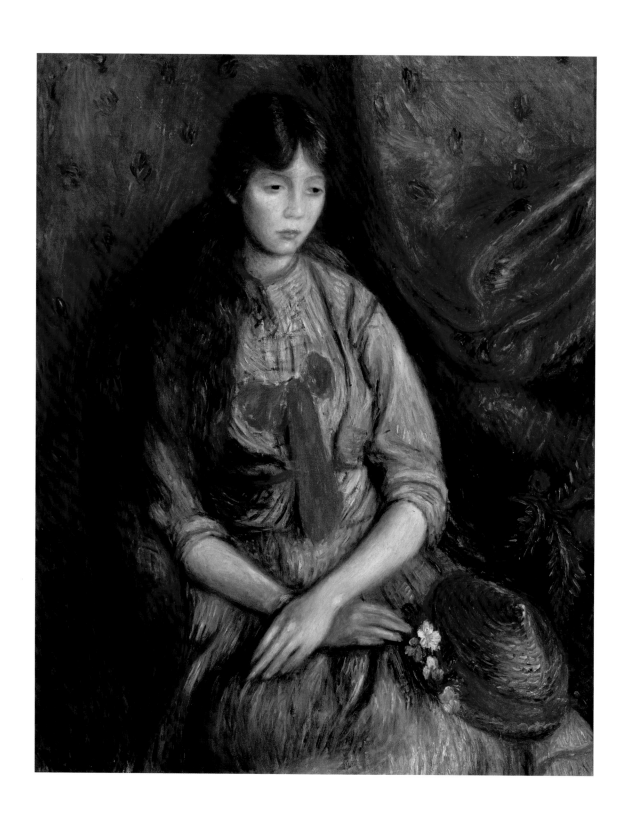

William Glackens
Portrait of a Young Girl
c. 1915
Oil on canvas
32 × 26⅛ in.
(81.3 × 66.36 cm)
New Britain Museum
of American Art,
A.W. Stanley Fund
1958.06

William Glackens
Beach, St. Jean de Luz
1929
Oil on canvas
23¾ × 32 in.
(60.3 × 81.3 cm)
Terra Foundation for
American Art, Daniel J.
Terra Collection, 1988.8

FIG. 12
John Sloan
Robert Henri, 1902
Etching
6¾ × 4½ in.
(17.1 × 11.4 cm)
Philadelphia
Museum of Art,
purchased with funds
contributed by
Lessing J. Rosenwald
and with the
Katharine Levin
Farrell Fund, 1956

Robert Henri

Henri

After the Armory: Robert Henri, Individualism and American Modernisms

Sarah Vure

When *The Art Spirit,* Robert Henri's (1865–1929) inspirational statement of his aesthetic philosophy, was published in 1923, an advertisement boldly proclaimed that although he "is one of the very few men today who has the real dignity of the old masters, he is thoroughly modern, and expresses in his book the conceptions that dominate the minds of the best modern painters."[1] While it is generally believed that the display of radical European modernism at the Armory Show in 1913 dramatically eclipsed Henri from the forefront of the American art world, a decade later he was still prominent and very much in touch with his time. A charismatic artist and teacher, Henri is renowned for leading a rebellion against the National Academy of Design, organizing the jury-free exhibition of The Eight in 1908, and advocating realist tenets of authenticity and contemporaneity that led his followers interested in realism to depict urban leisure and lower-class life. Beyond these endeavors, his advocacy of artistic freedom and progressive pedagogy ensured his continued relevance. Even the structure of his book embodied Henri's belief in self-education: to stimulate independent thought it presented his intellectual "sketches" like a picture gallery for the viewer to make his or her own selections. Exploring Henri's influential philosophy will demonstrate how his

dedication to individualism in art, writing, and teaching fostered American modernism.

With modernism broadly defined as a culture of experience characterized by "a continuous flux of sensations" and "an attempt to restore order to human experience," Henri has recently been recognized as an important champion of modern art in the early decades of the twentieth century.[2] The sensationalism of the Armory Show tends to obscure the fact that the initial goals of its organizers were directly descended from those of the Henri circle: to enlarge the audience for contemporary art by expanding exhibition opportunities and enlarging public knowledge of new art. As early as 1910, Henri advised his students to attend an exhibition of works by Henri Matisse and two years later he urged them to see the work of Max Weber, one of the most avant-garde of American moderns. Shortly after the Armory Show, Charles Sheeler wrote to thank Henri for recommending he visit Albert C. Barnes's collection of modern art; in a postcard Sheeler exclaimed, "Just returned and am still reeling!"[3] In the years following the landmark Armory Show, when numerous principles of anti-mimetic art and theory were being developed in the United States in response to European abstraction, artist Arthur Wesley Dow summarized the aspirations of

FIG. 13
Marcel Duchamp
(1887–1968)
*Nude Descending a
Staircase No. 2,* 1912
Oil on canvas
57⅞ × 35⅛ in.
(147 × 89.2 cm)
Philadelphia Museum
of Art: The Louise
and Walter Arensberg
Collection, 1950

to pierce the core, to get at the value of a movement and not be confused by its sensational exterior.[5]

His focus on the new art and its philosophical roots was substantial and on the rise.

A year before the exhibition, while on a trip to Paris, Henri was attentive to modernist developments. After a stop at the gallery of noted art dealer Ambroise Vollard, he attempted to copy Paul Cézanne's palette and brushwork in colored pencil on a sepia-toned postcard reproduction. Already steeped in color theory, Henri recorded, "The sense of the original is powerful, it all works, everywhere it is sensible of its own strength …. The warms, neutrals, and cools play successively and unite all."[6] To see the works of Matisse and Pablo Picasso, he paid a visit to the renowned Stein collection.[7] Most significantly, Henri went to the Salon d'Automne, accompanied by Walter Pach, a former student who would soon play a pivotal role in the Armory Show by securing for the display such paintings as Marcel Duchamp's notorious *Nude Descending a Staircase No. 2* (fig. 13).

Although Duchamp's work with its fragmented forms — the sensation of the exhibition — upstaged Henri's prominently displayed *Figure in Motion* (page 12), his frank portrayal of the nude female body was significantly modern in its own right. The figure itself and Henri's later comments demonstrate his familiarity with concepts of flux that echo the writings French philosopher Henri Bergson, an inspiration for many modernists. Henri's approach to creativity necessitated getting in touch with one's inner senses and the natural rhythms of the universe. According to writer Ralph Cheyney, the artist stated, "We must learn to let our vital energy operate unimpeded through us — whether we call it 'Life Force' or 'elan vital' or 'libido' or 'God,' it does not matter, if only we work its

American modernists. He wrote of the rejection of traditional concepts and the new attention to form over subject, freedom from the restraint of juries, interest in individual expression, and new stylistic modes through color relationships.[4] Although Henri did not create abstract paintings, he championed these fundamental tenets of modernism. Seeking to encourage its acceptance, Henri commented:

> There always has been a new movement, and there always will be a new movement. It is strange that such a thing which comes as regularly as clockwork [sic] should be a surprise …. It is necessary

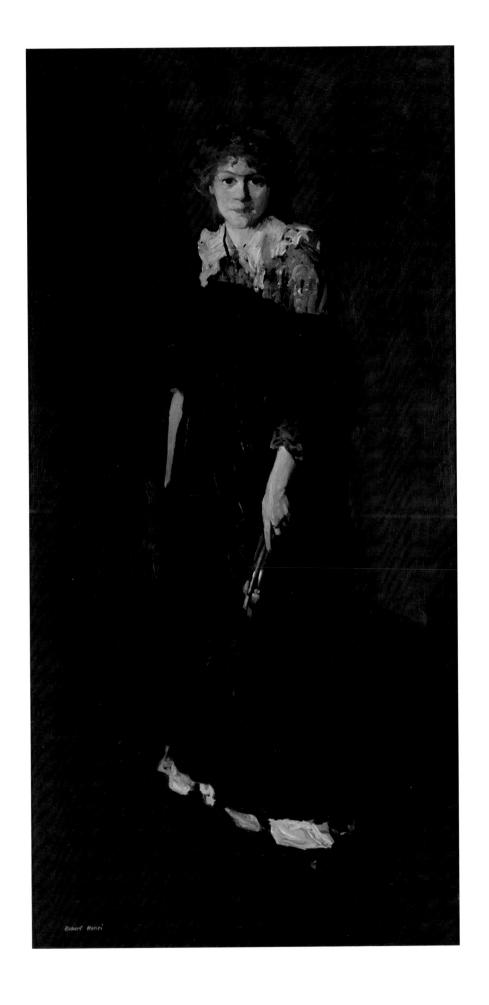

Robert Henri
The Art Student (Miss Josephine Nivison), 1906
Oil on canvas
77¼ × 38½ in.
(196.2 × 97.8 cm)
Milwaukee Art Museum,
Purchase, M1965.34

will."[8] Thus while Henri's formal goals differed with those of the avant-garde, his philosophical position overlapped considerably with painters pursuing various approaches to abstraction. For the majority of American artists, whether realist or abstractionist, the fundamental goal of aesthetic endeavor was individuality and freedom of expression. This sense of independence, as well as the creation of art as an emotional response to sensory experience rather than as an intellectual construction, aligned Henri with artists of the Alfred Stieglitz circle. Arthur Dove, for example, explained his art as a response to life's peak experiences; he wanted "to give in form and color the reaction that plastic objects ... have reflected from my inner consciousness." Similarly, Henri believed that "The object, which is back of every true work of art, is *the attainment of a state of being*, a state of high functioning, a more than ordinary moment of existence."[9]

Beyond regarding the act of painting as a transcendent experience, Henri applied theoretical systems to promote visual and social harmony, supersede the materialism of modern society, and connect to a metaphysical realm. His teaching of the theories of Hardesty G. Maratta, Denman Waldo Ross, and Jay Hambidge is the most misunderstood aspect of his pedagogy, for it seems to contradict his emphasis on individuality and free expression. It was not the loss of his position as a leader in the artistic avant-garde nor an anti-modernist stance that led Henri to these theorists, however, but experimentation and a new scientific approach to color. Responding to the chromatic brilliance of post-impressionist and fauvist painting at the Armory Show, Henri continued his exploration of color and compositional theories with greater inventiveness; yet his interest in them predates the exhibition.

Maratta, whom Henri first met in 1909, manufactured and marketed a new patented system of synthetic pigments in tubes based on chromatic scales.[10] He based his system on mixing the three primary colors—red, yellow, and blue—in equal amounts to achieve a variety of hues arranged in a pyramid. Calling his paints a tuned "instrument," Maratta related the spectrum of twelve colors to the musical octave. The palette of twenty-four equally spaced colors corresponded to the twenty-four major and minor triadic chords on the keyboard. Correspondence between color and music was a popular notion, one that paralleled modernist artists' justification of abstraction.

The impact of color theory on Henri's own work is demonstrated in the use of complementary color schemes in his *Spanish Girl of Segovia* (page 70), with its bright green fan and red patterned shawl. It marks a departure from the almost monochromatic *The Art Student (Miss Josephine Nivison)* (page 59). A lighter palette and sharper contrast appear in his post-Armory show paintings, such as *Chinese Lady* (page 71), which juxtaposes a dark Asian blouse against an intense, shockingly colored background. Although painted during a sojourn to southern California, where the dazzling sunshine influenced many artists toward high-keyed color, Henri was here likely exploring the theories of Ross, a Harvard lecturer who focused on harmonic sequences of color, value, and tone. Ross differed from Maratta in his inclusion of seven levels of value, or the mixture of black and white into the pigment. Ross also promoted the use of a set palette, a practice that Henri adopted and taught. The color in Henri's new works was immediately commented on in the press when they were displayed at the Los Angeles Museum of Science and Art and at the Macbeth Galleries in New York. One reviewer emphasized the striking change: "His schemes of color are brilliant, daring, unexpected, even startling. Yet somehow they are almost always right."[11] From this point on, Henri's many paintings of nudes and clothed models were vehicles for further

color exploration, as for example *Betalo Nude* (page 72) and *Dancer of Delhi (Betalo Rubino)* (page 65), in which the figures are surrounded by a rich array of hues.

Henri's concern with the science of color extended beyond the theories of Maratta and Ross; he began to investigate the permanence of paint pigment. As the sale of commercially manufactured art supplies increased, due to technological advances in the production of synthetic colors, Henri was not alone in advocating that artists enhance their knowledge of chemistry. In 1917, he suggested that the Art Students League, where he was then teaching, establish a class for the study of materials, including the chemistry of pigments. He told students: "The technique of painting begins with the simplest mechanical issues and extends through to the heights of science To have ideas one must have imagination, to express ideas one must have science."[12] While his proposed class would touch on questions of form, Henri stressed, "I do not mean by this the development of a formula."[13] A debate about the value of various palette formulas would occur in the art periodicals of the 1920s. At the same time, while fine artists had been fascinated with color for almost a century, according to *Fortune* magazine a revolution was sweeping through American industry as color experts helped businesses target consumers and design new products to meet increasing demand.[14] Characterizing the period, historian and editor Frederick Lewis Allen exclaimed, "The prestige of science was colossal." Based on the abundance of new machines and a deluge of information on the subject, Americans "were ready to believe that science could accomplish almost anything."[15]

Notwithstanding Henri's interest in science, he still believed that the artist's primary objective was most decidedly that of individual self-expression. A decade earlier he had reminded a former student, "There is one thing to always hold in mind that you are to remain master of the palette and any of its formulas and not allow them to become master over you."[16] Although some critics alleged Henri was too insistent on the methodology of color systems, he explained to his students that by providing them information about Ross's set palettes he hoped to put within their reach knowledge he had found very valuable to his own artistic practice. He implored them to be independent: "Please do not believe that I want to convert you or persuade you to anything—my object ... is to lay before you such knowledge as I have ... and to leave you entirely free to use or disregard. The one thing that I insist is that you use your judgment"[17] In fact, Henri's success in mentoring students to develop their own personal vision is demonstrated by the many who became well-known artists and the diversity of their stylistic approaches. From realist Edward Hopper to synchromist Morgan Russell to abstractionist Stuart Davis, Henri's students often recalled his formative influence as they developed and defended a variety of American modernisms (fig. 14).

This focus on the individual that Henri's students found so significant to their education was the central principle of his artistic practice. Based on his experience in New Mexico and his vehement opposition to World War I, Henri in

1915 wrote an article entitled "My People" for *The Craftsman* magazine. In what has been viewed as his personal aesthetic manifesto, Henri advocated order and beauty in an appeal for universal understanding. Seeking the psychological and spiritual essence of his subjects, Henri painted to express his own as well as his sitters' sense of life. Portraying a diverse selection of young people of different races and cultures, he expressed his continuing idealism and an optimistic faith in the vitality of human individualism. Describing the series of portraits, which includes *Pepita* (fig. 15), a young Hispanic girl of Santa Fe, Henri stated: "My love of mankind is individual not national, and always I find the race expressed in the individual I was not interested in these people to sentimentalize over them ... I am looking at each individual with the eager hope of finding there something of the dignity of life."[18]

Perhaps because of these lofty pronouncements about individualism, his enthusiasm for the theories of Jay Hambidge, another Harvard and Yale lecturer, has compounded confusion about Henri's later pedagogy. After World War I, a search for stability led some American artists, including Henri, to the treatise *Dynamic Symmetry* in which Hambidge espoused a mathematical method of composition based on ancient Greek art. Prior to its publication, Henri attended Hambidge's weekly lectures in New York, filling a notebook with jottings and diagrams demonstrating the role of geometry and mathematical relationships in beautifully proportioned, harmonious design. Because of the complexity of Hambidge's writing, critics overlooked his theory's foundation in the forms of the natural world. Intended to express life and growth, it appealed to Henri because he was already predisposed toward turn-of-the-century philosophies of vitalism, with its suggestion of self-determination.[19]

Critics saw Dynamic Symmetry's focus on Greek art as contradictory to modern impulses, especially in light of Hambidge's declaration, in a 1914 article, that cubism was antithetical to modernism.[20] Although Henri pasted a copy of the article into his scrapbook, in retrospect his response appears far less reactionary. At the time, cubism was also being strongly criticized in Europe and even Picasso turned to classicism as the French sought order and regeneration after World War I.[21] A second, 1915 article by Hambidge on art as a life's work reveals a position toward self-education that is surprisingly similar to Henri's views. This text expresses an appreciation for design that makes apparent the association between art and utility, an aesthetic appropriate to the developing machine age.[22]

It was this connection of art to life and theory to practice that made Henri as important in the post-war era as he had been at the turn of the century. However, his focus on individual expression, inspired by Ralph Waldo Emerson and Walt Whitman, took on new meaning in relation to remarkable societal changes. As the Armory Show transformed American art, Henry Ford's assembly line revolutionized manufacturing technology. Soaring economic prosperity, the result of mass production and consumerism, brought in its wake greater uniformity and regimentation. Along with many modernists, Henri was plagued by contradictory impulses, embracing the excitement of innovation while rejecting its negative social implications. Using portraiture as a vehicle for conveying personal integrity and not mere superficial likeness, he wrote that the first condition of painting was "something you want to say definitely about the subject" and that "completion does not depend on material representation. The work is done when that special something has been said." The key was to have all the features "in one expression which manifests the state of mind or

the condition of the sitter."[23] From *Dutch Joe (Jopie Van Slouten)* (page 68) to *Blond Bridget Lavelle* (page 75), Henri's best portraits, with their gestural brushwork, capture the compelling personality and abiding humanity of his subjects. As the country increasingly shifted toward standardization, there was an undeniable need for the individualism Henri's philosophy demanded. While his focus on a theoretical approach was part of an international call to order, it did not ultimately detract from his fundamental concern to foster American artists and modernist originality as the key ingredients for a free democratic society. A review of the Henri memorial exhibition at the Metropolitan Museum of Art in 1931 astutely concluded that his individual vigor and the vitality of his brushwork led his admirers to consider him a modernist: although his art was traditional, ideologically he always remained "in search of radical progress."[24]

Sarah Vure is a faculty member in art history at Long Beach City College in California.

FIG. 15
Robert Henri
Pepita, 1917
Oil on canvas
24⅛ × 19¹⁵⁄₁₆ in.
(61.20 × 50.64 cm)
Los Angeles County
Museum of Art,
Mr. and Mrs. William
Preston Harrison
Collection (20.3.2)

The essays on Henri and Sloan in this volume are based on my dissertation. I am grateful to my advisors Patricia Hills and Marianne Doezema for invaluable guidance and constructive comments on that earlier work. I also thank the members of my thesis committee Elizabeth Milroy, Kim Sichel, and John Stomberg. To the staffs at the Helen Farr Sloan Library, Delaware Art Museum and Beinecke Rare Book and Manuscript Library, Yale University, I owe a debt of gratitude for facilitating my research and for permission to quote from their collections of the artists' papers. My special thanks to Elizabeth Kennedy of the Terra Foundation for American Art for organizing this project.

1 Lippincott Publishers advertising brochure, Robert Henri Papers, Yale Collection of American Literature, Beinecke Rare Book and Manuscript Library (hereafter Henri Papers).

2 Daniel Joseph Singal, "Towards a Definition of American Modernism," *American Quarterly* 39, no. 1 (spring 1987): 7, 8, 11; Daniel A. Siedell, "Robert Henri and His Influence," *American Art Review* 14, no. 3 (June 2002): 148–53.

3 Charles Sheeler to Robert Henri, May 1913, Henri Papers.

4 Arthur Wesley Dow, "Modernism in Art," *Magazine of Art* 8 (January 1917): 115–6.

5 Helen Appleton Read, *Robert Henri* (New York: Whitney Museum of American Art, 1931), 12; and Robert Henri, *The Art Spirit* (1923; reprint ed., New York: Harper & Row, 1984), 152.

6 Henri quoted in Bennard B. Perlman and Helen Farr Sloan, *Robert Henri: His Life and Art* (New York: Dover Books, 1991), 105.

7 It is unclear if he visited with Gertrude and Leo Stein or Sarah and Michael Stein. Albert C. Barnes to Robert Henri, December 25, 1912, quoted in William Innes Homer, *Robert Henri and His Circle* (Ithaca: Cornell University Press, 1969), 175.

8 Ralph E. Cheyney, "Robert Henri, Painter and Philosopher," *The Touchstone* 5 (June 1919): 217. The concept of *élan vital* is discussed in Henri Bergson's *Creative Evolution* (1907).

9 Arthur Dove, *The Forum Exhibition of Modern American Painters* (New York: Anderson Galleries, 1916), unpaged; "Letter of Criticism," in Henri, *The Art Spirit,* 159.

10 For further explanation of these various color systems, see Michael Quick, "Robert Henri: Theory and Practice," in Valerie Ann Leeds et al., *"My People": The Portraits of Robert Henri* (Orlando: Orlando Museum of Art, 1994), 47–62.

11 Antony Anderson, "Of Art and Artists: Henri's La Jolla Portraits," *Los Angeles Times*, September 20, 1914.

12 Henri quoted in *Composition Notes*, 1919, Natalie Van Vleck Papers, Archives of American Art, Smithsonian Institution.

13 Robert Henri to Dorothea Chase, May 31, 1917, Henri Papers.

14 John Winstanley, "The Modern Merlin and his Palette Recipes," *International Studio* 73 (April 1921): suppl. 62; Regina Lee Blaszczyk, "The Importance of Being True Blue: The DuPont Company and the Color Revolution," in Elspeth H. Brown, Catherine Gudis, and Marina Moskowitz, eds., *Cultures of Commerce: Representation and American Business Culture, 1877–1960* (New York: Palgrave MacMillan, 2006), 27, 31.

15 Frederick Lewis Allen, *Only Yesterday: An Informal History of the 1920s* (1931; reprint ed., New York: Harper & Row, 1964), 164.

16 Robert Henri to Helen Niles, April 6, 1911, Henri Papers.

17 Undated Letter to Students, Henri Papers.

18 Robert Henri, "My People," *The Craftsman* 27 (February 1915): 459, 462.

19 Vitalism is the doctrine that the processes of life are not explicable by the laws of physics and chemistry alone and that life is in some part self-determining. *Webster's Collegiate Dictionary*, 10th ed. "Vitalism."

20 Jay Hambidge and Gove Hambidge, "The Ancestry of Cubism," *The Century* 87 (April 1914): 869–75; Edwin M. Blake, "Dynamic Symmetry—A Criticism," *Art Bulletin* 3 (March 1921): 107–27.

21 See Christopher Green, *Cubism and Its Enemies: Modern Movements and Reaction in French Art, 1916–1928* (New Haven: Yale University Press, 1987), and Kenneth E. Silver, *Esprit de Corps: the Great War and French Art, 1914–1925* (Princeton: Princeton University Press, 1989).

22 Jay Hambidge, "Choosing a Life-Work," *Lippincott's Magazine* 96 (August 1915): 101–8.

23 "Letter to the Class, Art Students League, 1915," transcribed in Henri, *The Art Spirit*, 20, 21–23.

24 "Metropolitan Museum Holds Fine Memorial Exhibition of Paintings by Robert Henri," *New York American*, March 3, 1931, clipping in Robert Henri Papers, Archives of American Art, Smithsonian Institution.

Robert Henri
***Dancer of Delhi
(Betalo Rubino),*** 1916
Oil on canvas
38½ × 57¾ in.
(97.79 × 146.68 cm)
Collection of Melinda
and Paul Sullivan

Robert Henri
Street Corner, 1899
Oil on canvas
32⅛ × 26 in.
(81.6 × 66 cm)
Milwaukee Art Museum,
gift of Mr. and Mrs.
Donald B. Abert
M1974.7

Robert Henri
**Wyoming Valley,
Pennsylvania,** 1903
Oil on canvas
26 × 32 in.
(66 × 81.28 cm)
Milwaukee Art Museum,
gift of Mr. and Mrs.
Donald B. Abert in Memory
of Mr. Harry J. Grant
M1965.32

Robert Henri
**Dutch Joe (Jopie
Van Slouten),** 1910
Oil on canvas
24 × 20 in.
(61 × 50.8 cm)
Milwaukee Art Museum,
gift of the Samuel O.
Buckner Collection
M1919.9

Robert Henri
The Rum, 1910
Oil on canvas
24 × 20¼ in.
(60.96 × 51.43 cm)
Milwaukee Art Museum,
gift of Mr. and Mrs.
Donald B. Abert in Memory
of Mr. Harry J. Grant
M1965.31

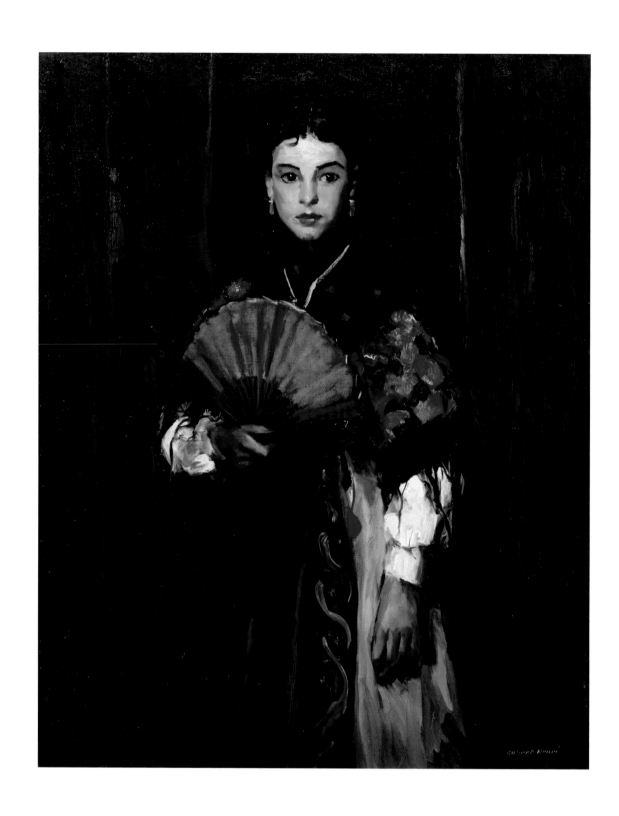

Robert Henri
Spanish Girl of Segovia, 1912
Oil on canvas
40¾ × 33⅛ in.
(103.5 × 84.13 cm)
New Britain Museum of American Art, A. W. Stanley Fund, 1941.07

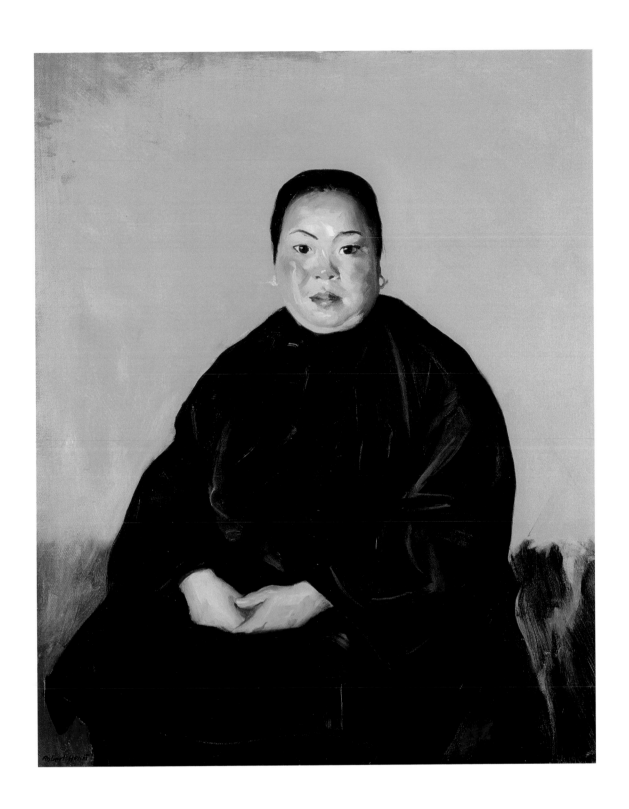

Robert Henri
Chinese Lady, 1914
Oil on canvas
41¼ × 33¼ in.
(112.4 × 84.45 cm)
Milwaukee Art Museum,
gift of Mr. and Mrs.
Donald B. Abert
M1965.61

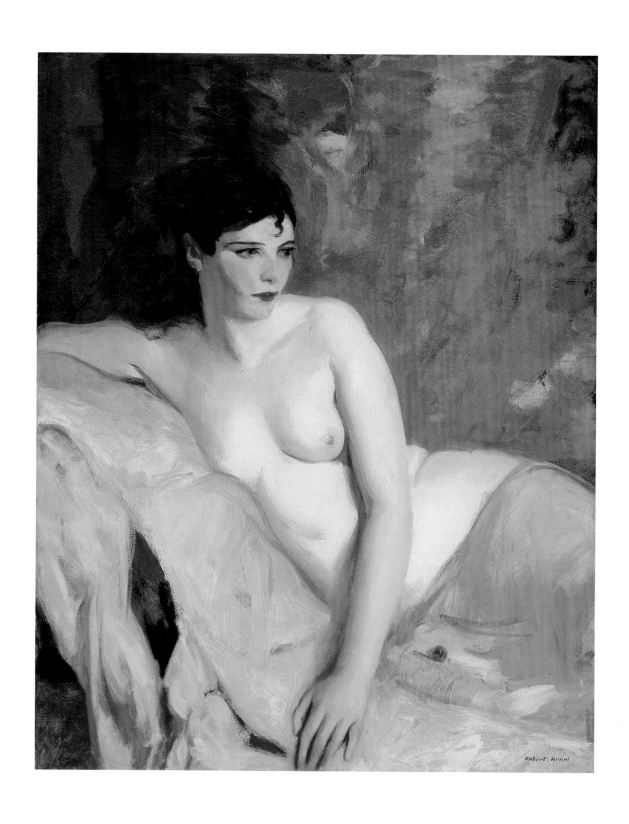

Robert Henri
Betalo Nude, 1916
Oil on canvas
41 × 33 in.
(104.14 × 83.82 cm)
Milwaukee Art Museum,
gift of Mr. and Mrs.
Donald B. Abert
M1972.24

Robert Henri
An Imaginative Boy, 1915
Oil on canvas
24⅛ × 20 in.
(61.27 × 50.8 cm)
New Britain Museum
of American Art,
Harriet Russell Stanley
Fund, 1950.04

Robert Henri
Portrait of Marjorie Henri, 1918
Oil and pastel on paper
19¹¹⁄₁₆ × 12⁷⁄₁₆ in.
(49.5 × 30.5 cm)
Milwaukee Art Museum,
Maurice and Esther Leah
Ritz Collection
M2004.78

Robert Henri
Blond Bridget Lavelle
1928
Oil on canvas
27¼ × 19¼ in.
(69.2 × 48.9 cm)
Milwaukee Art Museum,
Centennial Gift of
Mrs. Donald B. Abert
M1987.28

Lawson

Ernest Lawson: Nostalgia for Landscape

Jochen Wierich

Mr. Lawson gives us New York treated as nature.
— Anonymous critic, c. 1930[1]

In an early monograph on Ernest Lawson (1873–1939) published in 1932, Guy Pène du Bois reminded his readers that the artist was one of the "epoch making" artists known as The Eight and that he was closely allied to the cause of realism in art. At the same time, Lawson stood apart, for he was "the only pure landscapist" in the group.[2] According to du Bois, Lawson's great contribution to American art was to paint the landscape of modern-day America, exemplified by the changing scenery around New York, without a preconceived idea but as "pure" landscape. From du Bois's vantage point of the early 1930s, the great tradition of landscape painting in America seemed to have seen its heyday and was now pushed to the side by different forms of figurative art or abstraction. Du Bois's casting of Lawson as a great individualist who stood against the tide of artistic fashion was certainly on the mark and a fitting tribute to the heroic ideals of The Eight. Yet an assessment of Lawson's artistic legacy in light of the modernist movement in America and its different manifestations is still subject to debate.

Critics such as du Bois invariably included in their discussion of Lawson's accomplishments a broader conversation about the state of landscape painting in America. Often implicit in such reflections was a deeper longing or nostalgia for landscape painting. No matter what label the critics employed, whether they referred to Lawson as a realist, a romantic, or an impressionist, he always figured as both a great preserver of and an innovator in landscape painting. To many, Lawson's work followed the romantic tradition in American art that had its roots in Hudson River school painting. Yet they also admired him as an artist who was able to forge a new path. As the critics recognized, he was never simply backward-looking but always engaged with the modernist idioms of realism, impressionism, and post-impressionism. Lawson demonstrated to his contemporaries how the art of landscape could survive and refashion itself as an expression of modern life.

Du Bois echoed a common theme that had emerged in the critical discourse around Lawson since The Eight's 1908 exhibition at New York's Macbeth Galleries: that his dedication to landscape painting made him stand out from the group. Like Maurice B. Prendergast, however, Lawson frequently incorporated figures and manmade structures into his paintings.

Prendergast himself produced paintings and watercolors that were "purely" landscape. On several occasions, especially when he summered on Monhegan Island in Maine, Robert Henri explored landscape painting. John Sloan's paintings from Gloucester, Massachusetts, (pages 155, 156) were coastal landscapes as were several works from his visits to the Southwest. George Bellows, who was a student of Henri's and part of his circle, also was a painter of coastal and urban landscapes and, like Lawson, painted the waterways around New York. In other words, Lawson's immediate peers never abandoned landscape and sought opportunities to explore it.

The state of landscape painting in America during the first decades of the twentieth century was not at all dire. Numerous clusters of artists were practicing the art of landscape in different regional centers. A cursory list would have to include the artists known as The Ten, who exhibited from 1898 to 1919 their different versions of New England locales; the group of Pennsylvania impressionists who congregated in New Hope and surrounding Bucks County; the mostly East coast- and Midwest-trained artists who lived and worked in Taos, New Mexico; and those who formed an art colony in California's Laguna Beach. The art colony phenomenon itself — the product of painters seeking a close relationship with nature, the comforts of a community of like-minded individuals, and secluded places not too far removed from urban centers — reveals an ongoing preoccupation with landscape by artists and buyers. In these art colonies, American artists explored different types of impressionism broadly defined as plein air or outdoor painting. Lawson, however, went beyond the impressionism that had become the hallmark of landscape painting in the art colonies. Like Prendergast, he forged a style characterized more by surface texture, experimentation with color, and expressionistic brushwork, and which

therefore had more in common with European post-impressionism.[3]

To some degree, Lawson was a product of the art colony movement. In the early 1890s he had studied with John Twachtman and J. Alden Weir, mostly at their Cos Cob, Connecticut, art school, and he followed in their path with subtly impressionistic snow scenes such as *Spring Thaw* (page 79) painted along rivers in Connecticut and around New York. From Twachtman and Weir, Lawson learned to infuse his landscapes with lyricism and mood. Over time, however, Lawson's application of paint became rougher and less refined than Twachtman's. After meeting French painter Alfred Sisley in France in 1893, Lawson took a decidedly impressionist direction, experimenting more with plein air painting, taking more freedom with color, and expanding his range of subject matter. He frequently let areas of blank canvas show through and then juxtaposed such areas with thick layers of paint applied with palette knife or trowel. During his time in Paris, around 1894, Lawson was most likely also introduced to the work of Paul Cézanne. Technically and conceptually, Sisley and Cézanne provided a framework upon which Lawson expanded throughout his career.

Lawson's productivity peaked during the first three decades of the twentieth century as he executed paintings reflecting his travels around the city of New York and New England, trips to his native Canada, and an extended trip to Spain, culminating with a series of paintings from Colorado in the late 1920s. The fourteen major prizes he won between 1904 and 1927 made him the second most such honored artist among The Eight, after Henri. After 1931 Lawson painted mostly in southern Florida and on an occasional visit to Tennessee. Inspired by the lush scenery of the South, he painted some of these late works with great intensity, using bright colors applied in layers of rich impasto. The texture and animated brushwork of these

Ernest Lawson
Spring Thaw, c. 1910
Oil on canvas
25¼ × 30⅛ in.
(64.1 × 76.5 cm)
Terra Foundation for
American Art, Daniel J.
Terra Collection, 1999.85

late paintings make Lawson a precursor to the abstract expressionist movement of the post-war era. When he was already living in Florida, Lawson received a mural commission for the post office in Short Hills, New Jersey, from the federal government. He was able to complete the painting shortly before his death in 1939, and it was installed in 1940 (later demolished).

How important, then, was The Eight's 1908 exhibition for Lawson in establishing himself as a modern landscape painter in America? In 1907, the year the National Academy of Design denied him associate membership, Lawson's reputation was gaining momentum. He had solo exhibitions at the New York School of Art (in February) and at the Pennsylvania Academy of the Fine Arts (in March). The same year, he was awarded the Sesnan Medal for landscape painting for one of his entries in the Pennsylvania Academy's annual exhibition. These successes garnered Lawson increased critical attention and, as one reviewer noted, "after twenty years of hard and heroic work" as a landscape painter, Lawson was finally getting the recognition he deserved.[4] In another article, Henri was quoted as saying: "This man is the biggest we have had since Winslow Homer."[5] No doubt, the affiliation with Henri and The Eight helped Lawson accelerate his already thriving career.

The critics and patrons were taking notice of his special contribution to The Eight in the genre of landscape painting. Gertrude Vanderbilt Whitney bought his painting *Winter on the River* (fig. 17) directly from the Macbeth Galleries show in February 1908. Other prominent collectors who purchased his works around this time included William T. Evans, Albert C. Barnes (who bought at least eight Lawson paintings), Ferdinand Howald (whose collection is now at the Columbus Museum of Art), Marjorie and Duncan Phillips, John Quinn, and John Moore, the owner of Chez Francis, a popular restaurant and meeting place for The Eight. Among the first museums that acquired his work were the Newark Museum, the Saint Louis Museum of Fine Art, and the Metropolitan Museum of Art.

Lawson supported America's independent artist movement, participating mostly as an artist but also as an organizer of the 1910 exhibition of Independent American Artists, the 1913 Armory Show, and the first Society of Independent Artists show in 1917. Nevertheless, he was accommodating toward the much-maligned National Academy. In 1908, the year after his widely publicized rejection by the Academy, he won the First Place Hallgarten Prize in its annual exhibition with the painting *Ice on the Hudson* (present location unknown) and was made an associate member. For Lawson and his family, the sale of art was the primary source of income, and he simply could not afford to take a stand against the Academy and pass up the opportunity of an exhibition that might generate publicity and buyers. Equally important were the occasional financial rewards that came with Academy or other exhibition honors. When he won the prestigious Clark Prize at the 1916 Corcoran Biennial, the $1600 cash award, which equaled the sale of two or three paintings, enabled the artist to take his family to Spain. Although Lawson fell on financial hard times later in his life, he was clearly successful in moving between the Academy and the independent movement, building bridges among the conservative and progressive elements in American art.

Much of Lawson's reputation rested on his landscapes of New York that combine pastoral tradition with urban reality. After spending several years in France, Lawson and his wife, artist and art teacher Ella Holman, moved to New York, where they found an apartment at 453 West 155th Street. From there, Lawson explored the city's outskirts, especially the northern tip of Manhattan, the semi-rural region of Inwood, including Fort Tryon Park, and Washington Heights along the Hudson and Harlem rivers. Unlike his friend and colleague William Glackens, who was equally influenced

by the French impressionists, Lawson in general shied away from painting the prominent public places, such as Central Park, where New Yorkers promenaded. In contrast, he focused on the landscape of industrialization in early twentieth-century America, painting such subjects as excavation sites, laborers emptying ships at dock, squatter homes, and gigantic iron bridges traversing the rivers.

Yet many critics considered Lawson an artist on the fringes of the so-called Ashcan school movement. As one claimed, "Lawson's art is realistic, but he abhors the sordid and the ugly (so many moderns wrongly think this is synonymous with character)."[6] The New York pictured by Glackens, George Luks, Everett Shinn, and Sloan was a chaotic, voyeuristic spectacle; it was experienced from street level, from the back window of an apartment building, between a throng of park visitors, or in the midst of a theater audience. Lawson's views of the city were taken from a distance and had a classic harmony of composition disrupted only by his heavy impasto and short brushstrokes. He shared with Arthur B. Davies and Prendergast this sense of balance as well as a penchant for scenes of a premodern, pastoral landscape. Around the time he exhibited with The Eight, Lawson's critics began to refer to him as the Harlem River school painter, evoking memories of the Hudson River School painters of the previous century. As one critic noted, Lawson was able to render the urban wilderness of New York as a picturesque and natural environment. For many, Lawson's New York was even more than pure nature, it was nature refined and distilled. In 1921, Catherine Beach Ely remarked: "[H]e lends the tints of the opal to the squalid suburban wilderness adjacent to New York."[7]

Lawson's work posed a challenge, however, for those who saw it as a purely aesthetic experience. As a recent Lawson scholar has pointed out, he was drawn to the border regions of New York, the areas that were part of urban

FIG. 17
Ernest Lawson
Winter on the River, 1907
Oil on canvas
33 × 40 in.
(83.82 × 101.6 cm)
Whitney Museum of American Art, New York; gift of Gertrude Vanderbilt Whitney 31.280

America while they maintained a semi-rural look and were subject to intensive land speculation and urban development.[8] In portraying river life, Lawson captured the visible signs of transformation around the city's waterways. In *Spring Tapestry* (page 89), for example, he included a meandering river, a tugboat, and suburban homes and other types of real estate. *Boat Club in Winter* (page 88) is mostly likely a view along the Harlem River, an area that was still semi-rural but also the subject of real estate development. The boat club and its yard are modest and its members most likely from the working class. Yet the massive edifice in the distance, topped by a rotunda, suggests a powerful urban world beyond. Although Lawson never directly comments on these power relationships of these structures, their presence is always implied. There is an underlying tension in these works from upper Manhattan and the south Bronx: Lawson places the viewer into a landscape that was being developed, parceled, and urbanized.

Over several decades, Lawson created an extensive and far-reaching body of work focused on New York and its environs. While living in Washington Heights, Lawson was always mobile, riding the elevated trains or simply walking to

Ernest Lawson
Brooklyn Bridge, 1917–20
Oil on canvas
20⅜ × 24 in.
(51.8 × 61 cm)
Terra Foundation for
American Art, Daniel J.
Terra Collection, 1992.43

different locales. After 1906, when the artist moved to 23 MacDougal Alley, in Greenwich Village, he continued this pattern. Besides his familiar upper Manhattan, his artistic map now included Washington Square, Stuyvesant Square, Brooklyn Bridge, Coney Island, and other places. His project was expansive and ambitious, a catalogue of material that in the aggregate amounted to a long poem reminiscent of Walt Whitman or Hart Crane. As in the works of these poets of the city, New York in Lawson's paintings becomes a metaphor, an urban landscape that encapsulates America's national and even transnational potential. The art critic Mary Fanton Roberts, who wrote under the pseudonym Giles Edgerton, described Lawson's achievement in Whitmanesque terms: "[Lawson] will show them all the roar and the confusion and the blare and the somberness that a great city holds."[9] Another critic referred to Lawson as "a poet of the commonplace of nature," placing the artist squarely into the great literary tradition of Emerson and Whitman.[10]

In *Brooklyn Bridge* (page 82) Lawson painted an icon of modern engineering that has inspired much artistic and literary reflection ever since it opened in 1883. He chose a conventional landscape composition that allowed the architectural monument to appear almost in its entire length as it traverses the river, anchored by buildings in the foreground, the vague outlines of structures on the opposite shore, and a pale evening moon. In *Brooklyn Bridge*, Lawson shows himself a master of light and atmosphere, the pale orange and green haze of the sky alternating with darker greens in the East River punctuated by the artificial light of streetlamps and buildings. In this and other paintings, Lawson enveloped the city in a precious yet modernist patina, utilizing what critics referred to as his "palette of crushed jewels," a phrase attributed to art critic James Huneker.[11] Notwithstanding Lawson's obvious talent at creating canvases of luxurious color and texture, most of his critics considered him a masculine painter, describing his work as virile, robust, and bold. One writer directly discussed Lawson as a welcome contrast to "the nice, delicate, imitative and effeminate work of the ordinary American landscape painter."[12]

In addition to his many urban or semi-urban subjects, Lawson was also a prolific painter of the American, Canadian, and European countryside. His *Winter Scene* (page 87) is in the tradition of Twachtman and Weir, who were masters of painting snow-covered landscapes. The country road in *Winter Scene*, showing the markings of wagon or cart wheels, is also reminiscent of the paintings the impressionists produced in the French countryside, especially in the area around Fontainebleau. Lawson again demonstrated his penchant for early evening light, with a pale orange sun barely visible in the distance. He used orange-brown pigments to indicate foliage on the ground and on the slender trees. That works such as *Winter Scene* are rooted in ordinary landscapes only enhances the precious quality of their jewel-like surfaces. While Lawson's paintings acknowledge the presence of urban development, they also reassure viewers that the rural landscape is still holding its own.

Nostalgia for the American past motivated the Colonial revival of the early twentieth century, and paintings such as Lawson's *Colonial Church* (page 85) resonate with longing for relics of the colonial heritage that represented a simpler life. Still, Lawson's instinct for realism and direct observation allowed him to maintain a critical distance, avoiding any sentimentalizing of what he saw. The church, with its green shutters closed, looks abandoned. An architectural monument of solid shapes, it serves as a compositional device set up against the sinuous lines of the trees and their reflections. Lawson was perhaps less inclined to follow the Colonial revival as were Willard Metcalf and Childe Hassam, two American impressionists who helped found The Ten and who occasionally painted eighteenth-century churches and other markers of colonial times (fig. 18).

Lawson, like his fellow artists among The Eight, took the torch of artistic progress from The Ten and moved it forward. His legacy as a modernist innovator is complex, however. One of his great supporters, the collector Duncan Phillips, described Lawson's vision as magical and referred to the artist as a "great romanticist."[13] James Huneker referred to Lawson's work as "pantheistic magic."[14] It was as if some critics wanted him to be another George Inness, the late-nineteenth-century American landscape painter associated with purely spiritual images of nature. In the end, Lawson managed to attract so much praise because he was a modernist and innovator who appealed to the prevailing nostalgia for landscape. He dedicated himself to the urban landscape of New York and developed a painterly style that was both lyrical and expressive. He epitomized a new type of artist, one who could answer the challenging questions for modernist landscape painting in America.

Jochen Wierich is Curator of Art at Cheekwood Botanical Garden & Museum of Art.

FIG. 18
Frederick Childe Hassam (1859–1935)
Church at Old Lyme, Connecticut, 1905
Oil on canvas
36¼ × 32¼ in.
(92.07 × 81.91 cm)
Albright-Knox Art Gallery, Buffalo, New York, Albert H. Tracy Fund, 1909

I wish to thank Elizabeth Kennedy and the contributors to this volume for their support and collaborative spirit. While researching Lawson at the Smithsonian American Art Museum/National Portrait Gallery, I received valuable support from Stephanie Moye. My research was greatly aided by the Archives of American Art and its staff. I am grateful to Alice Ann Barge, Stephen Wicks, and Jim Hoobler for discussing Lawson's Tennessee connections with me. Finally, thanks to Jack Becker, Cheekwood's President and CEO, for his support.

1 "A Glorifier of New York," unidentified newspaper clipping, Ernest Lawson Papers, Archives of American Art, Smithsonian Institution.

2 Guy Pène du Bois, *Ernest Lawson* (New York: Whitney Museum of American Art, 1932), 7. The term "pure landscape painting" in connection with Lawson surfaced earlier. See, for instance, Ameen Rihani, "Landscape Painting in America: Ernest Lawson," *International Studio* 78 (February 1921): 114–7.

3 For a detailed evolution of Lawson's style, see Adeline Lee Karpiscak, *Ernest Lawson* (Tuscon: University of Arizona Museum of Art, 1979), 18–32.

4 Undated newspaper clipping, *Philadelphia Press*, Ernest Lawson Papers, Archives of American Art, Smithsonian Institution.

5 James Huneker, "Monet, Lawson, Dougherty," *The Sun*, February 7, 1907.

6 A. E. Gallatin, "Ernest Lawson," *International Studio* 59 (July 1916): 5.

7 Catherine Beach Ely, "The Modern Tendency in Lawson, Lever and Glackens," *Art in America* 10, no. 1 (December 1921): 31.

8 See Ross Barrett, "Speculation in Paint: Ernest Lawson and the Urbanization of New York," *Winterthur Portfolio* 42, no 1 (Spring 2008): 3–25.

9 Giles Edgerton [Mary Fanton Roberts], "The Younger American Painters: Are They Creating a National Art?" *The Craftsman* 13 (February 1908): 523–4.

10 Frederic Fairchild Sherman, "The Landscape of Ernest Lawson," *Art in America* 8 (January 1919): 33.

11 The "crushed jewels" analogy is ubiquitous in the literature on Lawson. As Valerie Leeds points out, no mention of it by Huneker in print has been located. See Leeds, "Ernest Lawson in a New Light," in *Ernest Lawson* (New York: Gerald Peters Gallery, 2000), 40, n. 9.

12 "A Glorifier of New York."

13 Duncan Phillips, "Ernest Lawson," *The American Magazine of Art* 8, no. 7 (May 1917): 262.

14 James Huneker, "The Academy Exhibition," *The Sun*, December 28, 1907, clipping in Ernest Lawson Papers, Archives of American Art, Smithsonian Institution.

Ernest Lawson
Colonial Church, c. 1908–10
Oil on canvas
24 × 20¼ in.
(61 × 51.43 cm)
New Britain Museum of
American Art, Charles and
Elizabeth Buchanan
Collection, 1989.33

Ernest Lawson
Springtime, Harlem River, 1900–10
Oil on canvas
25 × 36 in.
(63.5 × 91.44 cm)
Terra Foundation for
American Art, Daniel J.
Terra Collection, 1992.45

Ernest Lawson
Winter Scene, c. 1909
Oil on canvas
24⅛ × 30¼ in.
(61.27 × 76.83 cm)
Milwaukee Art Museum,
gift of Mr. and Mrs.
Donald B. Abert and
Mrs. Barbara Abert Tooman
M1981.188

Ernest Lawson
Boat Club in Winter, c. 1915
Oil on canvas
16⁵⁄₁₆ × 20¼ in.
(41.43 × 51.43 cm)
Milwaukee Art Museum,
Samuel O. Buckner Collection
M1928.6

Ernest Lawson
Spring Tapestry, c. 1930
Oil on canvas
40⅛ × 50 in.
(101.9 × 127 cm)
New Britain Museum
of American Art,
Charles F. Smith Fund
1948.09

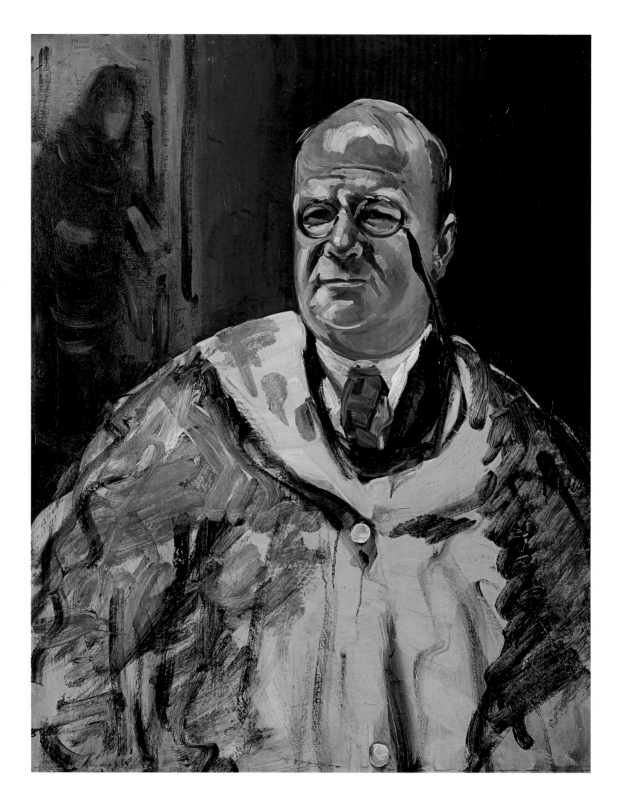

FIG. 19
George Luks
**Self-Portrait with
Pince-Nez,** 1930
Oil on canvas
32 × 26 in.
(81.3 × 66 cm)
Collection of
The New-York
Historical Society
2008.4

Luks

George Luks: Rogue, Raconteur, and Realist

Judith Hansen O'Toole

It is absolutely impossible to set down any adequate description of Luks. He is Puck. He is Caliban. He is Falstaff. He is a tornado. He is sentimental. He can sigh like a lover; and curse like a trooper. Sometimes you wonder over his versatility; a character actor, a low comedian, even song-and-dance man, a poet, a profound sympathizer with human misery, and a human orchestra.
— James Huneker,
New York art critic[1]

George Luks (1867–1933) was all of the above and more. A teller of tall tales, he lied about his age, fabricated a past as a pugilist named "Chicago Whitey," and boasted that he was one of only two great artists the world had ever seen (Frans Hals was the other). This bigger-than-life personality may have enabled Luks's interest in artistic experimentation throughout his career, thereby sustaining his relevance in the art world longer than some of his colleagues.

Although a rogue in other aspects of his life, Luks was earnest and down-to-earth when it came to his art. Like many with large egos, he had an insecure underbelly which ensured his openness to different styles, and he was constantly looking and adapting his approach.

He frequently sought out the opinions of critics and colleagues, altering a painting on the spot if he received less-than-positive feedback.[2] A chameleon, he absorbed new styles and theories as he was exposed to them, some surfacing in only a few experimental paintings, some affecting the course of his stylistic trajectory.

Everett Shinn, who roomed with Luks in Philadelphia before the formation of The Eight, described him as having a "God-given gift to see, feel and record it in paint"[3] Luks demonstrated an innate ability to observe and record life around him, from his earliest years as a teenager, when he drew portraits of customers while the druggist who employed him was out, to his days as a newspaper artist in Philadelphia and New York. He was once observed using both hands to finish a sketch, one hand filling in the foreground while the other worked on the borders.[4] This natural facility made him an undisciplined student in formal settings, causing him to drop out of both the Pennsylvania Academy of the Fine Arts and the Kunstakademie in Düsseldorf after only one month at each institution. Abandoning formal training, he toured Europe, going from Germany to France and England, visiting museums and learning directly from the masters by copying works by Francisco de Goya, Rembrandt, and

Hals. In France he admired the work of Edouard Manet, whose direct, forceful images and use of strong masses of brilliant color can be seen as an influence in his later work.

The purpose of The Eight's now-famous Macbeth Galleries' exhibition in 1908, which had such a dramatic impact on the course of American art, was not to exhibit the work of like-minded artists but to demonstrate new opportunities for exhibition and show new styles of painting. The Eight had little in common stylistically. But of the artists associated with urban realism, Luks was arguably the closest in his choice of portrait subjects and working methods to Robert Henri, the group's charismatic flag-bearer of change. Although he never admitted a debt to Henri, Luks's impulsive desire for action accorded with the older artist's teachings. Both worked quickly, blocked out large masses of color, and concentrated on the face in their portraits. Both men were passionate humanitarians seeking to forge a new artistic expression that was truly American and of their own time. As early as 1909, Luks's work was characterized as "a reflection of our American life as it is today, crude, vehement, inconsiderate though not without tenderness at times. [Collectors] do not want to be reminded of the bitterness of life, and have not yet learned to see the beauty of the common and the modern—in the expression of the vulgar ... life."[5] Although he never wanted his work to be seen as social commentary, it could be stated that it laid the groundwork for what would be characterized as social realism and American scene painting of the late 1920s and 1930s.

Luks was born to immigrant parents in Williamsport, Pennsylvania, and raised in the coal mining community of Shenandoah, in the same state, where his physician father tended to the needs of the Molly Maguires, their widows, and other working families who could not otherwise afford medical attention.[6] His parents instilled in him a regard for humanity and empathy for those

less fortunate. Luks's mother was an amateur painter who encouraged her children to pursue the arts by reading and playing music with them. Both George and his younger brother Will were taught the value of the arts to enrich their lives but George pursued it as a career.

By the turn of the twentieth century, Luks's work was well received in New York, where he had lived since 1896 after beginning his association with Henri, William Glackens, Shinn, and John Sloan in Philadelphia. He exhibited with the Society of American Artists beginning in 1903 and in the same year had a painting, *East Side, New York* (unlocated), accepted for the National Academy of Design's annual exhibition through Henri's assistance. Despite being "skied," this painting caught the attention of Charles Fitzgerald, critic for the *New York Evening Sun*, who praised the work and decried its unfair positioning.[7] William Macbeth gave Luks a solo exhibition in 1910 and in 1913, and after participating in the Armory Show, he began to be represented by John Kraushaar at his gallery.

By 1905 the sale and exhibition of his paintings permitted Luks to leave the newspaper business, in which he had been an artist since the 1890s, and concentrate on painting, taking some private students to supplement his income. He still prowled the streets of Manhattan with a reporter's eye, recording the life he saw around him. *Bleeker and Carmine Streets, New York* (page 100) shows the style he developed in this decade for rendering street scenes, using flat strokes of unmixed color in geometric, mosaic-like patterns. In *Pals* (page 101), we see this technique applied to a portrait of both bird and human, with an emphasis on color, form, and emotional appeal.

When his work was rejected by the Academy for its annual exhibition in the spring of 1907 and Henri withdrew his own submissions to protest the narrow-mindedness of the jury, Luks feigned indifference and was quoted saying: "I

FIG. 20
George Luks
The Wrestlers, 1905
Oil on canvas
48⅜ × 66⅜ in.
(122.87 × 168.59 cm)
Museum of Fine Arts,
Boston, The Hayden
Collection—Charles
Henry Hayden Fund
45.9

don't look on this thing from a personal point of view … I am trying to do things; if they don't understand them, I don't care anymore for them than I do for a bottle of turpentine. I don't propose to berate them. After all, it's a question for Father Time."[8]

But as early as 1905, Luks had begun a painting which he told Sloan would "vindicate Henri in his fight for my work on the National Academy juries."[9] *The Wrestlers* (fig. 20) shows two young men, limbs entangled in competition, ably displaying not only their own strength but Luks's grasp of human anatomy, a technical must from the point of view of the Academy. This was a private demonstration for the artist, however, since he refused to exhibit the painting after the Academy's rejection of his other works, waiting until 1915 to unveil it, at Kraushaar Galleries.

By 1912, Luks and his second wife, Emma Louise, were comfortable enough to move from their small apartment in the thick of downtown Manhattan to a large home with an attached studio on Jumel Place and Amsterdam Avenue in northern Manhattan, just a few minutes' walk from Highbridge Park on the Harlem River. The studio offered northern exposure and comfort the artist had not yet experienced in New York. The neighborhood was one of upper- and upper-middle-class residents. This change of scenery took Luks out of the city's gritty hustle and bustle and gave him new subject matter with which to work. He found himself surrounded with urban scenes of people at leisure in the bright sunshine of city parks, rather than in the gloomy dusk of downtown streets and markets. Nursemaids with babies, children playing, people strolling, old people

George Luks
Knitting for the Soldiers:
High Bridge Park, c. 1918
Oil on canvas
30³⁄₁₆ × 36⅛ in.
(76.7 × 91.8 cm)
Terra Foundation for
American Art, Daniel J.
Terra Collection, 1999.87

gossiping on park benches—these became his subjects. The brilliant color that had always enlivened his dark palette came to the fore and his brushwork became dappled and more playful. His emphasis on form embraced pattern while a flattening of perspective, apparent in earlier works, crept more firmly into his work. *Knitting for the Soldiers: High Bridge Park* (page 94) shows nursemaids busy not only tending their small charges but also working for the war effort in the bright, purple-shadowed sunlight of winter. A pretty painting, it also captures the personalities of each of the knitters, their hatted heads bowed in industrious concentration that also appears subtly humorous.

Watercolor had always interested Luks as a spontaneous and portable medium. He considered it not just a means for making sketches but a primary method for creating finished paintings. His early newspaper cartoons, including the "Yellow Kid" he created for Pulitzer's *New York World*, had been executed in watercolor. The first medal he ever received was awarded for a watercolor called *On the Marne* (1902; unlocated), an impressionistic river scene shown at the New York Watercolor Club, where it garnered the Hudnut award. He joined the American Watercolor Society in 1911 and exhibited regularly alongside the likes of Charles Burchfield and John Marin. By the end of the decade Kraushaar Galleries mounted exhibitions devoted exclusively to his watercolors.

Like many of his contemporaries, Luks was more adventurous in this aqueous medium, engaging in experimentation that he then translated to oil painting. The influence of his friend Maurice B. Prendergast, a fellow member of The Eight and an older artist whom Luks admired, can be seen in the short dot-and-dash style often seen in his watercolors of the teens. The two artists' subjects are also related—both painted families at leisure in park settings, for example—as are the flattened perspectives and

interest in pattern applied to them. Like Prendergast, Luks often left some of the pure white of the watercolor paper exposed to add sparkle to his work. The bright palette and flickering brushwork of *Knitting for the Soldiers* reflects the influence of Luks's work in watercolor.

After his move to northern Manhattan, Luks continued to visit his old haunts on the Lower East Side, where he remained connected with the immigrant poor toward whom he felt most empathetic and whose portraits he felt most suited to paint. He portrayed *Old Mary* (page 103), a well-known beggar woman, as an individual of great dignity. Her gnarled hands folded demurely in her lap; she stares out through narrowed eyes, daring the viewer to judge her. Similarly, *Cabby at the Plaza* (page 102) reveals his interest in capturing individuals and their expressive personalities. As Luks returned to such subject matter, he returned also to a dark palette and the format of a solitary subject positioned against a generalized dark background.

During these trips back to lower Manhattan, Luks would visit his brother Will, who ran the Northern Dispensary, an infirmary for the indigent in Greenwich Village. An imbiber of spirits all his life, Luks used his brother's place as a retreat during binges when he could not, or did not want to, return to Jumel Place. His drinking, which in earlier years added to his affability, affected his life differently in later years, contributing to a separation and divorce from Emma Louise, a move back to southern Manhattan by the early 1920s, and a stay in a Boston sanatorium thanks to the support of friends Mr. and Mrs. Shaw McKean, in 1922.

An avid outdoorsman, Luks made a fishing trip to Nova Scotia in 1919, most likely in the company of Ernest Lawson, a fellow member of The Eight who went there frequently. Always a man of action, Luks was invigorated by this trip both in body and his art. In Nova Scotia he

produced a remarkable series of watercolors that met with much critical praise. He later worked some of these images into oil paintings that were equally vivid in color and dramatic in composition and execution. Bold shapes, high vantage points that serve to flatten perspective, and saturated color align these works with modernist tenets. They emphasize purely painterly concerns, eliminating extraneous detail.

The watercolors Luks produced during this and other trips to northern coastal locales are startling in their freshness and immediacy. Upon seeing them, art critic Frederick James Gregg wrote, "Those who were in the habit of harking back to his earlier work and discussing Mr. Luks, with a sort of implication that the best part of his career was safely behind him, will find it necessary to reconsider that conclusion. It is now demonstrated beyond all shadow of a doubt that he has plenty of surprises up his sleeve for the future and before the time when he joins the ranks of American 'old masters.'"[10]

The 1919 watercolor painting entitled *The Screecher* (fig. 21) is one of these vibrant images, exuberant in color, pattern, and flattened perspective. With no horizon line to give it a conventional illusion of space, the composition

is taken up almost entirely by swirling strokes of pure color laid alongside each other to evoke the waves' vigorous movement. The figure of a boater peering at the rocks he may have just hit or narrowly avoided lends an anecdotal element to tie the image to reality. *Nova Scotia Guides, Lake Rossignol* (fig. 22), from the same year, is compositionally similar but executed this time in oils and showing two boaters maneuvering in swift waters.

The watercolors and oils Luks made from the twenties until his death in 1933 show the artist taking his early interest in formal qualities a few aggressive steps further toward abstraction. Although he never departed from realism, his work was invigorated by these innovations, and the public as well as the art world embraced them. Like his colleagues among The Eight, however, Luks did not like the modernist direction many of his artistic contemporaries were taking, perhaps not recognizing his nods to abstraction in his own work. He was quoted as saying that "modernism and mediocrity are synonymous,"[11] and he must have been rankled by an anonymous critic's comparison, in 1925, of his own watercolors to the work of the French fauve painter Maurice Vlaminck.[12]

Luks had begun to teach at the Art Students League in New York in 1920, but his classroom antics, rough language, haranguing critiques, and sporadic attendance soon forced a separation. His own lack of formal training, a fact that drew out his insecurity, made him ill-equipped to teach. Typically he covered it up by dismissing technique with bravado, saying, "Art my slats! I can paint with a shoestring dipped in pitch and lard …. Technique did you say? My slats! Say listen you—it's in you or it isn't. Who taught Shakespeare technique? Guts! Life! Life! That's my technique!"[13]

In the summer of 1925 and again in 1927, Luks was invited back to the coal-mining region where he had spent his childhood. Henry

Sheaffer of Pottsville, Pennsylvania, sought him out to paint a mural for the Necho Allen Hotel, named for the man who first recognized the long-burning properties of anthracite coal. The first summer, the artist was given a studio for two months and treated like a returning hero, a hometown boy made good. Newspaper articles documented his progress as long lines of miners, their wives, and children filed through Luks's temporary studio to have their portraits painted in preparation for the mural. *Suraleuska* (page 104) may well have been one of these portraits. A synthesis of emotion and formal painterly qualities, it presents the sitter facing the viewer squarely, as in his earlier

portraits. However, the bold use of four main colors divided into an equal number of shapes to complete the image demonstrates a more modernist approach. In Pottsville Luks was in his glory. He had plenty of rich subject matter, a willing audience for his tall tales, and plenty of adulation and publicity. It didn't matter that at least one of those who sat for him in coal-miner's gear was actually a janitor whose face Luks was drawn to.

Back in New York, the paintings from these trips to Pennsylvania solidified Luks's reputation as an "American" painter rooted in everyday life, including its hardships and travails. His tender and powerful portraits of the coal miners and

FIG. 22
George Luks
Nova Scotia Guides, Lake Rossignol, 1919
Oil on canvas
25 × 30 in.
(63.5 × 76.2 cm)
Courtesy of Michael Altman Fine Art & Advisory Services, LLC

vivid renderings of their ramshackle homes were hailed as beautiful expressions of everything that was hard and crude in life. The paintings from Pottsville were exhibited at the Rehn Gallery and applauded by critics, who urged younger artists to look to them to realize that there was no need to go to Europe to study, for there was plenty of rich, fresh material at home. This sentiment reinforced an earlier critic's observation that Luks was an "American painter of great originality and force," whose work inspired other artists to stay in the United States for their subject matter.[14]

Luks and his abiding interest in figural work found more material in the neighbors surrounding him in the Berkshire Mountains of Massachusetts, where he bought an old

FIG. 23
George Luks
The Polka Dot Dress, 1927
Oil on canvas
58 × 37 in.
(147.4 × 94 cm)
Smithsonian American Art Museum, gift of Mrs. Howard Weingrow 1969.148

farmhouse in 1925. In the portraits he painted there, he continued to investigate the quirks of human nature, but he employed bright colors rather than the earth tones of his earlier images of New York street figures. *The Polka Dot Dress* (fig. 23) exemplifies his portrait style from this period. The subject is dressed in her Sunday best, with white gloves and flower-festooned hat complementing the bright blue polka dots of her dress. She is shown perched on the edge of a simple wooden chair painted red, her lips tinted crimson as if to match and caught in a bemused smile. Luks also painted his little farmhouse and the surrounding meadows and mountains many times and with great affection. *Sunset* (page 107) shows a farmhouse, perhaps one neighboring his, nestled under a protective expanse of trees. Brightly colored flowers, probably hollyhocks, appear in the foreground along a dirt road. The sky is striped with red and blue in an evocation of the afterglow of the setting sun. Here Luks used broad washes of color and pointillist dabs of paint to evoke the scene in a full palette of saturated color.

Luks continued to receive recognition, being invited to exhibit at the Twenty-ninth Carnegie International in 1930. In 1932 he won the William A. Clark Prize and the Gold Medal at the Thirteenth Exhibition of Contemporary American Oil Paintings at the Corcoran Gallery of Art. *New York Times* art critic Elisabeth Luther Cary characterized Luks's work from the early thirties as showing "the ebullience and directness of a young mind" yet with qualities to be "found only in a mind that has been young a long time ... at once flexible and stable."[15]

Found dead in the doorway of a New York speakeasy in the cold early morning of October 29, 1933, Luks is believed to have been the victim of one of his legendary barroom brawls. It was as if he were still donning the alter ego of a young and confident "Chicago Whitey" at age sixty-seven. In fact, on his sixty-fifth

birthday he told an interviewer that "A man's just out of school at sixty …. I'm just getting started [in life]!"[16] The press covered up the details of his death and wrote that the great American painter had been sketching the effects of dawn near the Elevated when he was taken ill. He was eulogized as one of America's remarkable originals. As Everett Shinn added in his memoir, "[Luks was an artist] who has given me the keenest of thrills, that of paint-magic in its application to a flat surface that vibrates and tells me of life."[17]

Judith Hansen O'Toole is Director/CEO of the Westmoreland Museum of American Art.

I would like to acknowledge the support of Helen Farr Sloan who early in my career encouraged me to turn my attention to The Eight and especially to George Luks. She supported my research for an exhibition mounted at the Sordoni Art Gallery, Wilkes University in 1987. Stanley L. Cuba and Nina Kasanof contributed essays to the catalog published at that time. Recently, an invitation to speak at the Detroit Institute of Arts in conjunction with their exhibition, Life's Pleasures: The Ashcan Artists' Brush with Leisure, revitalized my interest in George Luks.

1 James Huneker, *Bedouins* (New York: Charles Scribner's Sons, 1920), 108.

2 Guy Pène du Bois, "George B. Luks and Flamboyance," *New York American*, March 1904, 110.

3 Everett Shinn, "Everett Shinn on George Luks: An Unpublished Memoir," *Archives of American Art Journal* 6, no. 2 (April 1966): 2.

4 Shinn, "Everett Shinn on George Luks," 4.

5 "An Assessment of George Luks," *The Stylus* 1, no.1 (December 1909): 12.

6 The Molly Maguires were members of an underground Irish organization that assisted the miners and worked to improve their working and living condition through strikes and other means.

7 Charles Fitzgerald, *New York Evening Sun*, April, 1903, clipping in scrapbook in Luks Family Papers, private collection.

8 Luks quoted in Bennard B. Perlman, *The Immortal Eight: American Painting from Eakins to the Armory Show, 1870–1913* (Westport, CT: North Light Publishers, 1979), 162.

9 Luks quoted in Perlman, *The Immortal Eight*, 77.

10 Frederick James Gregg, "George Luks Shows Work of a Year," *New York Herald*, January 11, 1920.

11 Luks quoted in du Bois, "George B. Luks and Flamboyance," 13.

12 *New York Times Magazine*, November 5, 1925, clipping in scrapbook in Luks Family Papers, private collection.

13 Luks quoted in Benjamin De Casseres, "The Fantastic Life of George Luks," *New York Herald Tribune*, September 10, 1933.

14 John Spargo, "George Luks, an American Painter of Great Originality and Force, Whose Art Relates to All the Experiences and Interests of Life," *The Craftsman*, 12, no. 6 (September 1907): unpaged.

15 Elisabeth Luther Cary, "George Luks," undated typescript in curatorial files, Whitney Museum of American Art, New York, 11.

16 *Herald Tribune*, August 4, 1932, clipping in scrapbook in Luks Family Papers, private collection.

17 Shinn, "Everett Shinn on George Luks," 12.

George Luks
Bleeker and Carmine Streets, New York, c. 1905
Oil on canvas
25 × 30 in.
(63.5 × 76.2 cm)
Milwaukee Art Museum,
gift of Mr. and Mrs.
Donald B. Abert and
Mrs. Barbara Abert Tooman
M1976.14

George Luks
Pals, c. 1907
Oil on canvas
30 × 25 in.
(76.2 × 63.5 cm)
New Britain Museum
of American Art,
Harriet Russell Stanley
Fund, 1943.11

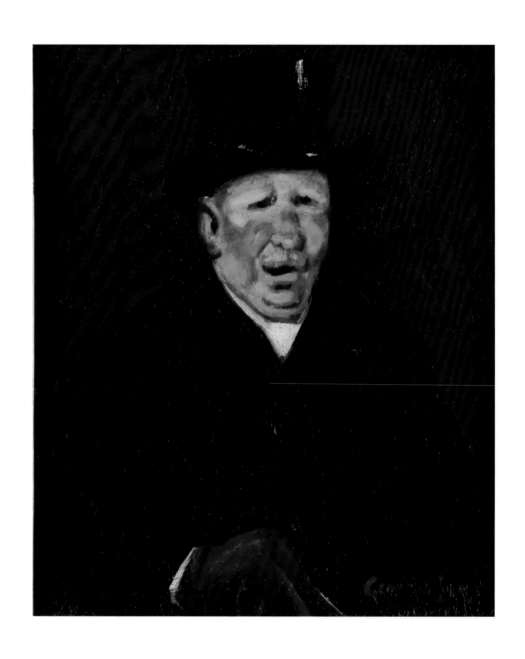

George Luks
Cabby at the Plaza
c. 1920–30
Oil on board
12 × 10 in.
(30.5 × 25.4 cm)
New Britain Museum of
American Art, John Butler
Talcott Fund, 1941.02

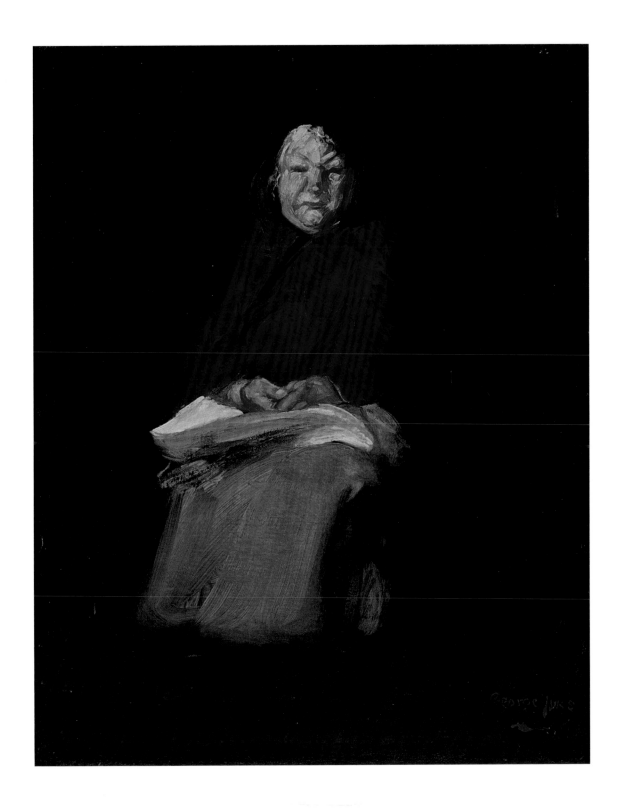

George Luks
Old Mary, c. 1919
Oil on canvas
20 × 16 in.
(50.8 × 40.64 cm)
Milwaukee Art Museum,
gift of Charles D. James
M1968.47

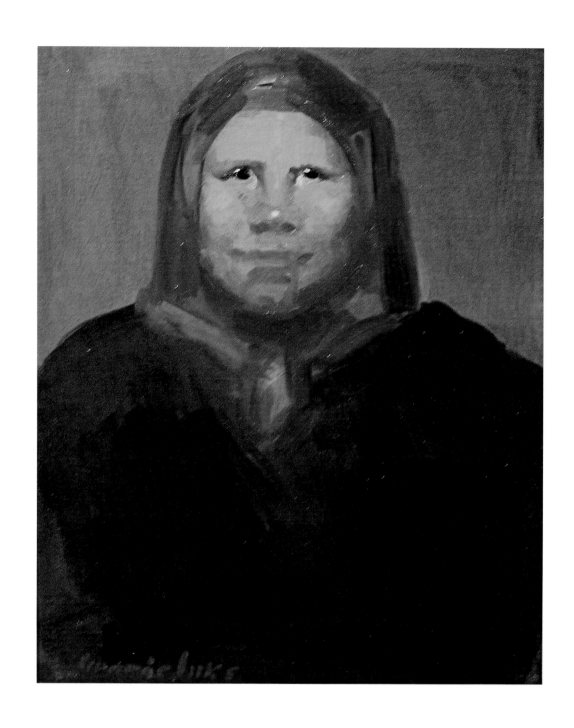

George Luks
Suraleuska, n.d.
(possibly c. 1925–27)
Oil on canvas
20 × 16 in.
(50.8 × 40.64 cm)
New Britain Museum
of American Art,
gift of Olga H. Knoepke
1996.13

George Luks
Pam, 1929
Oil on panel
31 × 23 in.
(78.74 × 58.4 cm)
New Britain Museum
of American Art,
gift of Olga H. Knoepke
1992.38

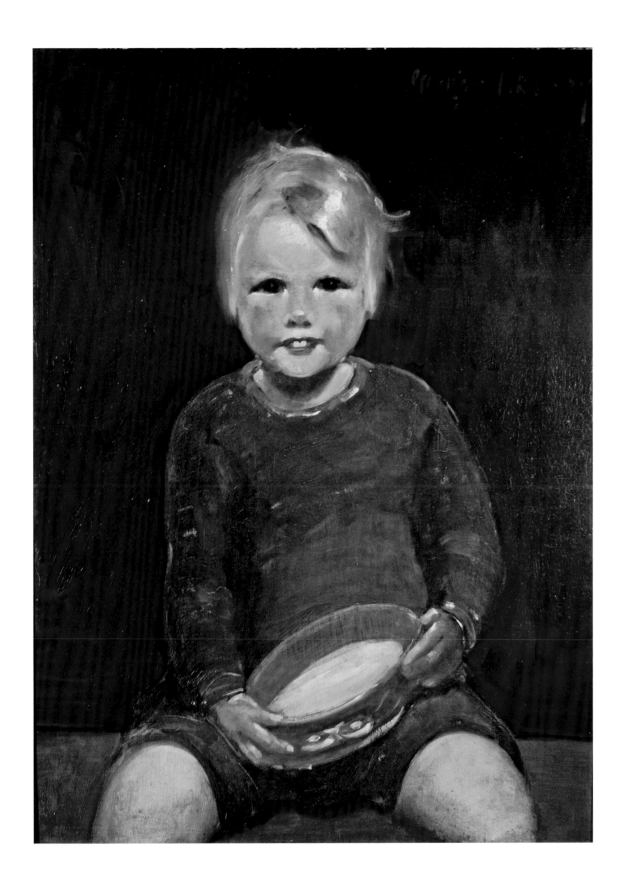

George Luks
City on River, c. 1921–27
Watercolor on paper
13½ × 19¼ in.
(34.3 × 48.9 cm)
New Britain Museum
of American Art,
gift of Olga H. Knoepke
1992.25

George Luks
Sunset, c. 1928–32
Watercolor on paper
14½ × 18 in.
(36.2 × 45.72 cm)
New Britain Museum
of American Art,
gift of Olga H. Knoepke
1992.26

FIG. 24
George Luks
Maurice B.
Prendergast, c. 1904
Graphite pencil
on paper
10 × 6¾ in.
(25.4 × 17.15 cm)
Whitney Museum of
American Art, New York;
gift of Mr. and Mrs.
Edward W. Root, 42.38

Prendergast

Maurice B. Prendergast: The Modern Spirit

Elizabeth Kennedy

Prendergast, whose pictures are often laughed at, [the pictures] are to me the most refined of decorations
— George Bellows, 1910[1]

DURING HIS FINAL ILLNESS, in December 1923, Maurice B. Prendergast (1858–1924) was cheered to learn that the Corcoran Gallery of Art had awarded him the William A. Clark Prize for his painting *Landscape with Figures* (fig. 25), which it subsequently purchased.[2] The artist had the satisfaction of knowing that, finally, a significant painting by him was in the collection of a major American art museum.[3] On hearing the news the artist, his good humor still intact, quipped, "I'm glad they've found out I am not crazy, anyway."[4] There is a bittersweet irony in this staunchly independent artist, who promoted the "no jury, no prizes" ideal for group exhibitions, realizing professional affirmation through a prestigious award from an establishment institution.

His ability to work compromised in his last year; Prendergast had time to reflect on his more than thirty years as an artist. Visits from his devoted brother Charles and his many friends no doubt led to reminiscing about his exciting transatlantic experiences—his introduction to a larger art world at age thirty-two during his belated student years in Paris, his visually enriching journeys to Italy, and, in the first decade of the new century, his pivotal return to Paris in his search for a "new impulse" to stir his creative juices. Did he recall feelings of trepidation in submitting new work to exhibitions now recognized as landmark events that brought him important critical exposure? Chuckles over the sensational press coverage of The Eight's 1908 show at Macbeth Galleries reminded him that his friendships with those artists were decisive in his involvement in numerous other exhibitions of "independent artists."

The distinct character of Prendergast's style and the disparate nature of his oeuvre have long made it difficult to relate his art to that of fellow members of The Eight and even to the history of American art because of the tendency to equate these artists only with urban realism, in particular under the restrictive and frequently misapplied label of "Ashcan school." The purpose of this essay is to delve into the critical fortunes of Prendergast's reputation as it relates to his association with The Eight. When the artists organizing the 1908 exhibition discussed who should fill the remaining gallery space, numerous New York artists whose work focused on modern city life were mentioned as likely candidates—for example Jerome Myers, whose art ultimately

was judged too sentimental, and Robert Henri's protégé George Bellows, who was thought too young.[5] Urban realism was not Prendergast's theme, except in the most casual sense of observing crowds in public places. More notable was the older artist's original aesthetic mode: he fit perfectly the group's ideology of artistic freedom because his style was both uniquely individual and strikingly modernist. In an early press release, the artists frankly expressed their intentions: "We've come together because we are so unalike ... and believe above all that art of any kind is an expression of individual ideas of life."[6]

Prendergast made his critical debut in New York in March of 1900 with a solo show at Macbeth Galleries, receiving excellent reviews. The Boston artist's sparkling watercolor masterworks,

produced during the previous eighteen months in Italy, were shown with his delicately colored monotypes. Exhibited in Boston, Chicago, and New York, such exquisite Italian watercolors as *The Grand Canal, Venice* (fig. 26) were much admired for their fresh approach to portraying contemporary Venetian scenes peopled with locals and tourists. Remarkably, the artist prized equally his watercolors and his monotypes or "colored prints" as he referred to them, and he exhibited them together regularly from 1895 to 1902. The colored monotypes are altogether original artistic achievements, exemplifying a Whisterlian mode in *At the Seashore* (page 121) and a Japanese accent in *The Breezy Common* (page 122).

The well-received Macbeth Galleries show enhanced Prendergast's artistic standing in New

York, and thereafter the Boston artist began to spend more time in the city, working and socializing with Arthur B. Davies, William Glackens, Henri, and George Luks.[7] In January of 1904, he participated in an exhibition organized by Henri at New York's National Arts Club that included Davies, Glackens, Luks, and John Sloan. Prendergast boldly sent several small oil paintings on panels, entitled *Promenade on the Seashore Nos. 1, 2, 3, 4, 5, 6*, and *7* (all unlocated), which were vastly different from his popular Venetian watercolors. *The New York Times* traditionalist critic Charles de Kay's comments were unexpectedly positive: "His spotty little pictures reveal a sense for color schemes that is very uncommon … and are appreciated by those who know pictures too well to put a great deal of weight on 'finish.'"[8] Prendergast's New York colleagues were less tepid in their enthusiasm for his brightly hued sketches, and in May of 1907—the same month he sailed to France for a return visit after almost twelve years—they invited him to participate in their self-organized show.

In the first decade of the new century, Prendergast was evaluating his artistic process. By 1902 he had entirely stopped making monotypes; although watercolor continued to be a significant medium within his artistic oeuvre, oil painting increasingly became his most expressive mode. During his student days in France, Prendergast had exploited the spontaneity of sketches painted on small wooden panels, or pochades, and he returned to this medium for his experiments in manipulating space and simplifying form, although he stopped short of total abstraction. Over time the boldly colored canvases became larger and their surfaces more densely covered with his flowing brushwork. *Evening on a Pleasure Boat* (page 123), one of his earliest oil canvases, is an urban scene but there is nothing realist about its approach. Seen at dusk, the row of faceless girls and their

chaperone—more dresses and hats than human forms—are rendered by expressive, fluid strokes. The figures are firmly positioned against a well-defined grid of poles, woven fence, and wooden decking, in contrast to the hazy portrayal of the cityscape in the background. The simplification of forms, the compressed space of the foreground, the atmospheric background arranged in a tripartite vertical layering all are elements that the artist had employed earlier in his monotypes.

In the wake of his visit to Italy, Prendergast adopted the brighter hues of his new watercolors in his oil paintings, discernable in one of his breakthrough pictures, *Salem Willows* (page 124). It offers a felicitous comparison with the watercolor *Beechmont* (page 113), as they date from about the same time: both depict a favorite theme of leisure at the seashore and, notwithstanding their appearance of spontaneity,

FIG. 26
Maurice B. Prendergast
The Grand Canal, Venice, c. 1898
Watercolor and graphite on paper
18⅛ × 14¼ in.
(46 × 36.2 cm)
Terra Foundation for American Art, Daniel J. Terra Collection, 1999.123

both emphatically demonstrate that Prendergast's art-making was anything but impulsive. Paradoxically, he achieved in watercolor a particular quality of iridescent light by applying the medium precisely and judiciously, leaving portions of the white paper untouched in order to brighten the final picture. In oil painting, in contrast, he applied colors just as carefully but in layers to attain the desired shimmering effect. *Beechmont's* delightfully fresh color seems to be the primary achievement of the watercolor, while its figures' awkward scale and pert facial features are somewhat discordant despite their delicately nuanced suggestion of movement. *Salem Willows*, which shows an affinity with *The Fete* of 1905, an unlocated work reproduced in the brochure for the Macbeth Galleries exhibition, reveals a master colorist in pigments and offers insights into the artist's style prior to his seminal sojourn in France in 1907.[9] In these early compositions the foregrounds are peopled by dozens of clearly outlined female figures that emphasize spatial recession in a non-narrative scene of a park enveloped in color and light. After 1908, Prendergast began to experiment with a distinctive surface pattern, often referred to as his tapestry style and seen in *Salem* (page 126), his later rendering of the popular park setting in

which the figures, still clearly females in colorful dresses, are abstracted versions of their former selves. Although design and color were always harmoniously balanced in Prendergast's early paintings, his mid-career works were described as "decorative" when an identifiable subject was dissolved in broken brushstrokes juxtaposed with dabs of pure color to indicate form. The term "decorative," as used by Bellows in the epigram, became a positive critical expression for the ultramodern art that Roger Fry would label post-impressionism in 1910.[10]

In Paris, Prendergast's viewing of several important contemporary art shows, especially a Paul Cézanne retrospective and a separate watercolor show, affirmed his own developing artistic vocabulary of decorative surface arrangements of bolder color and flowing forms in non-naturalistic compositions, created by both dabs of pure pigment and broad though often broken brushstrokes. Returning from Paris just four months before the opening of the Macbeth Galleries exhibition, Prendergast was eager to present his latest work. Displayed along with six other paintings, his series of eight small oil panels inspired by the beach at St. Malo demonstrated his affinity with international post-impressionist styles. In these works, it seemed, modernism had arrived in New York in an American mode.

The sarcastic reaction to Prendergast's entries from *The Globe's* conservative critic Arthur Hoeber is memorable: "Hung in a group, these canvases of Mr. Prendergast look for all the world like an explosion in a color factory."[11] Art critic de Kay, previously somewhat sympathetic to Prendergast's colorful pochades, was scathing in his review: "As for Prendergast, his work is unadulterated artistic slop" De Kay's disdain for the urban realism in the show was expressed in the equally dismissive comment that "Vulgarity smites one in the face at this exhibition"[12] Intentionally or not, de Kay's remarks were "vulgar" as well. "Slop" might have been

Maurice B. Prendergast
Beechmont, 1900–05
Watercolor on paper
19⅛ × 12¾ in.
(48.57 × 32.4 cm)
New Britain Museum
of American Art,
Harriet Russell Stanley
Fund, 1944.01

appropriate for Luks's portrait of pigs, but using the word to describe Prendergast's colorful and freely painted oil panels identified as "studies" seems strange. An examination of *Study St. Malo, No. 32* (fig. 27), for example, reveals a recognizable subject in the sketch, sufficient to be admired in its "unfinished" state for those "who know art too well," as the critic had previously remarked. De Kay was apparently frustrated by his lack of vocabulary to describe non-narrative and anti-naturalist art, and for the disgruntled critic, Prendergast was "guilty by association" for exhibiting with the urban realists prominent among The Eight. Another critic bluntly assessed Prendergast's art as impenetrable: in asserting that "the exhibition would be stronger if it were the show of 'the seven' rather than 'the eight,'" he implied that the works by the Boston artist were the most difficult to understand. Nevertheless, he stated contradictorily,

the show "is well worth while from any point of view, and just as it is. It represents originality, and native, instinctive power. There are ideas to burn here."[13] Whatever the limitations of the writer's appreciation of Prendergast's works, he recognized the significance of the group's exhibition as a showcase of diverse approaches to making art—art that was breaking the rules as they were known in New York.

William Macbeth had a high tolerance for the unconventional and believed a market and an audience existed for American art; he presented solo shows for Davies, Henri, and Prendergast before 1908.[14] His remarks in *Art Notes*, the gallery's newsletter, give no indication that he was consciously attempting to foster a revolution when he agreed to host this group exhibition of eight artists with diverse styles. The press, however, was delighted to sensationalize the event, peppering their reviews with pithy quotes

supplied by Henri, the spokesman for the artists dubbed The Eight by newsmen. Opening day was extraordinary, with an unbelievable three hundred people an hour crowding into the galleries, from society folks to curious citizens who had never before seen an art exhibition. Gertrude Vanderbilt Whitney bought four of the seven works sold: Henri, Lawson, Luks, and Shinn were the fortunate artists to receive her patronage. Whitney would eventually buy more works by Sloan and Glackens during their lifetimes, but she never purchased a work by Prendergast.

Prendergast continued to contribute to New York shows—the 1910 *Exhibition of Independent Artists* and *An Independent Exhibition of the Paintings and Drawings of Twelve Men* in 1911—and he thereby maintained his association with his progressive artist friends. Although he continued to reside in Boston, he was very much a part of the New York art scene. Thus it is not surprising that he was invited to join the Association of American Painters and Sculptors, the group that organized the Armory Show. Moreover, he was the only artist asked to participate in both the Domestic and the Foreign Exhibit committees of the exhibition, for more than any other mature American artist he was thoroughly transatlantic in his outlook. Evidently the organizers of the Armory Show, who included several of his associates among The Eight, admired Prendergast's recent work, and they selected one of his most daring pictures, *Seashore* (c. 1910–12; unlocated), an idyllic beach bathing scene, to reproduce as a postcard.[15] The inclusion of female nudes in his interpretations of his quintessential subject, figures promenading along a beach, indicated a new direction in his art. *Picnic by the Sea* (page 127) pictures a similar subject of women in a frieze-like arrangement preparing for sea-bathing, but it is a far more demure depiction with only three unclothed females. Noticeable is a partially drawn ghost-like figure that is frequently found in the artist's late canvases. As long as an oil painting remained in Prendergast's studio, it was susceptible to the artist's additional manipulations of the surface until he thought the picture finished. If viewers were confused by ghostly figures or equally disturbing patches of bare canvas, the artist was sanguine that his pictures would be appealing just as they were.

The 1913 Armory Show was a career-enhancing event for Prendergast; he was the only member of The Eight whose critical reception grew more favorable in its immediate aftermath. Amidst the exhaustive array of art shown at the exhibition, and especially in comparison with the works of the most avant-garde European artists, the post-impressionist style of the quirky American colorist no longer seemed so bizarre. Suddenly, new patrons were seeking Prendergast out. New York journalist Edward W. Root purchased *Landscape with Figures* (fig. 28) from the exhibition and lent it to the Metropolitan Museum of Art, where it was displayed from 1919 to 1928, to the consternation of some trustees.[16] Following the Armory Show, Prendergast's star continued to rise as he became one of the most sought-after modernist painters in America. After his years of mid-career struggle, it must have been thrilling, if not unsettling, to have America's most prominent collectors of European avant-garde art calling at his studio. Lillie Bliss, Ferdinand Howald, Duncan Phillips, John Quinn, and Alfred C. Barnes began seriously to collect large numbers of his paintings. A year after the Armory Show, the artist was given a solo exhibition at Carroll Galleries, an art gallery backed by Quinn, where sixty of his works from all phases of his career were shown. Tellingly, Prendergast was uncomfortable with the numerous sales and later complained, "I really felt ashamed. It didn't seem like art; it seemed more like a business."[17]

Although commercially successful beyond his expectations, Prendergast did not live to see his oil paintings appreciated except by the most advanced lovers of modern art. The Metropolitan Museum of Art refused to host a Prendergast memorial retrospective after his death in 1924, disappointing his patrons and artist friends. Some speculated that disgruntled trustees were not willing to sully their galleries with more incomprehensible modern art after the museum's disastrous first modern art exhibition in 1921, which had been pressed upon them by Bliss and Quinn; then, the public had been outraged by a show entitled "Impressionism and Post-Impressionism," featuring works that many in the art world already considered modern masterpieces and that were several decades old.[18] Apparently, the most advanced modern American art was not going to enter the Metropolitan Museum any time soon; several years later, however, the museum held memorial retrospectives for Davies (in 1930) and Henri (in 1931). With the founding of the Whitney Museum of American Art and the Museum of Modern Art in 1929 and 1931 respectively, twentieth-century art would finally be showcased in New York museums.

Prendergast's first New York memorial exhibition was held in 1934, ten years after his death, at the Whitney Museum of American Art. Four year earlier, before the museum officially opened, director Juliana Force began acquiring art by Prendergast and others to augment Gertrude Whitney's personal collection, in which the rest of The Eight were well represented.[19] In 1931 the Museum of Modern Art lost an anticipated major Prendergast donation when most of the twenty-six works owned by Bliss, one of the museum's founders, remained in the family after the collector's death. Other Prendergast pictures in private holdings did find their way into museum collections, notably through the auction sale of modern paintings owned

by Quinn in 1927, three years after his death. Outside New York, Prendergast's pictures were displayed in Philadelphia at the private museum created by the Barnes Foundation in 1922 and in Washington, D.C., at the Phillips Collection beginning in 1921, but their accessibility was limited. The Columbus Museum of Art in Ohio profited immensely from the bequest of Howald's modern art collection in 1931, including exceptional Prendergast paintings. Surprisingly, the first museum to hold a Prendergast memorial retrospective was the Cleveland Museum of Art, in 1926; the artist's hometown of Boston did not celebrate the art of this native son until the centenary of his birth in 1960.

A modernist whose art was once dismissed as "artistic slop," Prendergast was among the very first to embrace the "new American modernism," characterized by art historian Patricia Hills as a retreat into "the detached world of formal aesthetic relationships or into [an] individual emotional response to color."[20] Yet Prendergast's irrevocable association with The Eight left him stylistically isolated in genealogies of modern art, such as those created by Arthur B. Davies in 1913 (see Orcutt essay) and by painter Ad Reinhardt in 1946 (fig. 29), which attempted to rationalize the influence of past art and contemporary associations on modern styles. Critic Margaret Breuning's 1950 review of an exhibition at Kraushaar Galleries suggests a reason for the dimming of Prendergast's reputation after the halcyon days of the 1930s: "The fact that his genius was so independent, depending on no influence and foreign school, may account for much of the neglect that his work has suffered, for it appears that only if an artist can be neatly fitted into a movement, is his oeuvre worth serious consideration."[21] Yet as early as the Armory Show, critics had referred to European influences in Prendergast's art and Walter Pach considered him "the first American to appreciate Cézanne."[22] Ironically, Prendergast's

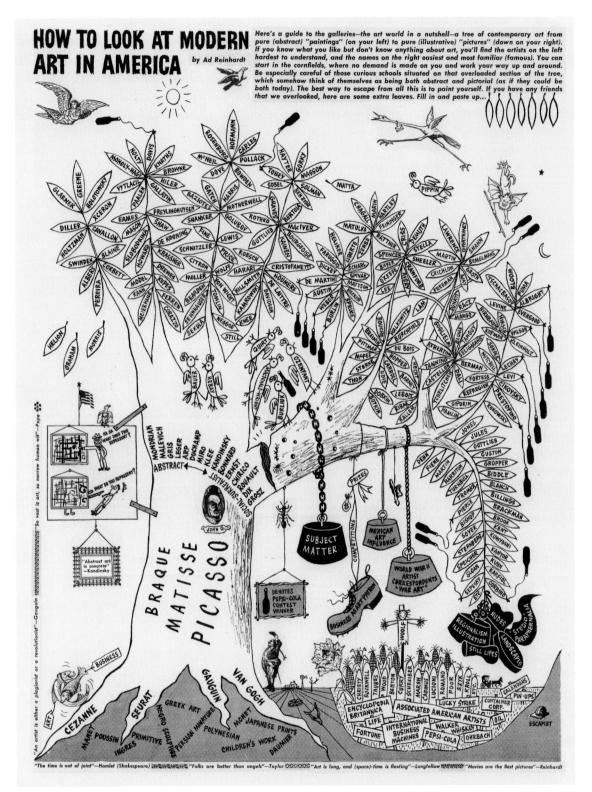

FIG. 29
Ad Reinhardt
(1913–1967)
"How to Look at
Modern Art in
America," illustrated
in *PM, Inc.*, 1946

evident transatlantic musings, embodied in the expressive reduction of representation in his pastoral landscapes, contributed to his marginalization in the history of American art, for they conflicted with an erroneous view that The Eight essentially were focused more on social content than on stylistic expression in their art. His belated link to the Whitney Museum and its promotion of an indigenous history of American art, in opposition to the European-dominated stylistic lineage of modern art codified by the Museum of Modern Art, further perpetuated his unaligned status in the canonical view of the development of early American modernism. As the history of avant-garde art in America is re-diagramed, Prendergast deserves a position on the branch dedicated to pioneers in ultramodern American art.

Elizabeth Kennedy is the Curator of Collection at the Terra Foundation for American Art in Chicago.

It is an honor to join the legendary scholars who have so thoroughly investigated Maurice B. Prendergast's biography and so passionately considered his stylistic evolution, especially Nancy Mowll Mathews, whose insights have been invaluable to me. On a more prosaic level, my colleagues Wendy Greenhouse and Ariane Westin-MaCaw have earned my endless gratitude for their timely and cheerfully offered expertise in the preparation of this essay.

1 George Bellows to Joseph Taylor, April 20, 1910, quoted in Richard J. Wattenmaker, *Maurice Prendergast* (New York: Harry N. Abrams, 1994), 103.

2 Prendergast's only other prize was a bronze medal at the 1901 Pan-American Exposition in Buffalo, New York, for a watercolor entitled *The Stony Beach*, possibly the work now known as *The Stony Beach, Ogunquit* (private collection); see Carol Clark, Nancy Mowll Mathews, and Gwendolyn Owens, *Maurice Brazil Prendergast, Charles Prendergast: A Catalogue Raisonné* (Munich: Prestel, 1990), CR 649.

3 The first Prendergast work to enter a museum collection was one of his well-received monotypes, *The Ships*, c. 1895–97 (Clark, Mathews, and Owen, *Maurice Brazil Prendergast, Charles Prendergast: A Catalogue Raisonné*, CR 1676), which was donated to the Memorial Art Gallery of the University of Rochester by Emily Sibley Watson in 1919.

4 Prendergast quoted in William M. Milliken, "Maurice Prendergast, American Artist," *The Arts* 9 (April 1926): 192, cited in Nancy Mowll Mathews, *Maurice Prendergast* (Munich: Prestel 1990), 37.

5 For a discussion of the selection of the artists for the Macbeth show, see John Loughery, *John Sloan: Painter and Rebel* (New York: H. Holt, 1995), 117.

6 Henri quoted in "Eight Independent Painters to Give an Exhibition of Their Own Next Winter," *New York Sun*, May 15, 1907, cited in Bennard B. Perlman, *Painters of the Ashcan School: The Immortal Eight* (New York: Dover Publications, 1979), 155.

7 Prendergast appears to have met Henri and Glackens in Paris sometime in 1894 through their mutual friend, Canadian artist James Wilson Morrice. His relationship with Davies began by the time of his 1900 Macbeth Galleries show, if not earlier. In short, Prendergast was well known to the core members of what became The Eight when they considered asking him to join their first group exhibition.

8 Charles de Kay, "Six Impressionists: Startling Works by Red-Hot American Painters," *New York Times*, January 20, 1904, cited in Wattenmaker, *Maurice Prendergast*, 170.

9 The brochure the artists produced to accompany the Macbeth show is reproduced in Perlman, 157–73. Prendergast is the fourth artist in the booklet, as his works were the last to be viewed in the first gallery. His entries, numbers 20 through 26, constituted the largest group in the show, although only sixteen of the seventeen listed works were actually exhibited. Eight of the works were oil on panel and shared the title *Study St. Malo* (fig. 27). The Maurice and Charles Prendergast catalogue raisonné lists one of the paintings in the Macbeth show as *The Fete* [sic], although there is no work with that title in the brochure, Clark, Mathews, and Owen, *Maurice Brazil Prendergast, Charles Prendergast: A Catalogue Raisonné*, CR 47

10 In London in 1910, historian and critic Roger Fry coined the word "post-impressionism" as a descriptive explanation for the symbolic and expressive use of color in works of art by Cézanne, Paul Gauguin, and Vincent Van Gogh.

11 Arthur Hoeber, "Art and Artists," *New York Globe and Commercial Advertiser*, February 5, 1908, quoted in Wattenmaker, *Maurice Prendergast*, 95.

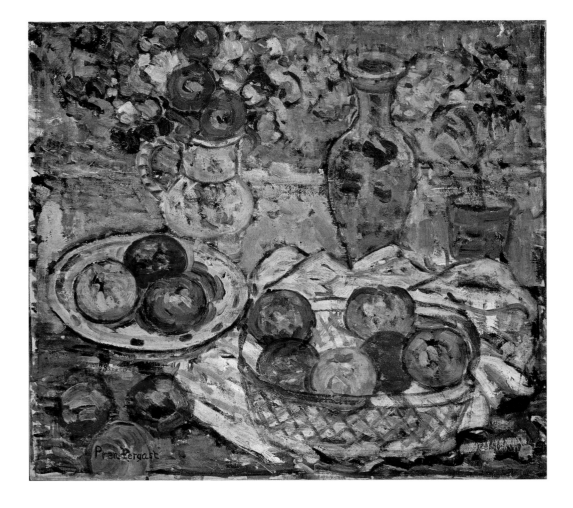

Maurice B. Prendergast
***Still Life with Apples
and Vase,*** c. 1910–13
Oil on canvas
19⅞ × 22¾ in.
(50.5 × 57.8 cm)
Terra Foundation for
American Art, Daniel J.
Terra Collection, 1999.122

12 Charles de Kay, "Brooklyn Revives Memories of The Eight," *Art Digest* 18 (December 1, 1943): 12, quoted in Perlman, *Painters of the Ashcan School*, 180.

13 Joseph E. Chamberlain, "Two Significant Exhibitions," *New York Evening Mail*, February 4, 1908, quoted in Wattenmaker, *Maurice Prendergast*, 95–6.

14 Gwendolyn Owens, "Art and Commerce," in Elizabeth Milroy, *Paintings of a New Century: The Eight and American Art* (Milwaukee: Milwaukee Museum of Art, 1991), 61–86.

15 The postcard of *Seashore* is reproduced in Clark, Mathews, and Owen, *Maurice Brazil Prendergast, Charles Prendergast: A Catalogue Raisonné*, CR 368. Prendergast exhibited three paintings and four watercolors in the Armory Show (nos. 893–899).

16 Wattenmaker, *Maurice Prendergast*, 111.

17 Prendergast quoted in Joseph Coburn Smith, *Charles Hovey Pepper* (Portland, ME: The Southworth-Anthoensen Press, 1945), 42, cited Mathews, *Maurice Prendergast*, 34.

18 For a comparative history of the two controversial 1921 modern art exhibitions, one at the Pennsylvania Academy of the Fine Arts and the other at the Metropolitan Museum of Art, see Sylvia Yount, "Rocking the Cradle of Liberty," *To Be Modern: American Encounters with Cézanne and Company* (Philadelphia: University of Pennsylvania Press, 1996), 9–25.

19 For the Whitney Museum of American Art's history of collecting Prendergast's works, see Patterson Sims, *Maurice B. Prendergast: A Concentration of Works from the Permanent Collection* (New York: Whitney Museum of American Art, 1980), and Avis Berman, *Rebels on Eighth Street: Juliana Force and the Whitney Museum of American Art* (New York: Atheneum, 1990).

20 Patricia Hills, *Turn-of-the-Century America: Paintings, Graphics, Photographs, 1890–1910* (New York: Whitney Museum of American Art, 1977), 173.

21 Margaret Breuning quoted in Ellen Mary Glavin, "Maurice Prendergast: The Development of An American Post-Impressionist, 1900–1915" (PhD diss., Boston University, 1988), 189.

22 Walter Pach, *Queer Thing, Painting: Forty Years in the World of Art* (New York: Harper & Brothers, 1938), 224, quoted in Mathews, *Maurice Prendergast*, 24.

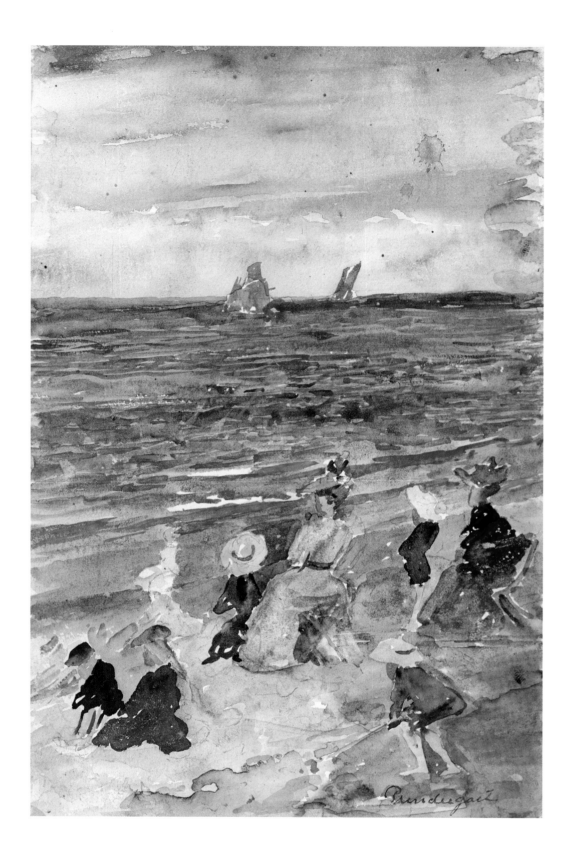

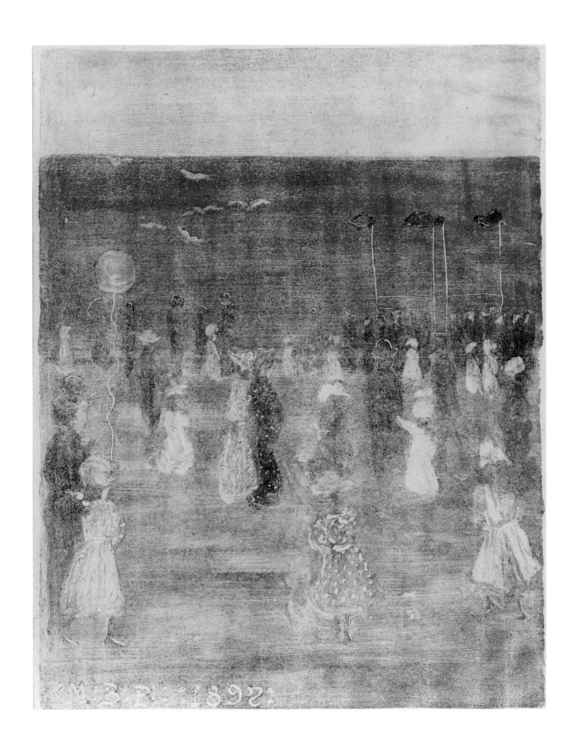

Maurice B. Prendergast
Brittany Coast
c. 1892–95
Watercolor on paper
10 × 6⅞ in.
(25.4 × 17.46 cm)
New Britain Museum
of American Art,
Harriet Russell Stanley
Fund, 1947.01

Maurice B. Prendergast
At the Seashore, 1895
Monotype on cream
Japanese paper
7¹¹⁄₁₆ × 5¹⁵⁄₁₆ in.
(19.5 × 15.1 cm)
Terra Foundation for
American Art, Daniel J.
Terra Collection, 1992.69

Maurice B. Prendergast
The Breezy Common
c. 1895–97
Monotype with graphic
additions on cream
Japanese paper
7 × 8¹⁵⁄₁₆ in.
(17.8 x 22.7 cm)
Terra Foundation for
American Art, Daniel J.
Terra Collection, 1992.73

Maurice B. Prendergast
Evening on a
Pleasure Boat, 1895–97
Oil on canvas
14⅜ × 22⅛ in.
(36.5 × 56.2 cm)
Terra Foundation for
American Art, Daniel J.
Terra Collection, 1999.110

Maurice B. Prendergast
Salem Willows, 1904
Oil on canvas
26¼ × 34¼ in.
(66.7 × 87 cm)
Terra Foundation for
American Art, Daniel J.
Terra Collection, 1999.120

Maurice B. Prendergast
St. Malo, after 1907
Watercolor and graphite
on paper
15⅛ × 22 in.
(38.4 × 55.88 cm)
Terra Foundation for
American Art, Daniel J.
Terra Collection, 1999.121

Maurice B. Prendergast
Salem, 1913–15
Oil on canvas
14¼ × 18¼ in.
(36.2 × 46.35 cm)
New Britain Museum
of American Art,
Harriet Russell Stanley
Fund, 1944.15

Maurice B. Prendergast
Picnic by the Sea
1913–15
Oil on canvas
23 × 32 in.
(58.4 × 81.3 cm)
Milwaukee Art Museum,
gift of the Donald B. Abert
Family in His Memory,
by exchange, M1986.49

FIG. 30
Everett Shinn
Self-Portrait, 1901
Pastel on blue paper
14 × 10¹⁄₁₆ in.
(35.6 × 25.5 cm)
National Portrait Gallery,
Smithsonian Institution
NPG.78.219

Shinn

Everett Shinn's Time Warp

Leo G. Mazow

In early 1975, carpenters, electricians, and contractors worked hurriedly to prepare the Belasco Theater for the Broadway opening of *The Rocky Horror Picture Show*. Massive renovations were needed for the aging building at 111 West Forty-fourth Street to meet the opening date of March 6. The installation of up-to-code wiring and air conditioning ducts was required, and this meant puncturing and otherwise defiling two of the remaining six of an original fourteen mural panels by Everett Shinn (1876–1953). Only a month or so earlier, the first biography of the artist had been published. When the Belasco's transformation was reported in *The New York Times*, the biography's author, Edith DeShazo, weighed in, offering that the damaged mural represented "not so much an artistic loss as a loss from a historical point of view." In this she echoed the newspaper story itself, which stated that the two murals to be lost to the ductwork "are mostly allegorical nudes in a vague Fragonard-Boucher style, [and] are not considered to be his best work" (figs. 31, 32). After all, she continued, "they were obviously included more as interior decoration than art."[1] In Shinn's lifetime, faced with his wildly divergent artistic output, critics all too often resorted to the faint, if not damning, praise of characterizing him as "the versatile artist."[2]

Migrating from early realist pastels and theater scenes to increasing numbers of decorative commissions and finally a return to a realism offset by neo-rococo sensibilities, Shinn remains difficult to classify.

This may account in part for his biographer's negative assessment of the Belasco murals. As the musical about to stage its American debut would make startlingly clear, however, the lines between artistic and decorative, between culture and camp, are notoriously slippery ones. The 1906–07 Belasco project marked only one of the first of several commercial and residential mural and interior design projects—in an eclectic style alternating between rococo, academic, and popular contemporary references—that occupied Shinn for much of the first half of the twentieth century. Typifying the trend are Shinn's decorations for the George H. Townsend House on Long Island of circa 1920–22. He painted the door of Townsend's "Italian Dining Room" with a *horror vacui* clutter of draperies over a balustrade, topped by two couples in heavy theatrical garb, flanked by overflowing fruit and flowers; to the right of center a clown-like figure repeats with his elongated limbs the contrived courtly gestures of the couples; above him, amid the garlands and statuary, two putti support a cartouche bearing a neoclassical profile (fig. 33).[3]

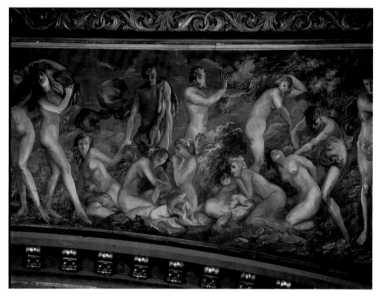

and the soft pastel studies for them, critics dubbed Shinn a neo-rococo artist. In 1905, he painted dramatist Clyde Fitch's Steinway grand piano with fête-champêtre scenery for his so-called Louis XIV room, and in so doing, according to one observer, "announce[d] himself as a disciple of Watteau, Fragonard and Boucher."[5] The same year, critic Henri Pène du Bois titled a story on the artist "A Fragonard of the Present Time."[6] But what passed as a compliment in some quarters was surely seen as pejorative in others, especially as the century wore on. As art historian Melissa Hyde and others have amply documented, the equation of rococo with levity, licentiousness, and anti-intellectual fluffiness has followed the term since its inception, and to this day rococo is often misleadingly typed as immoral and frivolous.[7]

In stark contrast, the style and subjects of the work for which Shinn first gained acclaim at the turn of the twentieth century, and which remain his chief contribution in the canon of modern art, stand at considerable distance from this oversimplified definition of rococo. The Shinn familiar to modern audiences is not likely to be compared to Watteau. In countless early pastels of New York and Paris, he depicted individuals huddled around ashcans for warmth on winter nights, gathered atop tenement roofs, aimlessly stirring about docks, and in other compromised situations. His early work as a newspaper illustrator joined artist Robert Henri's mentoring in impressing upon Shinn the value of the vernacular. Works like his *Theater Scene* (page 133) and *Paris Street No. 2* (page 139) partake of a new democratized conception of subject matter. An early reviewer enumerated Shinn's repertoire of subjects: "The artist in him was stirred at the spectacle of the busy shopping crowds, the dismal gaiety of the music halls excited his imagination, the sordid cheer of remoter dives, the bustle of the docks by day and the haggard faces of the streets at night."[8]

A similar aesthetic characterizes the panels Shinn produced for the Warren M. Salisbury house built in the 1930s in Pittsfield, Massachusetts, which, according to *The Philadelphia Inquirer*, were "inspired by the Fetes Champetres of the Court of Louis XV."[4] Largely on the strength of his murals, his interior decorations,

Shinn's 1899 watercolor and pastel *Spoiling for a Fight, New York Docks* (page 138) exemplifies the urban realism of his early work and foreshadows well over a decade of images that are frequently called Ashcan art. With its rough-and-tumble subject matter as well as its generalized modeling of form and sketchy network of lines, the drawing recalls much of his early newspaper work. Part of the pathos and seediness of this image lay in Shinn's very choice of subject matter. Industrial waterfronts recur in early works by Shinn, William Glackens, and others and, as scholars have noted, the docks were known in some quarters as places for men seeking same-sex encounters.[9] *Spoiling for a Fight* indeed matches the observations of reviewers who marveled at Shinn's "massed humanity and realism."[10]

In *Paris Street No. 2* (page 139), our attention is drawn both to the drab snow-covered cityscape and to the animal trudging along, head down as it strains to move the carriage whose inhabitants are out of view. By asking us to imagine the world as seen and felt by a horse — rushing by, an onward blur — Shinn emphasizes the realm of experience within the anonymous, modern labyrinth of the city. But more than this, we are asked to put ourselves in someone else's shoes, so to speak, to see how *that* feels. Shinn was one among several late nineteenth- and early twentieth-century urban realists who enlisted animal imagery in an effort to depict the experience and not just the appearance of the city. Cats figure yet more frequently in this strategy than do horses and, as Shinn's 1901 *Early Morning, Paris* (fig. 34) demonstrates, they help to emphasize the human subject's squalor and vulnerability. The drawing was first exhibited with the title *The Tired City*, and the arched backs of cat and human being suggest drudgery-induced fatigue in both.[11]

As a sort of analogue to *Paris Street No. 2* and *Early Morning, Paris*, Hart Crane's 1921

poem "Chaplinesque" illuminates the Ashcan pattern of using a fragile feline surrogate for the human subject. Crane's lines also count among the first examples in prose or poetry to enlist "ashcan" as a metaphor. Meaning and wholeness can be found, Crane writes, even in a "world" in which we find "a famished kitten on the steps" of some safe structure where the animal is sequestered:

> The game enforces smirks;
> but we have seen
> The moon in lonely alleys make
> A grail of laughter of an empty ash can,
> And through all sound of gaiety and quest
> Have heard a kitten in the wilderness.[12]

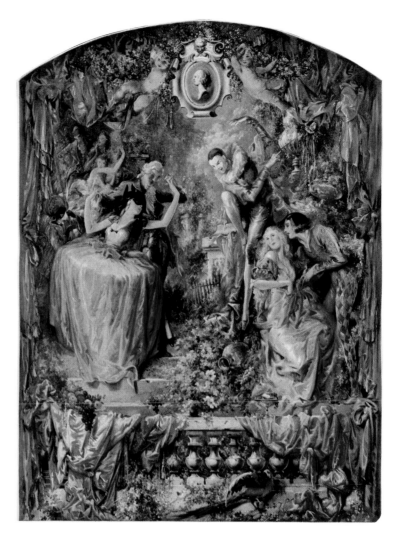

FIG. 33
Everett Shinn
Painted Door in Italian Dining Room, Townsend House, New York
c. 1920–22
Courtesy of Smithsonian Institution Libraries, Washington, DC

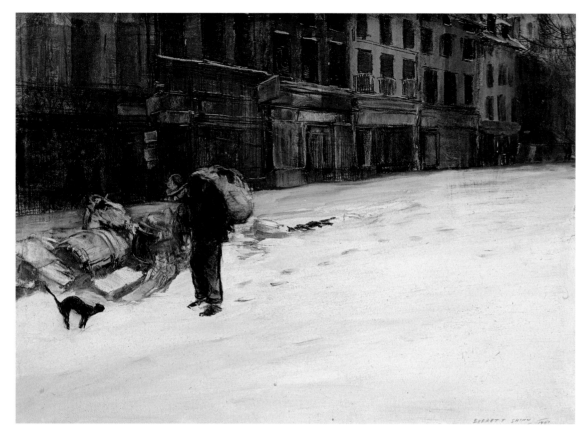

For Shinn, finding and giving voice to the kitten in that modern wilderness was part of the Ashcan mission. *Paris Street No. 2* makes clear the impenetrability of zones: the mercilessly laboring horse braving the inclement weather juxtaposed with the safe shelter and leisure suggested by the off-limits carriage interior. The suffering subject—not the official "gaiety and quest" of some "official" culture—is his concern.

One might reasonably ask how the artist who gave us gritty modernist engagement in paint and pastel could also create quasi-rococo decorative panels? In accounting for this contrast, it is worth noting that Shinn early on worked in both styles simultaneously. His first commercial mural project, the Belasco Theater panels with their elongated nymphs and garish coloring, date to 1906. Even before that, he was busy working on myriad interior design projects with dramatist

Clyde Fitch and decorator and trendsetter Elsie De Wolf, who formed part of a transatlantic salon in which Shinn was active.[13] The salon brought Shinn into contact as well with Stanford White, David Belasco, and De Wolfe's partner Elisabeth Marbury, and as a result several commercial and residential commissions came his way. Shinn, that is, was flexing his decorative muscle well before the 1908 exhibition of The Eight outed him as a rebel. Finding his niche—and his income—decorating for purveyors of the official culture that Crane had dubbed "gaiety and quest," Shinn was probably never quite the rebel that his Ashcan brethren were.

Shinn was sensitive to the accusation that he had left art behind for utilitarian pursuits, and he found in Watteau a legitimization of his increasing activity as a decorator. "Why shouldn't real artists paint signs?" he proposed in the early

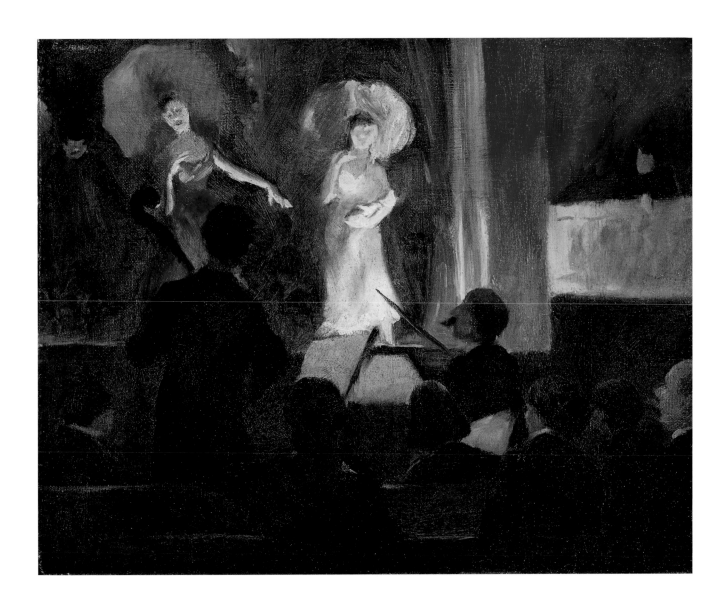

Everett Shinn
Theater Scene, 1903
Oil on canvas
12¾ × 15½ in.
(32.4 × 39.4 cm)
Terra Foundation for
American Art, Daniel J.
Terra Collection, 1999.136

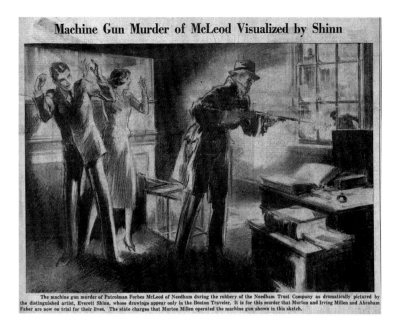

Machine Gun Murder of McLeod Visualized by Shinn

The machine gun murder of Patrolman Forbes McLeod of Needham during the robbery of the Needham Trust Company as dramatically pictured by the distinguished artist, Everett Shinn, whose drawings appear only in the Boston Traveler. It is for this murder that Murton and Irving Millen and Abraham Faber are now on trial for their lives. The state charges that Murton Millen operated the machine gun shown in this sketch.

FIG. 35
Everett Shinn
**Machine Gun Murder
of McLeod Visualized
by Shinn,** 1934
Boston Traveler
8⅝ × 10⅝ in.
(22 × 27 cm)
Courtesy of the Everett
Shinn collection,
1894–1953

1910s, citing the "brilliant artist's … priceless" fête galante *Signboard of Gersaint* (1721; Schloss Charlottenburg, Berlin).[14] He told the *New York Herald* that "true art should find expression in the things of every day," and he proceeded to produce a "French" sign for an architect's office to help make his point.[15] This merging of art and life led Shinn to team up with Belasco and others in designing a suffrage pageant and tableau in 1911.[16] And it was surely this logic that in part led him from easel painting and art exhibitions toward Belasco's mural project and the decorative commissions that followed, as well as projects in film and theater.

On several occasions in the decades following The Eight's 1908 exhibition, Shinn's modernism manifested itself more subtly than in the early Ashcan pastels, and it aspired to different goals. This is especially the case with several of the artist's later magazine, book, and newspaper illustrations.[17] Yet in selected instances, he relied on the same New York and Philadelphia newspaper training that imbued his first pastels with spontaneity and realism. In 1934, *The Boston Traveler* hired Shinn to record the murder trial in Boston of Abraham Faber and Murton and Irving Millen in the shooting death of policeman Forbes McLeod. In addition to his courtroom scenes and litigants' portraits

that appeared in the newspaper throughout that spring was a drawing captioned "Machine Gun Murder of McLeod Visualized by Shinn" (fig. 35). The image evokes the scripted artifice of plays Shinn himself had produced at Waverly Place, the makeshift theater attached to his home, but it also suggests a modernist sensibility of macabre entrapment. Showing the machine gun firing within a dark, enclosed space, the illustration anticipates slightly later developments in film noir cinema. The drawing's emphasis on unadulterated human experience remains allied to Shinn's earlier works, but its illustrative style and narrative format are markedly different.

Another difference concerns the stage-like quality of *The Boston Traveler* illustrations, which parallels Shinn's well-documented activities as a playwright, set designer and carpenter, actor, and producer throughout the first decades of the twentieth century. His first exhibition at the New York gallery Boussod, Valadon and Company in 1899 had featured three portraits of his friend the actress Julia Marlowe.[18] Bearing such names as *The Dump, The Golden Lancet, The Prune Hater's Daughter,* and *More Sinned Against Than Usual,* Shinn's plays received favorable reviews (fig. 36). Although artifice, pose, and contrived melodrama mark Shinn's post-1908 paintings, pastels, murals, and house decorations, any assessment of this work as "theatrical" requires some qualification. As in *auteur* film theory, Shinn directed and was sensitive to all aspects of the production and reception of his plays. In this way, the dramatic productions recall somewhat his earlier vaudeville and theater subjects. *Theater Scene,* for example, addresses a stage production, but it is also a record of the experience, presumably the painter's, of watching that production.

In both early and late Shinn works, modernism resides in his understanding of the viewer's experience, as mediated by the structures through which he frames his vernacular glance

and through which he participates in the spectacle of modern life. These can take the form of a layer of silt through which we see workers on the docks, the vantage point of our seat in the twentysomething row at some vaudeville production, or—as in *Nightclub Scene* (page 143)—faces intersecting our own gaze as we seek the visual subject. In its theme of self-location amid the crowd of countenances, Shinn's painting echoes modernist poet T. S. Eliot's lines from his 1917 poem "The Love Song of J. Alfred Prufrock": "There will be time, there will be time / To prepare a face to meet the faces that you meet."[19] Broadly conceived, the murals also concern the convergence of gazes that, according to Eliot, such looking facilitates. *Nightclub Scene* lacks some of the reductive color scheme and harsh realism of earlier examples of Ashcan modernism, but it maintains the archetypal emphasis on the modern themes of waiting, gazing, boredom, mass-entertainment, and visual confusion.

Nightclub Scene repeats aspects of but updates the earlier *Theater Scene*. Shinn's recurrent crowding, cropping, and use of diagonal movement imbues much of his later work with a cinematic sensibility.[20] Beginning in the late 1910s and through the mid-1920s, Shinn in fact worked as an art director for several motion picture companies. Samuel Goldwyn's first film, *Polly of the Circus* of 1917, featured backgrounds designed by Shinn, a personnel choice lauded by *Vanity Fair*.[21] Some of Shinn's sets applied to the movies the keen attention to mise-en-scène immersion and atmospheric conditions he had first explored in newspaper illustrations and pastels. In the months following Inspiration Pictures' 1923 release of *The Bright Shawl*, for which Shinn was also art director, the artist addressed the filmic "effects of realism" in a story on the movie in the *New York Telegram*.[22] Garnering especially heavy press coverage was his art direction for Cosmopolitan Pictures' *Janice Meredith*, a 1924 romance set

in colonial America. Shinn had long expressed an interest in interpreting the early republic for modern audiences. In February 1899 his model of "the outpost in the snows of Valley Forge" graced the cover of *Ainslee's* magazine.[23] For some observers, it was precisely this temporal switch-up—interpreting the past through the filter of the present—that lent his art, even his murals, an *au courant* sensibility. Reviewing the Belasco Theater murals, for example, one writer commented that the artist "has taken the mannerisms of another epoch and has blended with them a strong and powerful modernity."[24]

Shinn's *Trapeze Artists (Proctor's Theater)* (page 140) repeats the subject matter, elevated vantage point, and placement of audience and balustrade of his 1902 painting *The Hippodrome, London*, a work that contemporaries deemed among his best (fig. 37).[25] A frequent visitor to Proctor's famed New York vaudeville house, Shinn here captures the swing-propelled trapezist just before his downward thrust and, against the wall, as the artist remarked, "a blindfolded man … about to do a dangerous turn."[26] For all the performers' acrobatics, however, these pictures emphasize the role of the spectators, as if they complete the narrative begun by the aerialists. The 1940 pastel, as much as the 1902 painting, anticipates much later twentieth-century visual and performing arts productions, from happenings to performance art, in which actors' and onlookers' spaces collide.

FIG. 36
Everett Shinn
Work Set Design for "The Dump" 1934–40
Photographic print: sepia
7⅞ × 9⅞ in.
(20 × 25 cm)
Courtesy of the Everett Shinn collection, 1894–1953

Replete with audience participation, *The Rocky Horror Picture Show* is one such production. In this regard, it is useful to return to the 1975 *New York Times* story on Shinn's murals at the Belasco Theater. It is somewhat ironic that a few of the murals there were defiled to make way for a musical whose hit song is entitled "Time Warp." Anticipating the show's "Transylvanians," who sing the refrain "Let's do the time warp again," Shinn had his own time-suspending agenda. Such warping or collapsing of the temporal is part of the message of some of his late paintings, such as *French Vaudeville* (page 141), which reprises his interests of almost four decades earlier. When a critic wrote of Shinn, late in his life, that "this artist has a way of turning back the pages of time," he was, unwittingly or intentionally, commenting on the artist's retroactive mode and recasting mission.[27] That, Shinn believed, was one of the tasks of modern art.

Leo G. Mazow is curator of American art at the Palmer Museum at The Pennsylvania State University, where he is also affiliate associate professor of art history.

The author wishes to express gratitude to Elizabeth Kennedy and the contributors to this volume for their helpful suggestions and close readings of earlier versions of this essay. Special thanks are also extended to Shinn scholar Janay Wong, and, for her invaluable research assistance, to Ellery Foutch.

1 Paul L. Montgomery, "Aging Belasco Preens for a New Theatrical Life," *New York Times*, January 27, 1975.

2 See, for example, Donald Wilhelm, "Everitt [sic] Shinn, Versatilist," *The Independent* 101 (December 4, 1916): 398; Louis H. Frohan, "Everett Shinn, the Versatile," *International Studio* 78 (October 1923): 85–89: and Norman Kent, "The Versatile Art of Everett Shinn," *American Artist* 9 (October 1945): 8–11, 35.

3 See "Mural Decorations for an Italian Dining Room," *Vanity Fair* 24 (August 1925): 35.

4 *The Philadelphia Inquirer*, January 8, 1911, Smithsonian Institution, reel D179 (hereafter Shinn Collection), frame 82. See also "Notes: Everett Shinn's New Note in Mural Decoration," unidentified clipping dated February 1911, in Shinn Collection, Archives of American Art, reel D179, frame 91.

FIG. 37
Everett Shinn
The Hippodrome, London, 1902
Oil on canvas
26⅚₆ × 35⅛ in.
(66.9 × 89.3 cm)
The Art Institute of Chicago, Friends of American Art Collection; the Goodman Fund
1928.197

5 "The Transformed Piano: Everett Shinn Pleads for 'Intimate Decoration,'" *The New York Sun*, October 15, 1905; "Fitch Sale Totals $50,000," *Philadelphia Ledger*, April 2, 1911.

6 Henri Pène du Bois, "A Fragonard of the Present Time," unidentified clipping dated February 22, 1905, in Shinn Collection, reel D179, frame 11.

7 Melissa Lee Hyde, "Rococo Redux," in Sarah D. Coffin et al., eds., *Rococo: The Continuing Curve, 1730–2008*, (New York: Cooper-Hewitt, National Design Museum, Smithsonian Institution, 2008), especially 13–14, 16.

8 "Everett Shinn's Exhibition," *New York Sun*, March 11, 1903. As art historian Janay Wong has observed, the early pastels in particular demonstrate "Shinn's fascination … with vastly divergent public spaces that distinguished turn-of-the-century Manhattan." Wong, *Everett Shinn: The Spectacle of Life* (New York: Berry-Hill Galleries, 2000), 22.

9 Rebecca Zurier, Robert W. Snyder, and Virginia M. Mecklenburg, *Metropolitan Lives: The Ashcan Artists and Their New York* (Washington, D.C.: National Museum of American Art, 1995), 184.

10 Review of Shinn's show in early 1900 at Boussod, Valadon & Co., *New York Commercial Advertiser*, February 16, 1900; in Shinn Collection, reel D179, frame 7.

11 For the alternate title, see "Life is Depicted in Shinn's Pastels," *The Philadelphia Inquirer*, March 14, 1904, morning edition.

12 Hart Crane, "Chaplinesque" (1921), in *The Norton Anthology of American Literature*, 2nd edition, ed. Nina Baym et al. (New York: W. W. Norton and Company, 1985), 2:1563.

13 For a thoughtful examination of this network of patrons and its importance in Shinn's artistic development see Wong, *Everett Shinn*, 35–36, 45–46.

14 "Is High Art Needed In Signs?" *Philadelphia North American*, January 28, 1912. See also "Artist Paints a Sign Just to Prove That His Brush Knows No Bother," newspaper clipping, Shinn Collection, frame 72.

15 Shinn paraphrased in "Street Signs May Make Picture Gallery," *New York Herald*, October 13, 1911.

16 "Tableau to Show Woman Needs Vote," *New York Telegram*, January 17, 1911, evening edition.

17 From 1914 through 1920, Shinn's illustrations were a mainstay of *Metropolitan Magazine*; he also contributed drawings to *Century Magazine* and *Everybody's Magazine* during the years. Later, throughout the 1930s and 1940s, Shinn produced illustrations for reprints of novels by Charles Dickens, Washington Irving, Oscar Wilde, and other authors; see Appendix 6: Book and Magazine Illustrations by Everett Shinn, in Edith DeShazo, *Everett Shinn, 1876–1953: A Figure in His Time* (New York: Clarkson N. Potter, Inc., Publisher, 1974), 219–26.

18 The checklist of the 1900 exhibition is reproduced in DeShazo, *Everett Shinn*, 38. On Shinn's plays see *ibid.*, 71–81.

19 Eliot, "The Love Song of J. Alfred Prufrock," lines 26–27, in *Norton Anthology*, 2:1197.

20 Interpretations of *Nightclub Scene*'s formal dynamics are complicated by the fact that the present painting may have been cut down from a larger canvas perhaps twice the size, according to notes in curatorial files, Milwaukee Art Museum. Alternately, it may have been conceived in two halves; in any case, *Nightclub Scene* was in its present form on Shinn's easel at the time of his death, according to Edith DeShazo in a letter to I. Michael Danoff, August 24, 1975, registrar's object files, Milwaukee Art Museum.

21 "Show First Goldwyn Film," *The New York Times*, September 10, 1917; DeShazo, *Everett Shinn*, 113, 116.

22 Everett Shinn, "Everett Shinn Describes Settings of 'Bright Shawl,'" *New York Telegram*, circa 1924, clipping in Shinn Collection, reel D 179, frame 108.

23 "New Literature," *Boston Globe*, February 7, 1891, in Shinn Collection, reel D179, frame 3.

24 "New Stuyvesant Decorations Will Bring Fame to Shinn," *New York American*, October 1907, clipping in Shinn Collection, reel D 179, frame 215. According to the American Film Institute database (www.afi.org, accessed August 2008), in addition to these three films, Shinn was also the art director for *The Fighting Blade* (1923) and *Soul-Fire* (1925), both of which were produced by Inspiration Pictures and directed by John S. Robertson.

25 See for example Chloris Clark, "Some Impressions of the Work of the Independents," *Columbus* [Ohio] *News*, January 28, 1911. A critical aspect of *The Hippodrome, London*, as Wong has observed, is its "reversal of the traditional vantage point—we are looking not at the stage, but at the audience; and the later trapeze painting repeats this emphasis as well. See Wong, *Everett Shinn*, 74.

26 Shinn quoted in Wong, *Everett Shinn*, 79, 108, n. 267.

27 "Nostalgic Art of Everett Shinn Reviewed," unidentified newspaper clipping in Shinn Collection, frame 164.

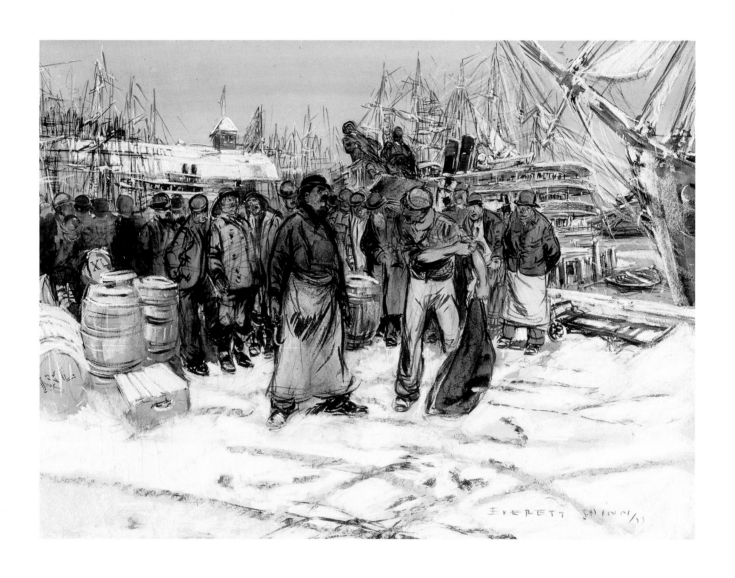

Everett Shinn
Spoiling for a Fight,
New York Docks, 1899
Watercolor and pastel
on board
22 × 29½ in.
(55.88 × 74.9 cm)
Milwaukee Art Museum,
gift of Mr. and Mrs.
Donald B. Abert and
Mrs. Barbara Abert Tooman
M1977.25

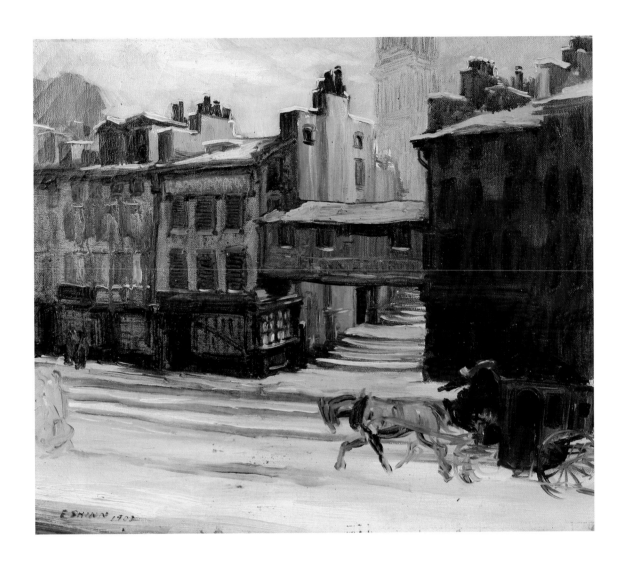

Everett Shinn
Paris Street No. 2, 1902
Oil on canvas
10 × 12 in.
(25.4 × 30.5 cm)
New Britain Museum
of American Art,
Harriet Russell Stanley
Fund, 1943.15

Everett Shinn
**Trapeze Artists
(Proctor's Theater),** 1940
Pastel on paper
19½ × 15¼ in.
(49.5 × 38.7 cm)
Collection of Rhoda and
David T. Chase

Everett Shinn
French Vaudeville, 1937
Oil on canvas
25⅛ × 30⅛ in.
(63.8 × 76.5 cm)
New Britain Museum
of American Art,
Harriet Russell Stanley
Fund, 1946.22

Everett Shinn
Cabaret Singer in Red, 1951
Gouache on paper
5¾ × 3⅝ in.
(14.6 × 9.2 cm)
Milwaukee Art Museum, gift
of Mrs. Edward R. Wehr
M1957.17

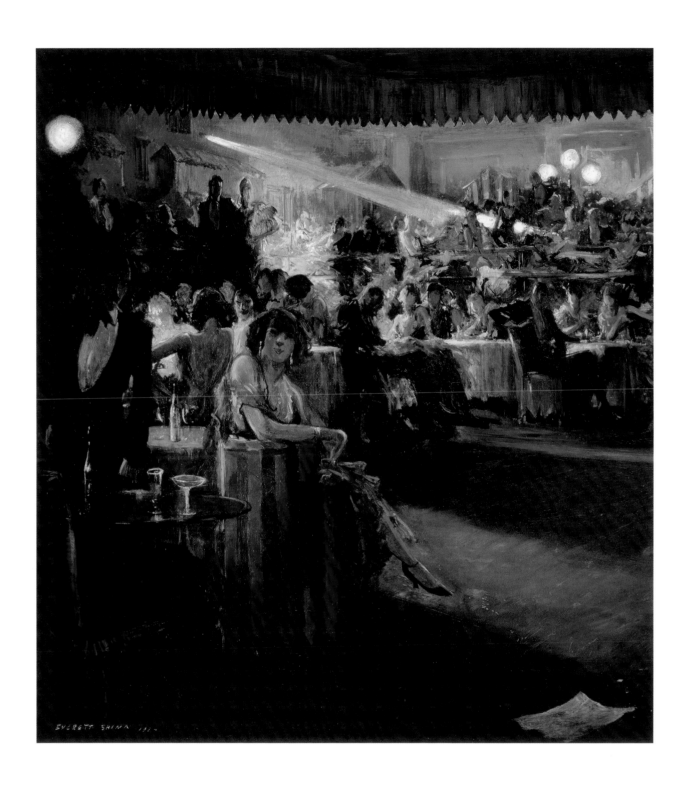

Everett Shinn
Nightclub Scene, 1934
(possibly reworked later)
Oil on canvas
36 × 34 in.
(91.44 × 86.36 cm)
Milwaukee Art Museum,
gift of Mr. and Mrs.
Donald B. Abert in Memory
of Harry J. Grant
M1966.112

FIG. 38
John Sloan
Self portrait, 1928
Oil on panel
26 × 20 in.
(66 × 50.8 cm)
Collection of the
McNay Art Museum,
bequest of Marion
Koogler McNay, 1950.41

Sloan

Art Matters: John Sloan, Independence and the Aesthetic Consumer

Sarah Vure

In *Copyist at the Metropolitan Museum* (page 146), John Sloan (1871–1951) depicted himself, handsomely attired and with his wife on his arm, as an observer of the art milieu—its producers, its audience, and its hallowed institutions. In his diary, Sloan wrote about the crowd surrounding the amateur painter who is reproducing "a sheep picture," connoting both the ornately framed French rural scene, the genre most sought by wealthy American collectors, and the distinct lack of individual judgment in the art patrons. As he struggled to capture his likeness on the etching plate, Sloan also noted, "I work to please myself, which perforce makes it hard sometimes to get the 'coin' from the world."[1] This can be interpreted as the artist's comment on his professional identity. As an independent with a complex and, at times, contradictory relationship with the art market, Sloan constructed a distinctly modern existence.

Often accused of being a publicity hound, Sloan reflected, "I have the ability to get art matters into the news through my sharp but honest tongue."[2] Like his colleagues in the Philadelphia Four (Glackens, Luks, and Shinn), Sloan's previous commercial work as a newspaper artist alerted him to the importance of the press in achieving success. He knew that extensive media coverage was crucial to marketing independent

exhibitions, such as The Eight's in 1908, that established his reputation and earned him a place in history. In Sloan's mind any publicity was good publicity; whether one's work was extolled or condemned, either was far better for the artist than being ignored. Throughout his life, the media commented on Sloan's personality, his fiercely independent nature, and his profoundly humanistic spirit. A man of compassion with a gift for fiery oratory, he might have entered the ministry if he had the financial means to attend college.[3] So it was with missionary zeal that Sloan became a preacher for independent expression, his fellow artists, and the social role of art in America.

In the eyes of his supporters, Sloan's refusal to cater to academic or market perceptions of acceptable art put him above the "common run of painters" whose commercialism yielded "preconceived … summer scenes … for winter sales." It was important that Sloan had "never chosen a subject or discarded one because of his relation to the public."[4] Ignoring fashionable styles and iconography, his "New York City Life" etchings, in the tradition of William Hogarth, George Cruikshank, and Honoré Daumier, were both acclaimed and scorned as realist social commentary.[5] Images such as *Roofs, Summer Night* (fig. 39), showing working class tenement

John Sloan
*Copyist at
the Metropolitan
Museum,* 1908
Etching
7⁷⁄₁₆ × 8¹⁵⁄₁₆ in.
(18.9 × 22.7 cm)
New Britain Museum
of American Art,
William F. Brooks Fund
1965.03

dwellers, were deemed uncouth, humorously satiric, and vigorously linear at a time when James MacNeill Whistler's evocative tonal etchings of Venice were considered the acme of aesthetic refinement.[6] The American Watercolor Society refused to exhibit four etchings in Sloan's series because they judged the prints too vulgar for public display. Sloan's sympathetic portrayal of the twentieth-century class and gender relations that resulted from the modernizing forces of urbanization and immigration surely impacted his prosperity. As art historian and museum director Lloyd Goodrich suggested, Sloan's lack of financial success resulted from the lag in public acceptance of his painting style and subjects. "His early work had been too realistic for its day; his mature genre paintings ran counter to the trend toward expressionism and his figure pieces to the trend toward abstraction."[7] Yet, Sloan claimed his lack of sales was creatively liberating.

Beyond his celebrated urban scenes, Sloan pursued portraiture, landscape, and the figure as important avenues of exploration. Paintings of models such as *Girl with a Fur Hat* (page 174) and *Big Hat (Blonde Girl)* (page 154) show his keen interest in character and an expanding attention to color. While he remembered the former for being the last painting submitted to a National Academy of Design jury, Sloan soon took a more advanced compositional approach in the portrait of modern dancer *Isadora Duncan* (page 149). This work captures his admiration for Duncan, an icon of feminism and aesthetic independence. Like many progressive artists,

146

Sloan was inspired by her revolutionary ideal of regenerating society through natural movement. His simplified, almost abstract composition pictures the dancer in diaphanous robes, bathed in a spotlight of intersecting arcs that dissect the stage into planes of mauve and orange. Her curving, boldly gesturing limbs were a means of direct communication with the audience, a concern Sloan investigated in his own practice through the appropriation of cinematic perspectives for spectator involvement.[8]

Sloan's attendance of Duncan's innovative performances and the latest silent movies mark his engagement with modernity. However, no event has been considered more significant for opening new aesthetic directions for American artists than the Armory Show of 1913. Sloan expressed his immediate reaction to the exhibition in a humorous cartoon parody in the April issue of the leftist journal *The Masses* entitled "A Slight Attack of Third Dimentia [sic] Brought on by Excessive Study of the Much-Talked of Cubist Pictures in the International Exhibition at New York" (fig. 40). Notwithstanding such apparent ridicule, Sloan was deeply affected by the modern art displayed in the show, although he had been keeping abreast of European modernism to the extent that one could without traveling abroad. He learned a great deal from his patron John Quinn, a leading collector of the avant-garde, and claimed that he would "seize the chance" to see Quinn's new acquisitions months before they arrived at the Armory.[9] Shortly before the exhibition, Sloan discussed Matisse and the cubists with a writer from *American Art News*, exclaiming, "I think these a splendid symptom, a bomb under conventions … the explosive force is there—revolution it is."[10] Years later he recalled, "When I saw the work of the moderns at the Armory Show I was struck by their concern with structure and particularly with texture."[11] Subsequently, Sloan increased his experimentation with color, form,

and composition, especially during the summers of 1914–1918 which he spent in Gloucester, Massachusetts. With its bright hues and impasto brushwork, *Autumn Dunes* (page 156), like many of his other Gloucester canvases, explores the techniques of Vincent Van Gogh and Paul Cézanne. But it was his anecdotal city scenes such as *Main Street, Gloucester* (page 157) that were praised by critics, who enjoyed Sloan's depiction of evocative characters and judged the work "very personal in expression."[12]

In addition to his painterly forays into non-realist styles, Sloan's modernity could be found in his independence from and interaction with the marketplace.[13] To reconcile the seemingly disparate objectives of self-expression and profitable success in a culture of consumption, he constantly invoked the ideal of artistic freedom to deflect the taint of commercialism from his work. But it was an act of self-promotion, when he appealed to Gertrude Vanderbilt Whitney to present his first solo exhibition at the Whitney Studio in 1916 that resulted in Sloan achieving representation by art dealer John Kraushaar, whose gallery still handles his estate today. Although given almost annual exhibitions by Kraushaar, Sloan was unable to earn a living from his art for much of his career.

Instead, he traded illustration for a teaching position at the Art Students League, which provided the financial freedom to be independent.

FIG. 39
John Sloan
Roofs, Summer Night
from the *New York City Life* series, 1906
Etching
5³⁄₁₆ × 7 in.
(13.17 × 17.8 cm)
Milwaukee Art Museum, Maurice and Esther Leah Ritz Collection
M2004.309

Considered one of the most liberal voices at the League for his classroom discussions of modern art, Sloan, like many in the era's new intellectual class, presented himself as humanity's conscience. He viewed art as a means of communication, not financial reward, telling his students:

> The work of artists, poets, musicians is a kind of food for starving souls, as necessary as food for the body …. The idea of taking up art as a calling, a trade, a profession is a mirage. Art enriches life. It makes life worth living. But to make a living at it — that idea is incompatible with making art …. [Art] brings life to life."[14]

Sloan further advised his students to shun monetary success in favor of personal progress. Once he even turned down a purchase offer for a drawing because he considered it an excellent indicator of his own achievement and a stimulus to further artistic growth.[15]

The distinction between creative independence and commercial success was clearly defined. However, through the lens of spectatorship, Sloan could associate the display of high art with mass consumption, as seen in *Picture Shop Window* (fig. 41), where potential buyers survey the brightly lit shop merchandise.[16] An earlier depiction of the art market, *Connoisseurs of Prints* (page 151), unfavorably contrasts the distracted gaze of wealthy collectors with the focused view of an appreciative expert, on the far right. Repeatedly drawn to the comedy of interpersonal dynamics that transpired during art sales, Sloan created an amusingly judgmental portrayal of dealer William Macbeth in *The Picture Buyer* (page 164). Sloan thought Macbeth's sales pitch overly effusive and commented that the casual gallery-goers were "awed by the presence of purchasing power" as they craned to catch a glimpse of the transaction.[17] In contrast, *Salesmanship* (fig. 42) caricatures the business practice of his dealer's brother, Charles Kraushaar, in "the wily art of selling a thing that is neither liked nor wanted."[18] Although acknowledging the difficulty of securing sales during the Depression, ironically or perhaps as the ultimate vindication, Sloan later donated impressions of the print to serve as a fundraiser for the Society of Independent Artists, an organization that exhibited the works of artists regardless of marketability.

As president of the Society for twenty-eight years, from 1918 to 1946, Sloan maintained his status among his peers by becoming a powerful spokesperson for inclusiveness and an expansive vision of art appreciation. A product of The Eight's enduring legacy, the Society of Independent Artists saw increased attendance at its annual exhibitions throughout the 1920s. Opening nights often drew museum people and gallery owners interested in finding new talent.[19] A writer for the *International Studio* considered the exhibitions "robust and lusty … and in its

THERE WAS A CUBIC MAN AND HE WALKED A CUBIC MILE AND HE FOUND A CUBIC SIXPENCE UPON A CUBIC STYLE

HE HAD A CUBIC CAT WHICH CAUGHT A CUBIC MOUSE

AND THEY ALL LIVED TOGETHER IN A LITTLE CUBIC HOUSE

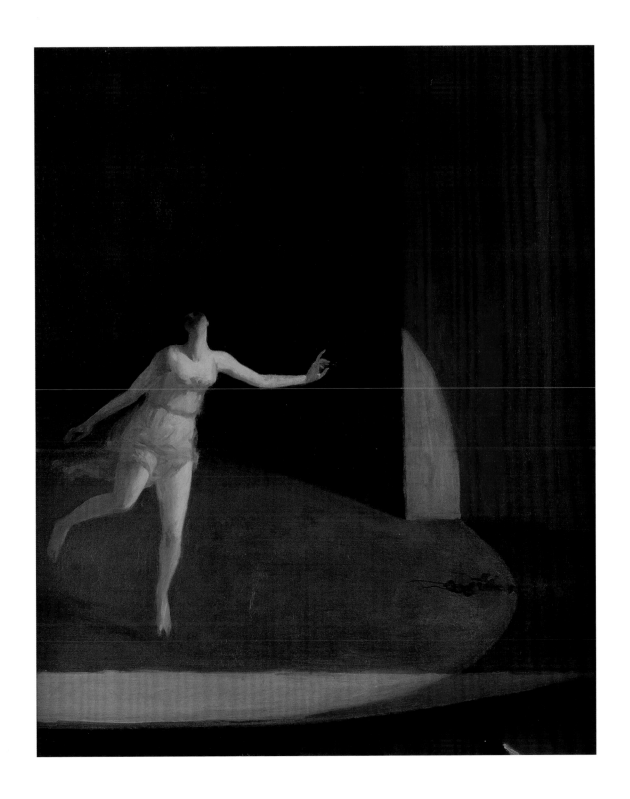

John Sloan
Isadora Duncan, 1911
Oil on canvas
32½ × 26¼ in.
(82.55 × 66.67 cm)
Milwaukee Art Museum,
gift of Mr. and Mrs.
Donald B. Abert
M1969.27

democratic completeness [the Society] is a true representative of America."[20] While Sloan deemed the "open door" policy of its non-juried system the organization's greatest achievement, he was also proud of the exhibitions' service in popular education and their appeal to the average citizens who came to see the latest art trends and to be entertained.

During the 1930s, Sloan's relations with the public, media, and market continued to evolve. Although the press was critical of his new approach to painting the female nude, Sloan maintained his independence. Formal experiments led him to impose a linear cross-hatching over the body to render three-dimensional volumes, a technique that was more successful in etchings such as *Long Prone Nude* (pages 160–61), than in oils. Unwilling to renounce the figure, Sloan stated that

"work which is purely non-representational loses some of the texture of life."[21] His depictions of everyday life were now heralded as an example for younger realists of American scene painting. However, Sloan deplored that term, associating it with jingoist flag-waving. He responded, "If you are American and work, your work is American."[22] With a more pluralist national vision, he sought to engage a diverse population in art appreciation and to expand the market for American art.

Sloan's publicity efforts and even his rhetoric seemed to parallel an expanding advertising industry that not only sold manufactured products but influenced public attitudes with a message of uplift, becoming modern through the use of mass communication as "it empathized with the public's imperfect acceptance of modernity."[23] In his 1939 book *Gist of Art*, Sloan proposed that "The artist paints first of all for himself, but the very next person he paints for is the aesthetic consumer, the person who is equipped to enjoy and appreciate."[24] To mold enlightened consumers, Sloan spoke to a mass audience on radio, the most popular medium of the day. As a member of New York's Municipal Art Committee, he was interviewed in 1936 about the organization's goal of stimulating community interest in living American artists and promoting the sale of their work. Presented to listeners as a "pioneer of American modern art," Sloan recounted the importance of The Eight and the Armory Show for awakening public attention, trumpeting the latter's ultramodern art as a "clarion call of freedom." Most significantly, he explained that repeated viewing was necessary to understand the new forms of art and he recommended listeners take time to get to know pictures. On the radio again in 1937, Sloan spoke on a weekly program sponsored by the Works Progress Administration's influential Federal Theatre of the Air, praising government

Connoisseurs of Prints

John Sloan
Connoisseurs of Prints
from the series *New York
City Life*, 1905
Etching
4¹⁵⁄₁₆ × 7 in.
(12.54 × 17.78 cm)
Milwaukee Art Museum,
gift of Mr. and Mrs.
Donald B. Abert and
Mrs. Barbara Abert Tooman
M1977.189

151

support for the remarkable rise in American art consciousness.[25] By 1950, he was educating the next generation of aesthetic consumers when he appeared on an N.B.C. television show for young audiences. Ultimately, Sloan hoped the modern movement would bring the artist and the public together. He counseled that one did not need to own pictures to become knowledgeable about art and to value it as a document of human communication.

Always an excellent communicator, in his later years Sloan was rewarded with numerous accolades for his eminent career. However, he was uncomfortable with establishment approval, for it conflicted with his image as a perpetual outsider. When his *Gist of Art* was published, *Life* magazine boldly asserted that no living man had greater influence in the American art world.[26] A decade later, the *New Yorker* declared that he had become "the dean of living American painters … with public attitude toward his work changing from scorn to veneration."[27] The 1952 retrospective exhibition at the Whitney Museum of American Art, which opened months after Sloan's death, became a memorial tribute. Its curator Lloyd Goodrich eulogized Sloan for his importance as an artist and teacher, but most of all as an activist who worked for artistic freedom, affirming that "the American art world today is a freer, more democratic and healthier world … in no small part due to him."[28]

Sarah Vure is a faculty member in art history at Long Beach City College in California.

FIG. 42
John Sloan
Salesmanship, 1930
Etching
$3^{15}/_{16} \times 4^{7}/_{8}$ in.
(9.24 × 12.38 cm)
Milwaukee Art Museum,
gift of Kent and Cecile
Anderson, M2000.200

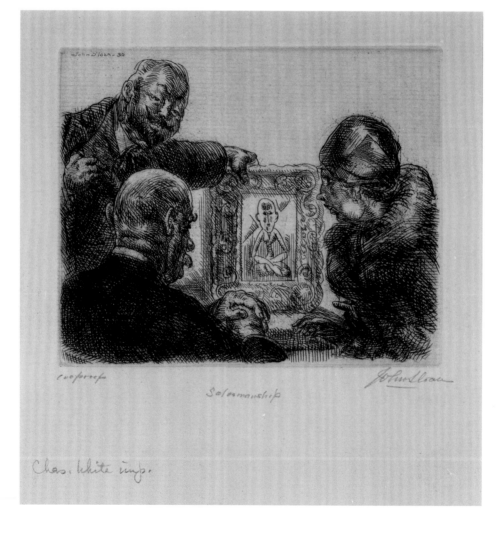

1 Diary entry for September 15, 1908, in *John Sloan's New York Scene: From the Diaries, Notes and Correspondences 1906–1913*, ed. Bruce St. John (New York: Harper and Row, 1965), 247

2 John Sloan, *Gist of Art: Principles and Practice Expounded in the Classroom and Studio* (New York: American Artists Group, 1939), 30.

3 Helen Farr Sloan, interview by the author, March 1999.

4 "Notes of the Studios and Galleries," *Arts & Decoration* 7 (April 1917): 336.

5 Charles Wisner Barrell, "The Real Life Drama of the Slums as Told in John Sloan's Etchings," *The Craftsman* 15 (February 1909): 558, 560, 563.

6 Sloan's avoidance of accepted styles is evidenced by his description of *Schuylkill River* (1894) as "one of my few plates that looks like an etching from the connoisseur's point of view. It might be that had I pursued the direction suggested here my etchings might have become quite popular." Sloan quoted in *John Sloan, Paintings and Prints* (Hanover, NH: Dartmouth College, 1946), 29.

7 Lloyd Goodrich, *John Sloan* (New York: Whitney Museum of American Art, 1952), 74.

8 Katherine E. Manthorne, "John Sloan, Moving Pictures and Celtic Spirits," in Heather Campbell Coyle and Joyce K. Schiller et al., *John Sloan's New York* (New Haven: Yale University Press, 2007), 150–79.

9 John Sloan to John Quinn, April 13, 1913, John Quinn Memorial Collection, The New York Public Library, Astor, Lenox and Tilden Foundations.

10 Diary entry for January 16, 1913, in *John Sloan's New York Scene*, 633.

11 Sloan quoted in notes by Helen Farr Sloan, John Sloan Manuscript Collection, Helen Farr Sloan Library & Archives, Delaware Art Museum.

12 *Art News*, March 16, 1918, quoted in Rowland Elzea, *John Sloan's Oil Paintings: A Catalogue Raisonné* Part I (Newark and London: University of Delaware Press and Associated University Presses, Inc., 1991), 205.

13 Sarah Burns, *Inventing the Modern Artist: Art and Culture in Gilded Age America* (New Haven: Yale University Press, 1996), 75.

14 Sloan, *Gist of Art*, 26, 35.

15 Sloan wrote, "The truth of the matter … is that it is one of the best drawings I ever made and I could not ask enough for it to compensate me for its absence as a sort of pace setter." Diary entry for March 24, 1912, in *John Sloan's New York Scene*, 612.

16 Laural Weintraub, "Women as Urban Spectators in John Sloan's Early Work," *American Art* 15, no. 2 (summer 2001): 80–1.

17 Diary entry for April 27, 1911, in *John Sloan's New York Scene*, 530.

18 John Sloan quoted in Peter Morse, *John Sloan's Prints: A Catalogue Raisonné of the Etchings, Lithographs and Posters* (New Haven: Yale University Press, 1969), 268.

19 "Independent Art Draws Huge Crowd," *The New York Times*, March 12, 1922.

20 "The 1923 Independents Show," *International Studio* 76, no. 311 (March 1923): suppl., unpaged.

21 Sloan quoted in *The Life and Times of John Sloan* (Wilmington: Delaware Art Center, 1961), 11.

22 Sloan quoted in "John Sloan: A Great Teacher-Painter Crusades for American Art," *Life* 7 (December 11, 1939): 46.

23 Roland Marchand, *Advertising the American Dream: Making Way for Modernity, 1920–1940* (Berkeley: University of California Press, 1985), 5, 13.

24 Sloan, *Gist of Art,* 24–25.

25 Erik Barnouw, *A History of Broadcasting in the United States* (New York: Oxford University Press, 1968), 84–9; transcripts of interviews on WNYC, New York, April 5, 1936, and WQXR, New York, May 26, 1937, in John Sloan Manuscript Collection, Helen Farr Sloan Library & Archives, Delaware Art Museum.

26 "John Sloan: A Great Teacher-Painter Crusades for American Art," 46.

27 Robert Coates, "Profile," *New Yorker* 25 (May 7, 1949): 36.

28 Memorial address given at Dartmouth College, September 11, 1951, quoted in Goodrich, *John Sloan,* 77.

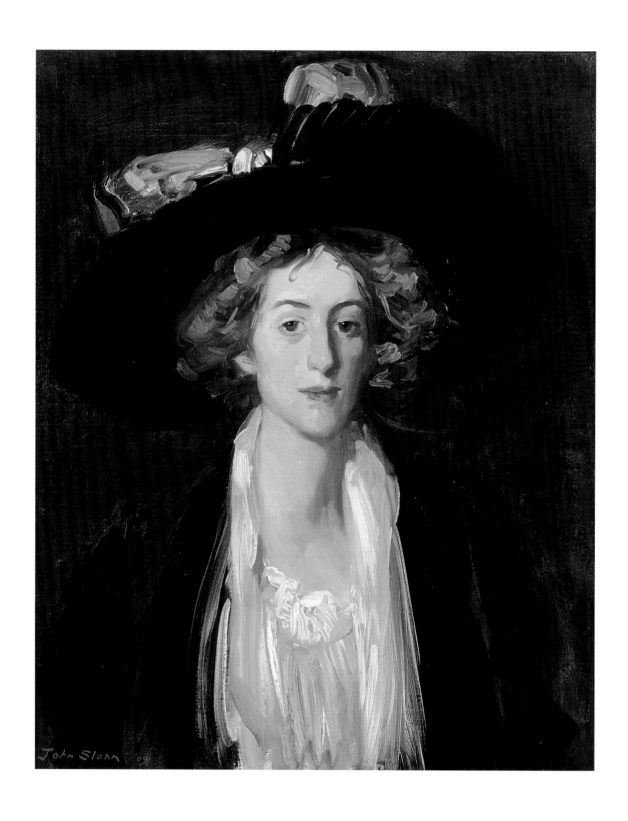

John Sloan
Big Hat (also known
as *Blonde Girl*), 1909
Oil on canvas
32¾ × 26¾ in.
(83.2 × 67.94 cm)
Milwaukee Art Museum,
Layton Art Collection,
Purchase, L1964.8

John Sloan
Dunes at Annisquam, 1914
Oil on canvas
26 × 32 in.
(66 × 81.3 cm)
Milwaukee Art Museum,
gift of Juel Stryker in
honor of her parents,
Clinton E. and
Sarah H. Stryker
M1989.29

John Sloan
Autumn Dunes, 1914
Oil on canvas
26¼ × 32¼ in.
(66.67 × 81.9 cm)
Milwaukee Art Museum,
gift of Mr. and Mrs.
Donald B. Abert
M1969.28

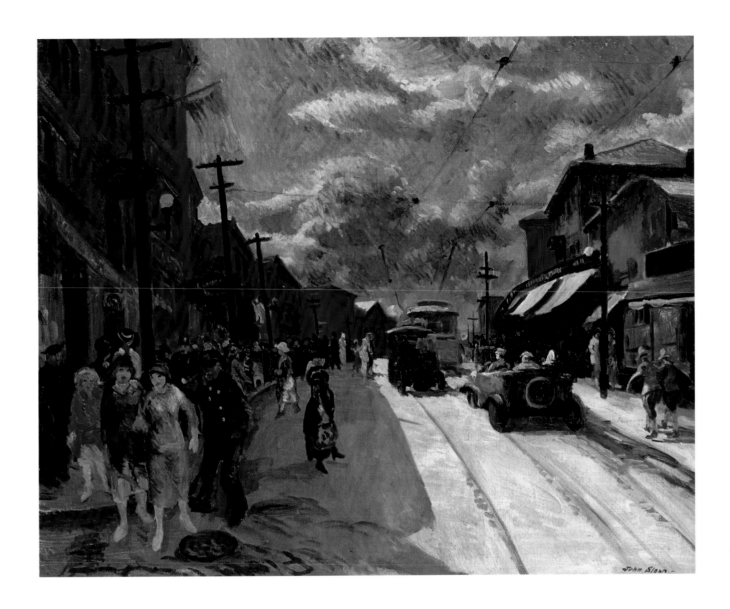

John Sloan
Main Street, Gloucester
c. 1914–18
Oil on canvas
26 × 32¼ in.
(66 × 81.9 cm)
New Britain Museum
of American Art,
Harriet Russell Stanley
Fund, 1943.16

You are Invited to a Party at
Dolly and John Sloan's Studio.
Sunday Evening January 30, 1921
R.S.V.P.

John Sloan
Invitation to a
Studio Party, 1921
Etching
3¾ × 2¼ in.
(9.5 × 5.7 cm)
New Britain Museum of
American Art, given in
memory of Anthony and
Mary Malinowski, 1993.51

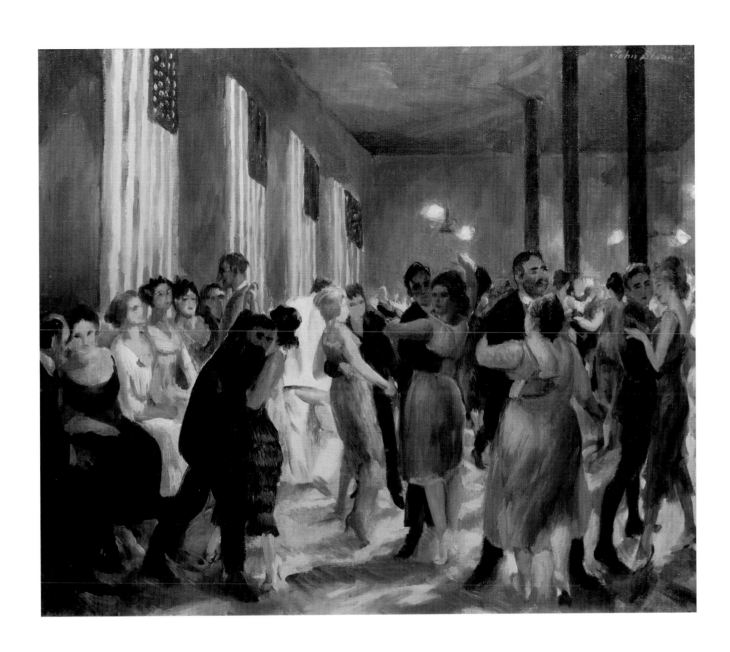

John Sloan
Hotel Dance, Santa Fe, 1919
Oil on canvas
20 × 24 in.
(50.8 × 60.96 cm)
Collection of Rhoda
and David T. Chase

John Sloan
Long Prone Nude, 1931
Etching and engraving
4¼ × 13¾ in.
(10.8 × 34.92 cm)
Milwaukee Art Museum,
gift of Juel Stryker in
honor of her parents,
Clinton E. and
Sarah H. Stryker
M1989.49

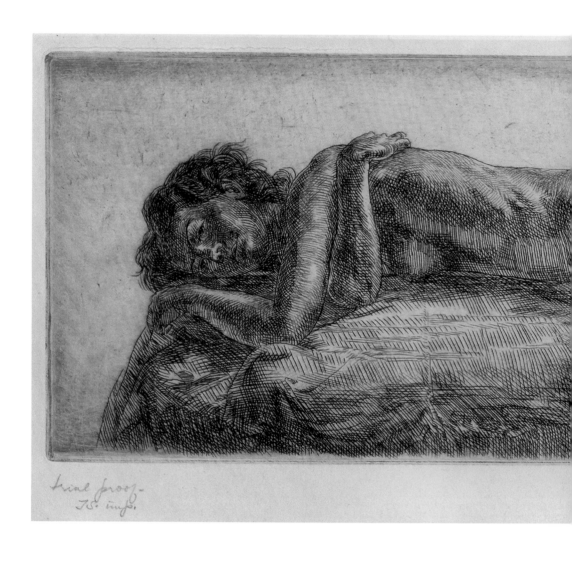

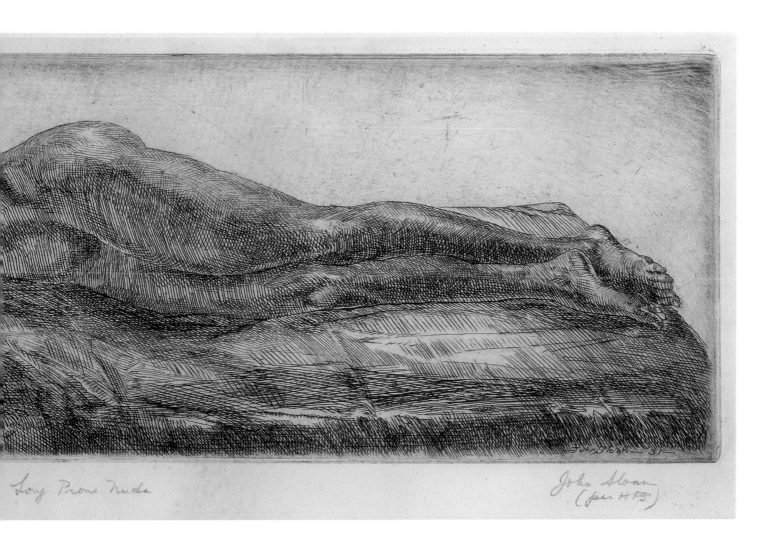

Long Prone Nude

John Sloan
(for H F S)

John Sloan
Rose and Gray Nude, 1931
Crayon on paper
9¹³⁄₁₆ × 14 in.
(24.92 × 35.56 cm)
Milwaukee Art Museum,
Maurice and Esther Leah
Ritz Collection
M2004.106

John Sloan
A Thirst for Art, 1939
Etching
3⅞ × 6 in.
(9.84 × 15.24 cm)
Milwaukee Art Museum,
gift of Juel Stryker in
honor of her parents,
Clinton E. and
Sarah H. Stryker
M1989.51

John Sloan
The Picture Buyer, 1911
Etching
5¼ × 7 in.
(13.33 × 17.8 cm)
New Britain Museum
of American Art,
William F. Brooks Fund
1964.51

Chronology: 1907–57

Prepared by James Glisson with Wendy Greenhouse

INSTITUTIONS (abbreviations in text)

American Association of Painters and Sculptors (AAPS)
Art Institute of Chicago (AIC)
Barnes Foundation, Merion,
 Pennsylvania (BF)
Brooklyn Museum (BM)
Carnegie Institute, Pittsburgh (CI)
Corcoran Gallery of Art,
 Washington, DC (CGA)
Metropolitan Museum of Art, New York (MMA)
Museum of Modern Art, New York (MoMA)
National Academy of Design, New York (NAD)
Pennsylvania Academy of the Fine Arts,
 Philadelphia (PAFA)
Philadelphia Museum of Art (PMA)
Phillips Memorial Gallery, later The Phillips Collection,
 Washington, DC (PC)
Whitney Museum of American Art, New York (WMAA)

1907

Socialite and sculptor Gertrude Vanderbilt Whitney establishes studio in MacDougal Alley, Greenwich Village, becoming Lawson's neighbor

Lawson solo show at PAFA, wins Sesnan Medal for best landscape painting for *The River in Winter* (1907; WMAA)

March Henri withdraws from NAD spring show after colleagues' works are rejected

April Henri and friends first meet to plan independent show

May "The Eight" first appears in New York *Sun* article

 Prendergast accepts Davies's invitation, leaves for France, returns late October

Fall Newspaper articles on The Eight's show appear

1908

Corporate lawyer and modern art collector John Quinn acquires two Lawson landscapes (unrecorded)

Feb. 3–17 The Eight show at Macbeth Galleries: 63 paintings, 7000 visitors

March 7–19 *The Eight* show travels to PAFA

Spring The Eight and Henri's students' artworks hung together at NAD's annual show

 Lawson awarded NAD's First Hallgarten Prize for *Ice on the Hudson* (unlocated), elected NAD associate member

Sept.–Dec. *The Eight* show travels to AIC; Toledo Museum of Art; Detroit Museum of Art

1909

Jan.–May The Eight show travels to John Herron Art Institute, Indianapolis; Cincinnati Art Museum; Carnegie Institute; Bridgeport Public Library, Connecticut; Newark Public Library, New Jersey

FIG. 43, Arthur B. Davies, c. 1907

Henri School of Art opens

Modern art collector Lizzie Bliss acquires first Davies painting

Henri meets color theorist, paint manufacturer Hardesty G. Maratta

1910

April Independent Artists Exhibition, organized by Henri and Sloan, includes Prendergast, Glackens, Shinn, Lawson, and Davies

 Luks first solo show at Macbeth Galleries

June Henri awarded International Fine Arts Exposition, Buenos Aires's Silver Medal for *Willie Gee* (1904; Newark Museum)

Nov. Sloan joins Socialist Party, runs for New York State Assembly on Socialist ticket.

1911

Jan. Davies solo show at AIC, which acquires *Maya, Mirror of Illusions* (c. 1910)

March Independent Artists Exhibition, organized by Rockwell Kent, includes Davies, Luks, and Prendergast but not Henri

April Union League Club of New York show, organized by Henri with Glackens, includes The Eight

 Shinn solo show at Union League Club

June Prendergast to Italy, returns January 1912

1911 *continued*

Nov. Emma Goldman invites Henri to teach classes at the Modern School of the Ferrer Center

Dec. Davies, Glackens, Lawson, and Luks present at the first meeting of the AAPS, instrumental in organizing "International Exhibition of Modern Art," known as the Armory Show

1912

Modern art collector Duncan Phillips acquires first Lawson painting, *High Bridge — Early Moon* (by 1910) and Albert C. Barnes purchases several of Lawson's paintings

Sloan acting art director of socialist political magazine *The Masses;* in 1916 resigns from the publication and from the Socialist Party

Jan. Davies elected AAPS president

Feb. Glackens to Paris for Barnes, purchases modern French art

March Davies solo show at Macbeth Galleries

Glackens first solo show at Madison Art Gallery

Sept. Henri visits the Salon d'Automne and Gertrude Stein in Paris

Dec. Davies makes AAPS appointments: Glackens chair of Committee on Domestic Exhibits; Lawson and Henri on Committee on Foreign Exhibits; only Prendergast on both committees

FIG. 44, William Glackens, c. 1935

1913

Barnes purchases first work by Sloan, *Nude, Green Scarf* (1913; unlocated)

Feb. 17– March 15 Armory Show draws some 300,000 visitors to view 1300 works; The Eight artists, except Shinn, participate; modified show travels to Chicago and European section to Boston

April Davies awarded CI's honorable mention for *Sleep Lies Perfect in Them* (1908; Worcester Art Museum)

Nov. Davies organizes show of contemporary American art for CI

1914

Prendergast elected AAPS president; Henri, Luks, and Sloan later resign; association disbands

Feb. Henri awarded PAFA's Beck Medal for *Herself* (1913; AIC acquired in 1924)

June Panama-California Exposition, San Diego, Henri organizes art show

Prendergast and brother Charles move to Greenwich Village studio in same building as Glackens

1915

Panama Pacific Exposition, San Francisco: Davies exhibits 40 paintings; Lawson wins gold medal; Henri wins silver medal

Lawson awarded AIC's Blair Prize for *Winter* (1914; MMA), his first painting to enter MMA

Prendergast first retrospective at Carroll Galleries: modern art collectors Quinn, Barnes, and Ferdinand Howald buy works

1916

Glackens elected first president of Society of Independent Artists; Prendergast and Sloan are officers

Forum Exhibition of Modern American Painters, organized by Alfred Stieglitz and Willard Huntington Wright, with Henri in honorary capacity

CGA's Clark Gold Medals awarded to Davies for *Castalias* (c. 1916; Hirshhorn Gallery); Lawson for *Boathouse, Winter Harlem River* (c1915; CGA); Luks for *Woman with Maccaw* (1907; Detroit Institute of Arts)

Lawson awarded NAD's Altman Prize for *Pigeon Coop* (c. 1916; private collection)

Sloan solo show at Whitney Studio

FIG. 45, Robert Henri, c. 1897

1917

Lawson elected Associate Member of NAD; awarded NAD's Inness Gold Medal for *Hills at Innwood* (1914; Columbus Museum of Art)

Sloan elected president of Society of Independent Artists (serves until 1944)

1918

Whitney Studio Club founded; Glackens, Prendergast, Sloan early members

Luks awarded PAFA's Temple Gold Medal for *Houston Street* (1917; St. Louis Art Museum)

1919

Prendergast's first work acquired by a museum, monotype *The Ships* (c. 1895–97; Memorial Art Gallery at the University of Rochester)

1920

Lawson awarded PAFA's Temple Gold Medal for *Ice-Bound Falls* (1919; AIC)

Davies solo show at AIC

Shinn show at Knoedler Galleries (last until 1937)

1921

MMA organizes its first modern art show, "Loan Exhibition of Impressionist and Post-Impressionist Paintings," proposed by Bliss and Quinn

Sloan sells *Dust Storm* (1906) to MMA

Lawson awarded NAD's Altman Prize and CI's First Class medal for *Vanishing Mist* (c. 1916–21; CI)

FIG. 46, Ernest Lawson, 1931

March "Overseas Exhibition of American Paintings," organized by Gertrude Vanderbilt Whitney, travels to International Art Exhibition in Venice; London's Grafton Galleries; and Whitney Studio (in November); includes Davies, Glackens, Henri, Lawson, Luks, Prendergast, and Sloan

April National Arts Club honors Henri at testimonial dinner at Salmagundi Club

Fall PC founded, acquires Davies's *Flood* (c. 1903) and *Along the Erie Canal* (1890); Luks's *Sulky Boy* (c.1908) and *The Dominican* (1912); and Henri's *Dutch Girl* (1910, later reworked)

1922

Barnes Foundation established

Glackens solo show at Whitney Studio Club

Duncan Phillips purchases Sloan's *Wake of the Ferry II* (1907) and *Six O'Clock, Winter* (1912) and works by Lawson, Luks, and Prendergast

FIG. 47, George Luks, c. 1920

1923

Davies awarded CI's First Class medal for *Afterthoughts of Earth* (c. 1921; Jane F. Clark collection, fig. 7)

Henri's *The Art Spirit* is published

Prendergast awarded CGA's Clark Third Prize Bronze Medal for *Landscape with Figures* (1921; CGA)

1924

Davies solo show at Dayton Art Institute; AIC; Worcester Art Museum

Glackens awarded PAFA's Temple Gold Medal for *Nude* (1924, unlocated)

Feb. 1 Prendergast dies

Summer Henri spends five months in Ireland annually until 1929

168

1925

Barnes publishes *The Art in Painting* and the short-lived *Journal of the Barnes Foundation* to pioneer education on modern art; BF's museum functions as an educational institution with little public access

Davies solo shows at CGA; CI; Baltimore Museum of Art

Luks opens the George Luks School of Painting

Glackens travels frequently to France until 1931; health begins to decline

Fall AIC purchases Glackens's *At Mouquin's* (1905)

1926

Luks awarded AIC's Logan Medal for *The Player* (c.1925; The Arkell Museum)

Cleveland Museum of Art organizes first Prendergast memorial retrospective

Sloan awarded Philadelphia Sesquicentennial International Exposition's gold medal for etching *Hell-Hole* (1917)

1927

Quinn's modern art collection is sold at auction (he dies in 1924), includes works by Davies, Luks, Prendergast, Sloan, among others

April Davies solo show at John Herron Art Institute, Indianapolis

Dec. Albert E. Gallatin founds Gallery of Living Art at New York University to display his modern art collection

FIG. 48, Maurice Prendergast, c. 1917

1928

Whitney Galleries founded, Studio Club disbands

Lawson awarded NAD's Altman Prize for *Hills in Winter* (unlocated)

Oct. 28 Davies dies in Florence

1929

MoMA founded; Alfred H. Barr Jr., director

PC and AIC organize Davies memorial show, opens MMA in 1930

Glackens awarded CI's prize for *Bathers, Isle Adam* (1927; unlocated)

Sloan elected to National Institute of Arts and Letters

Henri awarded PAFA's Temple Gold Medal for *The Wee Woman* (1927; Grandy collection)

July 12 Henri dies in New York

Dec. MoMA organizes "Nineteen Living Americans," includes Lawson and Sloan

1930

Feragil Galleries organizes first major Lawson retrospective

Lawson awarded NAD's Saltus Gold Medal for *Gold Mining, Cripple Creek* (1929; Smithsonian American Art Museum)

Dec. MoMA organizes "Painting and Sculpture by Living Americans," including Luks and Glackens

1931

Whitney Museum of American Art founded, Juliana Force director

Sloan awarded PAFA's Beck Gold Medal for *Vagis the Sculptor* (1930; private collection)

March MMA organizes Henri memorial show

1932

WMAA organizes first "Biennial Exhibition of Contemporary American Painting"; purchases Prendergast's *The Bathing Beach* (c. 1919)

Luks awarded CGA's Clark Gold Medal for *Woman with Black Cat* (1930; CGA)

MoMA organizes "American Painting and Sculpture, 1862–1932," including The Eight except Shinn

FIG. 49, Everett Shinn, c. 1933

1933

Dec. 21 Luks dies in New York

1934

WMAA organizes Prendergast's New York memorial retrospective

1936

WMAA organizes Sloan etchings show

Glackens awarded PAFA's Sesnan Medal for *Beach, St. Jean de Luz* (1929; Terra Foundation for American Art, page 55)

1937

Lawson awarded Salmagundi Club's Shaw Purchase Prize for *Newfoundland Coast* (unlocated); MMA acquires his *The Beach, Miami* (after 1928); he receives Federal Arts Program mural commission for Short Hills, New Jersey, post office

WMAA organizes "New York Realists, 1900–1914," including Henri, Sloan, Luks, Glackens, Lawson, and Shinn

1938

Glackens awarded PAFA's Schiedt Prize for *Bal Martinique* (1928 or 1929; private collection)

May 22 Glackens dies at Charles Prendergast's Connecticut home

Dec. WMAA organizes Glackens memorial show, travels to CI; versions to AIC; Los Angeles; Saint Louis; Louisville; Cleveland; Washington, DC; Norfolk

1939

Shinn awarded AIC's Blair prize for watercolor *Early Morning, Paris* (1901; AIC)

Sloan's autobiography, *Gist of Art,* is published

April-Oct. MMA organizes "Life in America" at 1939 World's Fair; includes Luks's *Hester Street* (1905; BM); Sloan's *Dust Storm* (1906; MMA); *The Old Haymarket* (1907; BM), *Wake of the Ferry* (PC, 1907), *Six O'Clock, Winter* (c. 1912; PC), *McSorley's Bar* (1912; Detroit Institute of Arts)

Dec. 18 Lawson dies in Florida

1942

Sloan elected to the American Academy of Arts and Letters

1943

BM organizes retrospective of The Eight, catalogue introduction by Shinn

Shinn elected full member of NAD

1945

Sloan delivers Moody Lecture at AIC

PMA organizes "Artists of Philadelphia: William Glackens, George Luks, Everett Shinn, John Sloan"

1946

Dartmouth College, Hanover, New Hampshire organizes "John Sloan Paintings and Prints: Seventy-Fifth Anniversary Retrospective"

FIG. 50, John Sloan at Sinagua, 1941

1950

MMA organizes "American Paintings Today," includes Shinn

Sloan inducted into American Academy of Arts and Sciences

1951

Sept. 8 Sloan dies in New York

1952

WMAA organizes Sloan memorial retrospective, artworks selected by the artist

1953

May 1 Shinn dies in New York

1957

William Glackens and the Ashcan Group, an anecdotal history of The Eight that descries their development as painters, by Glackens's son Ira, is published

Exhibition Checklist

Works are listed by institution, artist, and date.

Milwaukee Art Museum

Arthur B. Davies
Fountain Play, c. 1900
Oil on canvas
16¹⁄₁₆ × 20⅛ in. (25.56 × 51.1 cm)
Milwaukee Art Museum, gift of
William Macbeth Incorporated
M1949.2
Page 33

Arthur B. Davies
Rhythms, c. 1910
Oil on canvas
35 × 66 in. (88.9 × 167.64 cm)
Milwaukee Art Museum, gift of
Mr. and Mrs. Donald B. Abert
in Memory of Harry J. Grant
M1966.57
Page 35

Arthur B. Davies
Male Model with Bow
Early 20th century
Charcoal and chalk on green paper
12½ × 10¼ in. (31.75 × 26 cm)
Milwaukee Art Museum, gift of
Mr. and Mrs. Donald B. Abert
M1974.1
Page 36

Arthur B. Davies
Reclining Female Nude, c. 1910
Charcoal and chalk on brown paper
13 × 17¾ in. (33 × 45 cm)
Milwaukee Art Museum, gift of
Mr. and Mrs. Donald B. Abert
M1974.2
Page 37

Arthur B. Davies
Andante, 1916
Drypoint
6 × 4¾ in. (15.24 × 12 cm)
Milwaukee Art Museum,
Maurice and Esther Leah Ritz
Collection, M2004.173
Page 38

Arthur B. Davies
*Moonlight on the
Grassy Bank*, 1920
Aquatint and drypoint, printed
in color on green paper
11⅞ × 7⅞ in. (30.16 × 20 cm)
Milwaukee Art Museum, gift of
Mr. and Mrs. Donald B. Abert
and Mrs. Barbara Abert Tooman
M1984.12
Page 41

William Glackens
*Breezy Day, Tugboats,
New York Harbor*, c. 1910
Oil on canvas
26 × 31¾ in. (66 × 80.65 cm)
Milwaukee Art Museum, gift of
Mr. and Mrs. Donald B. Abert
and Mrs. Barbara Abert Tooman
M1974.230
Page 52

Robert Henri
Street Corner, 1899
Oil on canvas
32⅛ × 26 in. (81.6 × 66 cm)
Milwaukee Art Museum, gift of
Mr. and Mrs. Donald B. Abert
M1974.7
Page 66

Robert Henri
*Wyoming Valley,
Pennsylvania*, 1903
Oil on canvas
26 × 32 in. (66 × 81.28 cm)
Milwaukee Art Museum, gift of
Mr. and Mrs. Donald B. Abert
in Memory of Mr. Harry J. Grant
M1965.32
Page 67

Robert Henri
*The Art Student (Miss
Josephine Nivison)*, 1906
Oil on canvas
77¼ × 38½ in. (196.2 × 97.8 cm)
Milwaukee Art Museum,
Purchase, M1965.34
Page 59

Robert Henri
Dutch Joe (Jopie Van Slouten), 1910
Oil on canvas
24 × 20 in. (61 × 50.8 cm)
Milwaukee Art Museum,
gift of the Samuel O. Buckner
Collection, M1919.9
Page 68

Robert Henri
The Rum, 1910
Oil on canvas
24 × 20¼ in. (60.96 × 51.43 cm)
Milwaukee Art Museum, gift of
Mr. and Mrs. Donald B. Abert
in Memory of Mr. Harry J. Grant
M1965.31
Page 69

Robert Henri
Chinese Lady, 1914
Oil on canvas
41¼ × 33¼ in. (112.4 × 84.45 cm)
Milwaukee Art Museum, gift of
Mr. and Mrs. Donald B. Abert
M1965.61
Page 71

Robert Henri
Betalo Nude, 1916
Oil on canvas
41 × 33 in. (104.14 × 83.82 cm)
Milwaukee Art Museum, gift of
Mr. and Mrs. Donald B. Abert
M1972.24
Page 72

Robert Henri
Portrait of Marjorie Henri, 1918
Oil and pastel on paper
19¹¹⁄₁₆ × 12⁷⁄₁₆ in. (49.5 × 30.5 cm)
Milwaukee Art Museum,
Maurice and Esther Leah Ritz
Collection, M2004.78
Page 74

Robert Henri
Blond Bridget Lavelle, 1928
Oil on canvas
27¼ × 19¼ in. (69.2 × 48.9 cm)
Milwaukee Art Museum,
Centennial Gift of
Mrs. Donald B. Abert, M1987.28
Page 75

Ernest Lawson
Winter Scene, c. 1909
Oil on canvas
24⅛ × 30¼ in. (61.27 × 76.83 cm)
Milwaukee Art Museum, gift of
Mr. and Mrs. Donald B. Abert
and Mrs. Barbara Abert Tooman
M1981.188
Page 87

Ernest Lawson
Boat Club in Winter, c. 1915
Oil on canvas
16⁵⁄₁₆ × 20¼ in. (41.43 × 51.43 cm)
Milwaukee Art Museum,
Samuel O. Buckner Collection
M1928.6
Page 88

George Luks
*Bleeker and Carmine
Streets, New York*, c. 1905
Oil on canvas
25 × 30 in. (63.5 × 76.2 cm)
Milwaukee Art Museum, gift of
Mr. and Mrs. Donald B. Abert
and Mrs. Barbara Abert Tooman
M1976.14
Page 100

George Luks
Old Mary, c. 1919
Oil on canvas
20 × 16 in. (50.8 × 40.64 cm)
Milwaukee Art Museum, gift of
Charles D. James, M1968.47
Page 103

Maurice B. Prendergast
Picnic by the Sea, 1913–15
Oil on canvas
23 × 32 in. (58.4 × 81.3 cm)
Milwaukee Art Museum, gift of
the Donald B. Abert Family
in His Memory, by exchange
M1986.49
Page 127

Everett Shinn
*Spoiling for a Fight,
New York Docks*, 1899
Watercolor and pastel on board
22 × 29½ in. (55.88 × 74.9 cm)
Milwaukee Art Museum, gift of
Mr. and Mrs. Donald B. Abert
and Mrs. Barbara Abert Tooman
M1977.25
Page 138

Everett Shinn
Nightclub Scene, 1934
(possibly reworked later)
Oil on canvas
36 × 34 in. (91.44 × 86.36 cm)
Milwaukee Art Museum, gift of
Mr. and Mrs. Donald B. Abert
in Memory of Harry J. Grant
M1966.112
Page 143

Everett Shinn
Cabaret Singer in Red, 1951
Gouache on paper
5¾ × 3⅝ in. (14.6 × 9.2 cm)
Milwaukee Art Museum, gift of
Mrs. Edward R. Wehr, M1957.17
Page 142

John Sloan
Connoisseurs of Prints, from the
series *New York City Life*, 1905
Etching
4¹⁵⁄₁₆ × 7 in. (12.54 × 17.78 cm)
Milwaukee Art Museum, gift of
Mr. and Mrs. Donald B. Abert
and Mrs. Barbara Abert Tooman
M1977.189
Page 151

John Sloan
Big Hat (also known as
Blonde Girl), 1909
Oil on canvas
32¾ × 26¾ in. (83.2 × 67.94 cm)
Milwaukee Art Museum, Layton
Art Collection, Purchase, L1964.8
Page 154

John Sloan
Isadora Duncan, 1911
Oil on canvas
32½ × 26¼ in. (82.55 × 66.67 cm)
Milwaukee Art Museum, gift of
Mr. and Mrs. Donald B. Abert
M1969.27
Page 149

John Sloan
Anshutz on Anatomy, 1912
Etching
7¼ × 8⅞ in. (180.4 × 22.54 cm)
Milwaukee Art Museum, gift of
Juel Stryker in honor of her parents,
Clinton E. and Sarah H. Stryker
M1989.36
Page 18

John Sloan
Autumn Dunes, 1914
Oil on canvas
26¼ × 32¼ in. (66.67 × 81.9 cm)
Milwaukee Art Museum, gift of
Mr. and Mrs. Donald B. Abert
M1969.28
Page 156

John Sloan
Dunes at Annisquam, 1914
Oil on canvas
26 × 32 in. (66 × 81.3 cm)
Milwaukee Art Museum, gift of
Juel Stryker in honor of her parents,
Clinton E. and Sarah H. Stryker
M1989.29
Page 155

John Sloan
Dolly, 1929
Etching
4¼ × 3 in. (10.79 × 7.6 cm)
Milwaukee Art Museum, gift of
Juel Stryker in honor of her parents,
Clinton E. and Sarah H. Stryker
M1989.39
Page 16

John Sloan
Long Prone Nude, 1931
Etching and engraving
4¼ × 13¾ in. (10.8 × 34.92 cm)
Milwaukee Art Museum, gift of
Juel Stryker in honor of her parents,
Clinton E. and Sarah H. Stryker
M1989.49
Pages 160–61

John Sloan
Rose and Gray Nude, 1931
Crayon on paper
9¹³⁄₁₆ × 14 in. (24.92 × 35.56 cm)
Milwaukee Art Museum,
Maurice and Esther Leah Ritz
Collection M2004.106
Page 162

John Sloan
A Thirst for Art, 1939
Etching
3⅞ × 6 in. (9.84 × 15.24 cm)
Milwaukee Art Museum, gift of
Juel Stryker in honor of her parents,
Clinton E. and Sarah H. Stryker
M1989.51
Page 163

New Britain Museum of American Art

Arthur B. Davies
Remembrance, c. 1903
Oil on canvas
22 × 17 in. (55.9 × 43.2 cm)
New Britain Museum of American
Art, John Butler Talcott Fund
1909.01
Page 32

Arthur B. Davies
Hylas and the Nymphs, c. 1910
Oil on canvas
18 × 40 in. (45.72 × 101.6 cm)
New Britain Museum of American
Art, Harriet Russell Stanley Fund
1946.11
Page 25

Arthur B. Davies
Struggle, 1917
Drypoint
3⅛ × 9⅛ in. (7.9 × 23.2 cm)
New Britain Museum of American
Art, gift of Mrs. Sanford Low
1973.54
Page 34

Arthur B. Davies
The Temple, 1918–19
Etching on blue paper
11⅞ × 8 in. (30.16 × 20.32 cm)
New Britain Museum of American
Art, gift of the Alix W. Stanley
Estate, 1954.57
Page 40

Arthur B. Davies
Snow Crystals, 1919–20
Etching
6⅜ × 4½ in. (16.2 × 11.4 cm)
New Britain Museum of American
Art, gift of Mrs. Sanford Low
1973.05
Page 39

William Glackens
Interior, 1899
Pastel on green wove paper
13½ × 7½ in. (34.3 × 19 cm)
New Britain Museum of American
Art, Harriet Russell Stanley Fund
1949.03
Page 47

William Glackens
Washington Square, 1910
Oil on canvas
25 × 30 in. (63.5 × 76.2 cm)
New Britain Museum of American
Art, Charles F. Smith Fund
1944.03
Page 53

William Glackens
Portrait of a Young Girl
c. 1915
Oil on canvas
32 × 26⅛ in. (81.3 × 66.36 cm)
New Britain Museum of American
Art, A.W. Stanley Fund, 1958.06
Page 54

Robert Henri
Spanish Girl of Segovia, 1912
Oil on canvas
40¾ × 33⅛ in. (103.5 × 84.13 cm)
New Britain Museum of American
Art, A. W. Stanley Fund, 1941.07
Page 70

Robert Henri
An Imaginative Boy, 1915
Oil on canvas
24⅛ × 20 in. (61.27 × 50.8 cm)
New Britain Museum of American
Art, Harriet Russell Stanley Fund
1950.04
Page 73

Robert Henri
Dancer of Delhi
(Betalo Rubino), 1916
Oil on canvas
38½ × 57¾ in. (97.79 × 146.68 cm)
Collection of Melinda
and Paul Sullivan
Temporary loan
Page 65

Ernest Lawson
Colonial Church, c. 1908–10
Oil on canvas
24 × 20¼ in. (61 × 51.43 cm)
New Britain Museum of American
Art, Charles and Elizabeth
Buchanan Collection, 1989.33
Page 85

Ernest Lawson
Spring Tapestry, c. 1930
Oil on canvas
40⅛ × 50 in. (101.9 × 127 cm)
New Britain Museum of American
Art, Charles F. Smith Fund
1948.09
Page 89

George Luks
Pals, c. 1907
Oil on canvas
30 × 25 in. (76.2 × 63.5 cm)
New Britain Museum of American
Art, Harriet Russell Stanley Fund
1943.11
Page 101

George Luks
Cabby at the Plaza
c. 1920–30
Oil on board
12 × 10 in. (30.5 × 25.4 cm)
New Britain Museum of American
Art, John Butler Talcott Fund
1941.02
Page 102

George Luks
City on River, c. 1921–27
Watercolor on paper
13½ × 19¼ in. (34.3 × 48.9 cm)
New Britain Museum of American
Art, gift of Olga H. Knoepke
1992.25
Page 106

George Luks
Suraleuska, n.d.
(possibly c. 1925–27)
Oil on canvas
20 × 16 in. (50.8 × 40.64 cm)
New Britain Museum of American
Art, gift of Olga H. Knoepke
1996.13
Page 104

George Luks
Sunset, c. 1928–32
Watercolor on paper
14½ × 18 in. (36.2 × 45.72 cm)
New Britain Museum of American
Art, gift of Olga H. Knoepke
1992.26
Page 107

George Luks
Pam, 1929
Oil on panel
31 × 23 in. (78.74 × 58.4 cm)
New Britain Museum of American
Art, gift of Olga H. Knoepke
1992.38
Page 105

Maurice B. Prendergast
Brittany Coast, c. 1892–95
Watercolor on paper
10 × 6⅞ in. (25.4 × 17.46 cm)
New Britain Museum of American
Art, Harriet Russell Stanley Fund
1947.01
Page 120

Maurice B. Prendergast
Beechmont, 1900–05
Watercolor on paper
19⅛ × 12¾ in. (48.57 × 32.4 cm)
New Britain Museum of American
Art, Harriet Russell Stanley Fund,
1944.01
Page 113

Maurice B. Prendergast
Salem, 1913–15
Oil on canvas
14¼ × 18¼ in. (36.2 × 46.35 cm)
New Britain Museum of American
Art, Harriet Russell Stanley Fund
1944.15
Page 126

Everett Shinn
Paris Street No. 2, 1902
Oil on canvas
10 × 12 in. (25.4 × 30.5 cm)
New Britain Museum of American
Art, Harriet Russell Stanley Fund
1943.15
Page 139

Everett Shinn
French Vaudeville, 1937
Oil on canvas
25⅛ × 30⅛ in. (63.8 × 76.5 cm)
New Britain Museum of American
Art, Harriet Russell Stanley Fund
1946.22
Page 141

Everett Shinn
*Trapeze Artists (Proctor's
Theater)*, 1940
Pastel on paper
19½ × 15¼ in. (49.5 × 38.7 cm)
Collection of Rhoda and
David T. Chase
Temporary loan
Page 140

John Sloan
Memory, 1906
Etching
7¹⁵⁄₁₆ × 8¹³⁄₁₆ in. (20.16 × 22.4 cm)
New Britain Museum of American
Art, gift of the Alix W. Stanley
Estate, 1954.15
Page 14

John Sloan
*George Luks in
His Studio*, 1908
Ink on paper
10½ × 8⅛ in. (26.7 × 21.6 cm)
New Britain Museum of American
Art, A. W. Stanley Fund, 1954.14
Page 15

John Sloan
*Copyist at the Metropolitan
Museum*, 1908
Etching
7⁷⁄₁₆ × 8¹⁵⁄₁₆ in. (18.9 × 22.7 cm)
New Britain Museum of American
Art, William F. Brooks Fund
1965.03
Page 146

John Sloan
Girl with Fur Hat, 1909
Oil on canvas
31½ × 25½ in. (80 × 64.77 cm)
New Britain Museum of American
Art, Harriet Russell Stanley Fund
1950.21
Not pictured

John Sloan
The Picture Buyer, 1911
Etching
5¼ × 7 in. (13.33 × 17.8 cm)
New Britain Museum of American
Art, William F. Brooks Fund
1964.51
Page 164

John Sloan
Main Street, Gloucester
c. 1914–18
Oil on canvas
26 × 32¼ in. (66 × 81.9 cm)
New Britain Museum of American
Art, Harriet Russell Stanley Fund
1943.16
Page 157

John Sloan
Hotel Dance, Santa Fe, 1919
Oil on canvas
20 × 24 in. (50.8 × 60.96 cm)
Collection of Rhoda and
David T. Chase
Temporary loan
Page 159

John Sloan
*Invitation to a
Studio Party*, 1921
Etching
3¾ × 2¼ in. (9.5 × 5.7 cm)
New Britain Museum of American
Art, given in memory of Anthony
and Mary Malinowski, 1993.51
Page 158

William Glackens
Bal Bullier, c. 1895
Oil on canvas
23¹³⁄₁₆ × 32 in. (60.5 × 81.3 cm)
Terra Foundation for American Art,
Daniel J. Terra Collection, 1999.59
Page 51

William Glackens
*A Headache in
Every Glass*, 1903–04
Charcoal, watercolor,
and gouache on paper
13¼ × 19½ in. (33.7 × 49.5 cm)
Terra Foundation for American Art,
Daniel J. Terra Collection, 1992.170
Page 44

William Glackens
Julia's Sister, c. 1915
Oil on canvas
32⅛ × 26⅛ in. (81.6 × 66.4 cm)
Terra Foundation for American Art,
Daniel J. Terra Collection, 1999.58
Page 49

William Glackens
Beach, St. Jean de Luz, 1929
Oil on canvas
23¾ × 32 in. (60.3 × 81.3 cm)
Terra Foundation for American Art,
Daniel J. Terra Collection, 1988.8
Page 55

Robert Henri
Figure in Motion, 1913
Oil on canvas
77¼ × 37¼ in. (196.2 × 94.6 cm)
Terra Foundation for American Art,
Daniel J. Terra Collection, 1999.69
Page 12

Ernest Lawson
Springtime, Harlem River, 1900–10
Oil on canvas
25 × 36 in. (63.5 × 91.44 cm)
Terra Foundation for American Art,
Daniel J. Terra Collection, 1992.45
Page 86

Ernest Lawson
Spring Thaw, c. 1910
Oil on canvas
25¼ × 30⅛ in. (64.1 × 76.5 cm)
Terra Foundation for American Art,
Daniel J. Terra Collection, 1999.85
Page 79

Ernest Lawson
Brooklyn Bridge, 1917–20
Oil on canvas
20⅜ × 24 in. (51.8 × 61 cm)
Terra Foundation for American Art,
Daniel J. Terra Collection, 1992.43
Page 82

George Luks
*Knitting for the Soldiers: High
Bridge Park*, c. 1918
Oil on canvas
30³⁄₁₆ × 36⅛ in. (76.7 × 91.8 cm)
Terra Foundation for American Art,
Daniel J. Terra Collection, 1999.87
Page 94

Maurice B. Prendergast
At the Seashore, 1895
Monotype on cream Japanese paper
7¹¹⁄₁₆ × 5¹⁵⁄₁₆ in. (19.5 × 15.1 cm)
Terra Foundation for American Art,
Daniel J. Terra Collection, 1992.69
Page 121

Maurice B. Prendergast
*Evening on a
Pleasure Boat*, 1895–97
Oil on canvas
14⅜ × 22⅛ in. (36.5 × 56.2 cm)
Terra Foundation for American Art,
Daniel J. Terra Collection, 1999.110
Page 123

Maurice B. Prendergast
The Breezy Common
c. 1895–97
Monotype with graphic additions
on cream Japanese paper
7 × 8¹⁵⁄₁₆ in. (17.8 x 22.7 cm)
Terra Foundation for American Art,
Daniel J. Terra Collection, 1992.73
Page 122

Maurice B. Prendergast
Salem Willows, 1904
Oil on canvas
26¼ × 34¼ in. (66.7 × 87 cm)
Terra Foundation for American Art,
Daniel J. Terra Collection, 1999.120
Page 124

Maurice B. Prendergast
St. Malo, after 1907
Watercolor and graphite on paper
15⅛ × 22 in. (38.4 × 55.88 cm)
Terra Foundation for American Art,
Daniel J. Terra Collection, 1999.121
Page 125

Maurice B. Prendergast
*Still Life with Apples
and Vase*, c. 1910–13
Oil on canvas
19⅞ × 22¾ in. (50.5 × 57.8 cm)
Terra Foundation for American Art,
Daniel J. Terra Collection, 1999.122
Page 119

Maurice B. Prendergast
The Grove, c. 1918–23
Oil on canvas
15¼ × 20³⁄₁₆ in. (38.7 × 51.3 cm)
Terra Foundation for American Art,
Daniel J. Terra Collection, 1992.63
Frontispiece, page 4

Everett Shinn
Theater Scene, 1903
Oil on canvas
12¾ × 15½ in. (32.4 × 39.4 cm)
Terra Foundation for American Art,
Daniel J. Terra Collection, 1999.136
Page 133

Photography Credits

We would like to thank all those who gave their kind permission to reproduce material. The publication would not have been possible without the generosity of the following institutions: Ad Reinhardt Foundation; Albright Knox Art Gallery, Buffalo, New York; The Art Institute of Chicago; Columbus Museum of Art, Ohio; The Corcoran Gallery of Art, Washington DC; Delaware Art Museum, Wilmington (especially Jennifer M. Holl and Rachael DiEleuterio); The Library of Congress, Washington DC; Los Angeles County Museum of Art; The McNay Art Museum, San Antonio; The Metropolitan Museum of Art; Michael Altman Fine Art & Advisory Services, LLC; Munson-Williams-Proctor Arts Institute, Utica, New York; Museum of Art, Fort Lauderdale; Museum of Fine Arts, Boston; National Academy of Design, New York; National Gallery of Art, Washington DC; New-York Historical Society, New York; The Newark Museum, New Jersey; Philadelphia Museum of Art; The Phillips Collection, Washington DC; The Shubert Archive; Smithsonian American Art Museum; Smithsonian Institution Archives of American Art; Smithsonian Institution Libraries; Smithsonian Institution National Portrait Gallery; Whitney Museum of American Art, New York (especially Berit Potter); and Williams College Museum of Art, Williamstown, Massachusetts.

Photographs by Sheldan C. Collins: 81

Photographs by Whitney Cox: 130

Photographs by P. Richard Eells: 155

Photographs by John R. Glembin: 16, 18, 33, 36–38, 41, 66–69, 74, 75, 138, 142, 143, 151, 160, 163

Photography by Gertrude Käsebier: 165

Photographs by Efraim Lev-er: 59, 127, 154, 162

Photographs by John Nienhuis: 54

Photographs by Jerry L. Thompson: 17

Photographs by John Urgo: 14, 15, 18, 25, 32, 34, 39, 40, 47, 53, 54, 70, 73, 85, 89, 100, 102, 103, 105–107, 113, 120, 126, 139, 141, 146, 157, 158, 164

Photographs by Dedra Walls: 35, 54

Photography © 2009 Museum of Fine Arts, Boston: 93

Photography courtesy The Art Institute of Chicago: 30

Photography courtesy of the Everett Shinn collection, 1894–1953, Archives of American Art, Smithsonian Institution: 134, 135, 167 (Henri)

Photography courtesy of the Forbes Watson papers, 1900–1950, Archives of American Art, Smithsonian Institution: 168 (Luks)

Photography courtesy Helen Farr Sloan Library & Archives, Delaware Art Museum, Gift of Helen Farr Sloan, 1978: 170

Photography courtesy Library of Congress: 165

Photography courtesy Museum of Art | Fort Lauderdale, Nova Southeastern University; Bequest of Ira Glackens: 166

Photography courtesy Peter A. Juley & Son Collection, Photograph Archives, Smithsonian American Art Museum: 28, 29, 167 (Lawson), 169

Photography courtesy Prendergast Archive and Study Center, Williams College Museum of Art: 168

© Ad Reinhardt Foundation: 117

© The Art Institute of Chicago: 132, 136

© Artists Rights Society (ARS), New York / ADAGP, Paris / Estate of Marcel Duchamp: 58

© Delaware Art Museum / Artist Rights Society (ARS), New York: 14–16, 18, 56, 144, 146–152,154–163

© Estate of William James Glackens: 42

© The Metropolitan Museum of Art: 24